NOISE CHANNELS

Electronic Mediations

Katherine Hayles, Mark Poster,
and Samuel Weber, Series Editors

(continued on page 164)

NOISE CHANNELS
Glitch and Error in Digital Culture

Peter Krapp

Electronic Mediations
VOLUME 37

University of Minnesota Press
MINNEAPOLIS
LONDON

Portions of chapter 1 were previously published as "Hypertext avant la Lettre," in *New Media, Old Media: A History and Theory Reader*, ed. Wendy Hui Kyong Chun and Thomas Keenan, 359–74 (New York: Routledge, 2006). Portions of chapter 2 were previously published as "Terror and Play, or What Was Hacktivism?" *Grey Room* 21 (Fall 2005): 70–93; copyright 2005 by Grey Room, Inc., and the Massachusetts Institute of Technology. Portions of chapter 4 were previously published as "Gaming the Glitch: Room for Error," in *Error: Glitch, Noise, and Jam in New Media Culture*, ed. Mark Nunes, 113–32 (New York: Continuum, 2010). Portions of chapter 5 were previously published as "Of Games and Gestures," in *The Machinima Reader*, ed. Michael Nitsche and Henry Lowood, 159–74 (Cambridge, Mass.: MIT Press, 2011); copyright 2011 by the Massachusetts Institute of Technology.

Published by the University of Minnesota Press
111 Third Avenue South, Suite 290
Minneapolis, MN 55401-2520
http://www.upress.umn.edu

Library of Congress Cataloging-in-Publication Data

Krapp, Peter.
Noise channels : glitch and error in digital culture / Peter Krapp.
 p. cm. — (Electronic mediations ; v. 37)
Includes bibliographical references and index.
ISBN 978-0-8166-7624-8 (hc : alk. paper)
ISBN 978-0-8166-7625-5 (pb : alk. paper)
1. Computers—Social aspects. 2. Cyberspace—Social aspects. 3. Digital media—Philosophy. 4. Software failures. 5. Serendipity. I. Title.
QA76.9.C66K74 2011
302.23'1—dc22
 2011003819

17 16 15 14 13 12 11 10 9 8 7 6 5 4 3 2 1

CONTENTS

ACKNOWLEDGMENTS

WHEN I ARRIVED at UC Irvine in 2004, I had the good fortune to connect with a number of like-minded faculty members and students who joined me in exploring digital culture. Above all, I should mention the core lectures on new technologies I have offered every spring in the film and media studies major; the pioneering, writing-intensive, First Year Integrated Program in Computer Games as Art, Culture, and Technology I co-taught with Bill Tomlinson and Dan Frost of the Department of Informatics for three years in a row, sponsored by the Division of Undergraduate Education; and my two upper-division seminars on machinima that resulted in a lot of highly watchable computer game puppeteering on various hard drives. Without them, chapters 4 and 5 would not have been written. I should also mention my graduate seminars on archives, on the media history of secrecy, and on models and simulations, as opportunities to discuss material that went into this book. At Bard College, Tom Keenan deserves a cross-continental wave for including an earlier version of chapter 1 in an edited collection he put together with Wendy Chun: *New Media, Old Media: A History and Theory Reader* (New York: Routledge, 2006). Before leaving Irvine, Felicity Scott and Branden Joseph gave me significant feedback on an earlier version of chapter 2, which first appeared in the journal *Grey Room* 21 (MIT Press, 2006). Completion of the rest of this book project was delayed by a cascade of onerous commitments to academic shared governance, in the School of Humanities, then on the Irvine campus, and then at the UC headquarters in Oakland. Without naming the many colleagues from all ten UC campuses whom I had the pleasure to meet through the Academic Senate, I acknowledge my debt to their contagious idealism, work ethic, and institutional memory.

Thanks also to everyone who invited me to present my work. Parts of this project were discussed at the University of Aberdeen, Universiteit van Amsterdam, Universität Basel, UC Berkeley, Freie Universität Berlin, Brown University, University of Cape Town, University of North Carolina at Chapel Hill, Georgetown University, University of Melbourne, Northwestern University, Parsons The New School for Design, Universität Potsdam, Princeton University, Tainan National University of the Arts, Europa-Universität Viadrina in Frankfurt/Oder, and the University of the Witwatersrand, as well as at annual conventions of the National Communication Association and the Popular Culture Association and American Culture Association in Chicago, San Diego, and New Orleans, respectively.

Without Mark Poster as a seminal figure in media studies, I doubt I would be able to do what I do at UC Irvine, and I was inspired by guest speakers at events I organized here: John Seely Brown, Wendy Chun, Daniel Clancy, Rosemary Coombe, Chris Csikszentmihalyi, Marc Davis, James DerDerian, Mark Dimunation, Cory Doctorow, Alex Galloway, Mark Hansen, Andrew Herman, Eva Horn, Erkki Huhtamo, Natalie Jeremijenko, Markus Krajewski, Henry Lowood, Peter Lunenfeld, Lev Manovich, Trevor Paglen, Claus Pias, Rita Raley, Stefan Rieger, David Rosenthal, Jeffrey Schnapp, Erhard Schüttpelz, Eugene Thacker, Noah Wardrip-Fruin, McKenzie Wark, and Samuel Weber.

At the University of Minnesota Press, I thank Doug Armato, the Electronic Mediations series editors, and the external reviewers for their help in getting this book out. Since I conceived this project, I have derived pleasure from six framed glitch photo prints by Ant Scott; they serve as reminders that some glitches can be recuperated, and I am glad to see one of his works on the cover of this book. My wife is my most insightful colleague and companion; last but not least, I continue to learn about videogames from playing with my son Leo, and I dedicate this book to him.

INTRODUCTION

Noise is the ultimate limiter of communication.
—Colin Cherry, *On Human Communication*

We are buried within ourselves; we send out
signals, gestures, and sounds indefinitely.
—Michel Serres, *The Parasite*

ANALYZING COMPUTER-MEDIATED communication in a series of noisy channels, this study of cultural forms developing around the human–computer interface looks at digital culture through the lens of inefficiencies. Rather than focus on how one might design the most ergonomic interface or engineer trustworthy reciprocity of encoding and decoding under conditions of lossy transmission, this book profiles a digital culture that goes against the grain of efficiency and ergonomics and embraces the reserves that reside in noise, error, and glitch. Digital culture taps reservoirs of creative expression under the conditions of networked computing, despite an apparent trend toward clean interfaces and tightly controlled interactions. The motivation for this book is not to restate Murphy's law—anyone using computers knows they will inevitably fail—but to engage with some core assumptions about "new media" and the hype surrounding each new technology in its early stages. From the anachronisms of hypertext theory to the mythologies of cyberterrorism, and from the glitchy sounds that computers unleash to the compelling scenarios of erring and exploring in gaming, this book engages with the dynamics of innovation and teleology in media history, discussing text, image, sound, virtual spaces, and gestures in channels of computer-mediated communication that embrace the limitations and closures of computing

culture around the turn of the twenty-first century rather than trying to overcome them. This book therefore profiles the productivity of noise in computer culture, tracing it in a series of examples: from writing under the conditions of the database, to questions of secrecy and visibility in a world of networked screens, to laptop music distributed by net labels, to playing with games as models of contingency, and finally to the question of archival access and cultural memory of the experience of play and performance in computer culture.

Tracing in new media cultures a resistance against the heritage of motion studies, ergonomics, and efficiency, I borrow some terminology from information theory, which influenced the work of some of the foremost media theorists of the second half of the twentieth century, ranging from Marshall McLuhan, Michel Serres, and Max Bense to Vilém Flusser, Friedrich Kittler, and Katherine Hayles, to name but a few. As humanities scholars grounded in historical and conceptual inquiry, they integrate insights from the history of technology and the philosophy of science. For instance, Hayles writes with reference to Claude Shannon and Serres of "formal results within information theory that demonstrated noise in a communication channel need not always destructively interfere with the message, but rather could itself become part of the message."[1] Following in their conceptual footsteps, this book not only treats of signals, gestures, and sounds in emerging forms of creative expression—ranging from writing and music to film and games—but also aims to contribute theoretically to current debates in the field of critical new media studies. Arguably this burgeoning field has never been more in need of historical grounding, because the role of critical analysis and conceptual interpretation is too often swept aside by an emphasis on current social and political factors in the industry.[2] By the same token, as Alan Liu emphasizes, "when new media is understood to be fully embedded in history rather than (as when it is facilely said that the internet makes books obsolete) post-historical, then it appears to be trickily both before and after its time."[3] Media technologies that afford time axis manipulation complicate discourse analysis; although the following chapters roughly follow a historical sequence, the story of our "information society" does not simply provide a linear index of progress.

The term *information* has a varied career, from its etymological con-

notations of the formative (including education) to denoting something communicable across time and space (and its value may depend on a particular time and space), and thence on to Shannon's quantitative definition.[4] These aspects are retained (to different degrees) in the current use of the word in media studies; Mark Poster contrasts Marx's mode of production to a more contemporary mode of information, and Bense juxtaposes a classical, Archimedean world, understood in terms of expenditures of energy and labor, with a nonclassical, Pascalian world of communication and information.[5] In the historical context of a confluence of radar screens, telephone and radio communication, game theory, and mathematical thought on secure channels, "the concept of information applies not to the individual messages (as the concept of meaning would), but rather to the situation as a whole."[6] Furthermore, "the productive ambiguity of noise emerged from the consideration that it is too much information—and precisely *unexpected* information."[7] Along such a trajectory, the structural and quantitative approach of what came to be called information theory is related to cybernetics as a general "science of relations" between systems (including biological, computational, neurological, social, and other systems), with an emphasis on communication or human–machine interactions.[8]

Soon, Turing machines, cybernetics, and information theory began to influence other academic areas. For instance, Jacques Lacan calls cybernetics and psychoanalysis parallel instances of the same thought experiment.[9] Asserting that "the entire field covered by the cybernetic program will be the field of writing," Jacques Derrida goes on to argue that "cybernetics is itself intelligible only in terms of a history of the possibilities of the trace as the unity of a double movement of protention and retention."[10] Indeed, cybernetics has a history in Germany and elsewhere that predates the Macy conferences and the publication of Norbert Wiener's writing: in the early 1940s, Hermann Schmidt developed a "theory of circular relations" in collaboration with several biologists, striving to express it mathematically and explore it technically.[11] Nobel Prize winner François Jacob writes that biological "heredity is described today in terms of information, messages, and code," and of course the genetic analogy is consequential.[12] In turn, at a colloquium on the nature of medical thought, Michel Foucault suggested that it ought to be conceived not in positivist terms but as information

processing, as interpretation of a pathological message emitted by a body. Such messages of health and illness were to Foucault above all auditory rather than visual. He hastened to add that this should not be misunderstood as a kind of humanistic dialogue between patient and doctor, and he pointed out that the body does nothing but make noise. Medical practice is to "decode the non-silence of the organs." A medical doctor is not dealing with the patient's narration but with the primordial noise of the body: "He is dealing with the noise. Through this noise, he must hear the elements of a message." By extension of the diagnostic metaphor, Foucault writes that the doctor "must eliminate the noise, close his ears to everything that is not an element of the message."[13] Commentators have aligned this little-known essay by Foucault on "message or noise" with a juxtaposition of objectifying gaze versus sonorous attention, but it seems as if Foucault here applies noise suppression to both.[14] As these samples show, one must beware that a concept such as information not be naturalized and emptied of its specificity.[15]

For communication as we discuss it here, the addressee is almost always a human recipient, in a multiplicity of channels—whether directly, as in film or on the telephone, or indirectly as via a postcard or a secret code, whether received through sight or hearing or touch or smell, across space (as in radio or television) or across time (as in books or audio recordings), whether communicating one to one, one to many, or for that matter many to one or many to many. A steady, uninterrupted, monotonous sound carries little or no information beyond the fact that there is a source emitting a sine wave, but if it is interrupted, that already allows for encoded messages according to the scheme, for instance, of Morse code. Every message presupposes the unpredictable mutability of its physical channel, whether it is electricity, air, or whatever; this minimal variability allows the channel to carry information by dint of signal modulation. Predicated on an inventory of signs, a communications process has a finite duration T and bandwidth B, which means that although it may appear to a recipient as a continuous signal, it can be transmitted as a finite sequence of discrete values, $K = 2BT$. As Alan Turing put it for computer processing, "We might say that the clock enables us to introduce a discreteness into time, so that time for some purposes can be regarded as a succession of instants instead of a continuous flow. A digital machine must essentially

deal with discrete objects."[16] This defines digital transmission or storage of analog signals. However, as Warren McCullough summarizes the multifaceted discussion at the Macy conferences,

> Analogue devices showed tendencies for errors to appear in the least significant place, but were limited by precision of manufacture and could not be combined to secure additional places. *Digital devices might show errors in any place* (a limitation inherent in all positional nomenclatures), never required extreme accuracy, and could always be combined to secure another place, at the same price per place as previously. When components are relays, the digital devices sharpen the signal at every repetition.[17]

As resolution increases, a limitation of channel capacity is that it carries a certain amount of noise; Harry Nyquist found that noise gains energy as bandwidth increases.[18] A programming language called Nyquist (named in his honor and based on Lisp) was designed to analyze, synthesize, and manipulate sounds, including reverse noise removal in an audio editing program such as Audacity so as to keep rather than suppress a noise.[19]

The present study will treat of "noisy" interactions under the conditions of what is often called *information society*, or human communication under the auspices of computing. The chapters seek to investigate how creativity in audiovisual culture is communicable within the networks of computer-mediated interaction, from hypertext and tactical media arts to music and computer games. Although there are some references to the vocabulary of informatics, the emphasis here is on the cultural layer, as it were, that develops in coping with the structures and strictures of digital media. The pivotal question here is not whether culture changes under the conditions of ubiquitous computing, nor whether the trajectory from Morse code and pulse code modulation to the Internet and social media necessitates adaptations in our analytical and critical vocabulary; both are obvious questions that are besides the point. The issue is, rather, that expressions of cultural creativity operate in embracing rather than overcoming or ignoring limitations, whether those of a hairy brush and oily paint on canvas or those of a highly regimented calculating machine and its peers on a mycelium of nodes. In what is still essentially a modernist

paradigm, aesthetic expressions in digital culture seek to be recognized as both entirely new and inheriting the legitimacy of any serious art that preceded it. And even as the arts seek to put modernism behind them, there is arguably no art without any constraints at all. As the break with tradition has become its own tradition for aesthetic communication, digital culture is at times accused of teetering between kitsch, nostalgia, and cargo cult or celebrated as camp or postmodern pastiche. Nonetheless, there is room for real innovation, specifically against the industrial trends of efficiency and ergonomics. The formalization of scientific knowledge about probability and selection, stochastics and statistics, channel capacity and error correction helped produce a wealth of communication platforms and engineering solutions, yet the exploration and expression of audiovisual creativity responds to reserves and resistances in these formations.[20]

For new media studies in particular and digital humanities in general, this raises the question whether looking for such reserve or resistance is merely an attitude or luxury, or whether there is not a fundamental claim staked in aesthetic communication. It would surely oversimplify matters to surmise that the signal–noise dichotomy has come to displace codes pivoting on distinctions such as old–new, original–conventional, interesting–boring, simple–complex, ugly–beautiful, order–disorder, redundant–informative, serious–trivial, or progressive–conservative. Indeed, none of these pairs are analogous, and their slippage will motivate the subsequent chapters here. But whether developing formal or structural, sociological or art historical observations of ideological and historical options in digital culture, theories of aesthetic communication in the digital age tend to revolve around access. As pioneering new media arts curator Jasia Reichardt wrote four decades ago,

> The role of the computer in the realm of the visual arts is not limited to the production of graphics, sculptures, computer-aided action paintings, films and cybernetic devices. . . . The computer could be the tool for the democratization of art in its availability, even if it could do very little about making art more comprehensible or desirable.[21]

What binds the following five chapters together is that each observes a cultural register of human–computer interactions in digital culture: our purportedly "interactive" life under the conditions of the database, of various screens and displays and their interface metaphors, and of the input and output devices and peripherals that afford humans ways of storing, accessing, and manipulating information. As Rudolf Arnheim read Wiener, "information is defined as the opposite of entropy, and entropy is a measure of disorder."[22] Shannon's famous diagram shows the information source passing a message from a transmitter as signal to a receiver destination, via the contingent yet systemic interference that is the noise source. However, this renders the distorting interference not only as a "parasite" but also as a second-order signal source, where it can act both as negation and as generation of received signals. As Serres modifies the model, "background noise is the ground of our perception, absolutely uninterrupted, it is our perennial sustenance, the element of the software of all our logic. It is the residue and cesspool of our messages."[23] Moreover, the concept of feedback can be illustrated if you picture yourself at a lively party: you may notice the involuntary tendency for people to raise their voices in the presence of noise in the environment, yet that very attempt to resist degradation of the intelligibility of their messages makes them harder to understand, as they add to environmental noise. This compensation is sometimes called the Lombard reflex, and its result, like other forms of feedback, can defeat efficient communication.[24] Yet by the same token, the productivity of distortion for media culture was formalized as a cybernetic insight, whereby noise functions as negation of communication, and its valorization allows operational observation of communication systems. This realization inevitably led to research into the possibility of transmitting information with *zero probability of error*; as Shannon put it, "it may be of interest to consider, rather than codes with probability of error approaching zero, codes for which the probability is zero and to investigate the highest possible rate of transmission."[25] But knowing that a theoretical zero error capacity is "certainly less than or equal to the ordinary capacity for any channel" is cold comfort as long as contaminations abound. One consequence for computer-mediated communication is that redundancy can turn from an attribute of security

to an attribute of insecurity, as will be discussed in detail in chapter 2. When recurring noise patterns become signal sources as their regularity renders them legible, the systemic function of distortion doubles over as deterioration of message quality and as enrichment of the communication process. Information theory owes crucial impulses to anticipating interception by an enemy cryptanalyst:

> From the point of view of the cryptanalyst, a secrecy system is almost identical with a noise communication system. The message (transmitted signal) is operated on by a statistical element, the enciphering system, with its statistically chosen key. The result is the cryptogram (analogous to the perturbed signal) which is available for analysis.[26]

Thus the synthesis of signal and key decrypts the noisy transmission into a received message for the destined receiver, but it is encoded so that the anticipated distortion of communication, namely the interception and decoding of the message by enemy cryptanalysts, might be avoided. For instance, the normal frequency of letters in different languages yields a clue: whereas in Italian, the most common letters are E, I, A, and O, in French they are E, A, S, and N, in German E, N, R, and I, and in English E, T, O, and A, respectively. Another way to distinguish them is if we know that the hyphen is used 14 times per 1,000 characters in written German but 17 or 18 times per 1,000 characters in English. Moreover, consider the statistical frequency of digrams or trigrams; in French, the most common combinations of any three letters of the alphabet are ENT (118 times in any 1,000) followed by LES (77 times), whereas in German it is EIN followed by SCH (120 and 105 times, respectively), and in English THE followed by AND (233 and 90 times per 1,000), which helps with encoding for efficient throughput but also with decoding a cryptogram. The same holds for other channels, and thus Shannon's communication theory of secrecy collapses noise (to foes) and message (to friends) and always has to anticipate both desirable and undesirable negation: what is noise to one may be message to another. This book will seek to unfold the consequences of this insight across a variety of cultural channels.

From the earliest radio transmissions and interceptions to the commercial union of military technology and entertainment in television and videogames, and from the protocomputers of Bletchley Park to data mining on the Internet, media history can be told as the history of secret intelligence, defining the reality of the past century and a half. New media studies thus survey technologies of the sign from software engineering as information hiding to the split screens of our divided attention, concealment from Turing games to the use of avatars in virtual worlds, and data integrity from espionage and signal intelligence to secure e-commerce. Arguably there is no digital technology that does not raise questions about secrecy, in relation to often irreconcilable demands of privacy, security, trust, freedom of speech, and human rights. Thus Guy Debord suggests that our obsession with revelations, with uncovering secrecy everywhere, is part of the society of the spectacle, and he criticizes it as a distraction from the ways secrecy actually permeates our media society.[27]

Media theorist Vilém Flusser, who had joined the Brazilian society for cybernetics in 1959, anticipated the importance of computing in a number of ways and incorporated its vocabulary productively into his thought.[28] Flusser argued that media technologies functioned according to a specific program that precedes their affordances; information is only the knowledge for the user of media technology that is not redundant, and human culture and communication are forms of negative entropy that counter the inexorable process of nature.[29] He saw the transition to computer culture as a stark one when he conjectured that "occidental culture is a discourse whose most important information is stored in an alphanumeric code. This code is in the process of being replaced by other, differently structured codes."[30] However, the present study argues that the ongoing process to be investigated is not in fact simply a replacement and that the introduction of nonlinear codes does not happen all at once with the advent of computing. It may be more accurate to talk about supplements that never unambiguously displace the purportedly linear codes of writing or music but productively complicate them in a range of repertoires. Inversely, a systematic look at storage, processing, and transmission of information conveys a sense that linear, historical, process-oriented thought does not simply yield to analytical, structural, nondimensional thought but that they supplement each other, long

before—and all along with—the manifestation of one or another emphasis in technical form.[31] Flusser's pessimistic warning was that "writing, in the sense of placing letters and other marks one after another, appears to have little or no future. Information is now more effectively transmitted by codes other than those of written signs."[32] Yet what made him an influential media theorist was his insistence on conceptualizing images, words, and codes systematically. This is now the main task of the digital humanities.

> In the last decade, major digital text and image archives at East Coast centers of humanities computing in the United States (such as Brown University and the University of Virginia) have proved the sophistication and robustness of text encoding for literature. In a logically similar move, some of the most advanced humanities computing projects on the US West Coast—for example, those associated with the University of California's Digital Cultures Project and Digital Arts Research Network—have pursued the complementary paradigm of database technology.[33]

As Alan Liu puts it by way of an allusion to Kittler, the distinctive signal at the turn of the twenty-first century synthesizes 1800 and 1900.[34] Since Leibniz, Babbage, and Boole, machines afford simulations, and since cut and montage and linear prediction code, cinema and new media have revolutionized our sense of time and space.[35] Arnheim complains that "the tempting prospect of applying information theory to the arts and thereby reducing aesthetic form to quantitative measurement has remained largely unrewarding," but with the advent of computing that is not merely numerical but capable of rigorous modeling, immersive simulation, and dimensional audiovisual stimulation, it is no longer merely a question of reduction as such.[36] McLuhan's observations on media transpositions rendered the traditional distinction between logic and aesthetics invalid: we are enveloped in mediascapes that would not exist without computing technology.[37] This book will not try to trace mimesis or simulation as much as a generative and participatory "information aesthetics" that is no longer representational in the conventional sense but hinges on technologies of access to and interaction with raw data.[38] Thus chapter

1 argues that plurivocal hypertext may have seemed like a radical shift but in fact grew out of the historical logic of the archive and the database. Far from proving Flusser's pessimistic surmise that writing has no future when other codes take over, chapter 2 illustrates some of the effects of a shift in emphasis: media activism under the conditions of the Net and Web raises fundamental political question of who gets to say, show, or write what, whether visibly on the displays or less visibly in the source code. By extension, chapter 2 engages in what one might call "occultural studies," or the history of secret communications.[39] Furthermore, this book sets out to examine other peculiar strictures of creative expression and "unprogrammed" communication in digital culture, not only in forms of creative writing under the conditions of networked computing but also in the rhetoric of technological correctness that is neither simply libertarian nor anarchic but has palpably shaped the way questions of access and control are negotiated in computer-mediated communication in general and the expressive politics of hacktivism and tactical media in particular. This will be seen in the use of computers to synthesize sounds, generate patterns, and compose music; and in two chapters on computer game culture. Building on the opening chapters that discuss writing, visual communication, and music, chapter 4 focuses on glitches in the human–computer interfaces that come to the fore in gaming and chapter 5 on the production of digital animation within computer games that can take documentary, fictional, or experimental forms, a practice commonly called machinima. Here it should be emphasized that Shannon is a seminal reference not just for information theory in general but also for music and games in the digital age, because in his house he had collected five pianos, more than thirty other musical instruments, a range of pioneering chess computers (many of which he built himself), and various electronic toys he invented, such as "Throbac," "Nimwit," "Hoax," and the mind-reading machine. Alan Turing was astonished that "Shannon wants to feed not just data to a brain, but *cultural* things! He wants to play music to it!"[40] Shannon was a gadgeteer as well as an early pioneer in computer gaming (although he was careful to describe his gadgets as nonnumerical computing, to distinguish them from Turing machines). He divided his computational toys into three categories: those based primarily on rules and tables, those dominated by strategy,

and those that could learn. Arguably this typology of gaming still raises productive questions in digital culture; in playing with games, reading machinima through its gestures may ground new media studies in the conditions of possibility of computing culture, the triple setup of computer graphics, interface ergonomics, and database form.

Questions of access and interaction must be raised also for making music in the digital age. Flusser talks about the codes of occidental culture as both enumerating and narrative gestures, and these modes of counting and accounting appear to him to line up in ways that allow for closure, whereas the gestures of the media age depart from such modes. In the tsunami of publications about new media, digital culture, and media theory, the area of music generated with the aid of computers is all too often ignored. Perhaps it was always already easier for music to bridge alleged gaps between nature and culture in favor of their coevolution. Therefore, chapter 3 focuses on making music with the new affordances of computers, be it harnessing complex algorithms to make a laptop your performance partner or poking at keys to play *Guitar Hero* on a Blackberry. Chapters 4 and 5 will extend that argument about creative expression under the conditions of computer games. As Flusser surmises, telematic society can playfully produce information to resist entropy.[41] Specifically, chapter 4 investigates the tension between ludic contingency and rule-bound computing, and chapter 5 takes a look at playing with games in ways that transfer the gestural registers of theater and cinema into the differently circumscribed realms of off-the-shelf videogames.

Each of the following chapters will thus explicate the stakes of a computing culture that is perpetually fending off the kind of closures associated with efficient and ergonomic interfaces, lossless communication, perfect sound forever, jitter-free, tamper-resistant, low-latency datascapes. Clearly access remains as important as ever, yet it is increasingly regulated and constrained in visible and palpable ways. This tendency to black-box applications, to cordon off hardware and software, is met with a range of responses, from user policies to hacking, from repurposing hardware to open-source software, and from playing with games to rewriting the interface altogether.

1

HYPERTEXT AND ITS ANACHRONISMS

It is as though I had lost my way & asked
someone the way home. He says he will show
me and walks with me along a nice smooth
path. This suddenly comes to an end. And now
my friend says: All you have to do now is to
find the rest of the way home from here.

—Ludwig Wittgenstein, *Culture and Value:*
A Selection from the Posthumous Remains

THE TRANSITION from analog to digital media is perhaps too readily
understood as a shift from continuity to fragmentation, from narration
to archeology.[1] One might instead view it as a process of translation,
because what is completely untranslatable into new media will disap-
pear as fast as what is utterly translatable.[2] Such threats of disappearance
tend to lead to symptomatic cultural formations in a network culture
that Tiziana Terranova describes as "characterized by an unprecedented
abundance of information output and by an acceleration of informational
dynamics," a dynamic she describes as "the relation between noise and
signal, including fluctuation and microvariations, entropic emergencies
and negentropic emergences, positive feedback and chaotic processes."[3]
As a consequence, new media studies can be portrayed as organized
around a distinction between information and meaning. Moreover, the
implications of digitalization for learning and pedagogy are the topic of
numerous scholarly efforts; the most widely used hypertextual systems
seemed to bear witness to the creation of a "new economy." But whereas
some saw the Internet conquering the world and hoped for complete,

1

encyclopedic fulfillment of meaning, others saw only total noise and formed their neo-Luddite resistance against the overload. Their discontent concerned not so much the machine as its purported effects. Curiously, the news media are constantly abuzz with reports of cyberslacking and other forms of corporate employee ambivalence but without much critical reflection along the lines of what Michel de Certeau analyzed as "la perruque."[4] Both positions pivot on the same unquestioned assumption: that something irreversibly, incontrovertibly new is intruding on the turf of textual production and reception.[5]

Hypertext is the popular form of computer-mediated communication that has raised perhaps the highest expectations for a transformation of culture.[6] It has been hailed as a new form of literature, a new encyclopedia, a universal library, and a metamedium that would ingest and replace all older media. Theodor Nelson, who coined the term in 1963, proposed considering hypertext a "generalized footnote," and other media theorists such as Jacob Nielsen, Norbert Bolz, and Friedrich Kittler have followed him in this respect.[7] However, the footnote is still for the most part coextensive with the technology of the printing press, even as it expresses a certain strain against the linearity of narrative conventions.[8] More than constituting an extension of annotation and gloss, hypertext draws on processes of subverting, inverting, and exploding the apparent linearity of the page, in self-referential ways modern literature has already exploited. (A radicalization of general self-annotation is playfully illustrated by Heath Bunting's *readme.html*, where every word is a hypertext link.[9]) But broader acceptance of hypertext in and as culture will be achieved only partly by way of improved technical concepts.[10] Therefore, we need an attentive reading both of the promises that throw historical caution to the winds of mass distraction and of the quick assimilations that tend to reduce the complexity of any new situation to something already known. Thus, if one were to maintain a truly innovative character of hypertext, a more promising model might be the database.[11] Indeed, new media art no longer presents itself as narrative; its forms have no beginning or end, no predetermined sequence. Consequently, information theory can assign various probabilities to a set of possible messages. These and related observations about the symbolic form of computer-age fiction, cinema, games, art, and literature may or may not carry the full weight

of the hype with which an absolute innovation was heralded. The point of the present argument will be to test, as a selective probe in the genealogy of media, whether claims of an absolute departure are justified. If the following paragraphs focus mostly on hypertext (before subsequent chapters focus on the visual tactics of hacktivism, the recuperation of glitches in sound art, electronica, and games, and finally machinima as an emergent new media practice), it is because the widespread aestheticization of digital forms of expression, distinguishing between hypermedia and intermedia, separating fiction from interactive art, and so forth, in the end invariably fails to account for the fundamental question raised exemplarily by hypertext: how to explain the anachronism of claiming precursors and forefathers while presenting a radical departure. It is a curious side effect of positing such a paradigm shift that the logic of the break is applied to itself, and suddenly, with hindsight, it appears as if everyone knew it all along: as hypertext is hyped, much of what it supposedly superseded turns into hypertext *avant la lettre*.

To be sure, a text that contained its own exhaustive index would already be nothing *but* its own index and therefore the end of what it indexes; thus, the computer explodes the boundaries of the book. Hypertext makes references within the textual machine available, while their exact manner of connection remains open. The factors that affect and transform culture are less a matter of the media achievements that challenge the capacity of cultural memory than of the conditions that question the functioning of memory as such.[12] However, it is not enough to counter the promise of new media with the oldest critique on the books, that they scatter knowledge, undermine memory, and expose thinking to its deterioration.[13] It is feasible to see hypermedia as little more than an improved means to an old end, as Thoreau said of the telegraph—but with hindsight we know that technologies not only change the institutions of learning, they also transform the juridical and political milieu of culture.[14] To arrive at an appreciation of hypertext, one may look back at the development of the card index. Yet the point is not to historicize what goes beyond the book by pointing out that what first took shape as a bound sheaf recently has begun to fall apart again. Certainly in the sixteenth century, one knew to generate and copy excerpts and to summarize them in a register, but the loose pages were invariably threaded together, not handled individually.[15]

For rhetorical memory it was imperative not to work with loose sheets; because such excerpts were to be reread and committed to memory, it would imperil the entire project if their position in the collection were variable.[16] The ability to sort and shift entries in varying correlations was long perceived not as a valued feature of knowledge management but as a dangerous weakness of the system.

At the end of the seventeenth century, a historical comparison of different techniques for excerpting and indexing led to the development of a "learned box" that would enable the relational manipulation of notes.[17] This repository was soon adapted and adopted by writers, lawyers, historians, and philosophers: whereas John Locke published the description of his card index in 1686 anonymously, by 1796 Jean Paul could publish a novel called *The Life of Quintus Fixlein,* pulled from fifteen card indexes. Whatever occurred to Leibniz while reading or even on his walks, he scribbled onto slips for which he had a special cabinet constructed.[18] The search for a page norm was easily settled: playing cards had been in use for indexing at least since the French revolution. On May 15, 1791, the French government decreed that a list of confiscated books was needed to decide their fate: sell the libraries of noble families and monasteries, or make them accessible to the public. Local authorities resisted the scheme, because they had good reason to fear that after a book index went to Paris, the books themselves would not be far behind. Thus the National Assembly recommended quick new ways of indexing. Instructions were issued to inexperienced aides, who would take stock where the intractable librarians seemed to procrastinate. Regardless of local library customs, they were to go and copy each book's publishing information on a numbered playing card. These cards would later be more easily handled and sorted than a number of incongruent lists from the eighty-three departments; the operation netted the commission 1.2 million cards, to be used for a national library.[19]

As contemporaries of Hegel describe in detail, he systematically hoarded ideas and excerpts on note cards and carried them around from his school days, when he started at age fifteen, to his death.[20] A similar system is described by Charles Darwin: "I keep from thirty to forty large portfolios, in cabinets with labeled shelves, into which I can at once put a detached reference or memorandum. I have bought many books and

at their ends I make an index of all the facts that concern my work. Before beginning on any subject I look to all the short indexes and make a general and classified index, and by taking the one or more proper portfolios I have all the information collected during my life ready for use."[21] Gerhart Hauptmann "wrote his nocturnal ideas on the wallpaper near his bed," then cut it up to paste it into his daily output.[22] Beatrice Webb remarks in her autobiography *My Apprenticeship* of her attempts to persuade Oxbridge graduates that her index cards were "an indispensable instrument in the technique of sociological enquiry," and C. Wright Mills mentions his discovery that what he called cross-classification was crucial in keeping index cards.[23] Raymond Carver taped citations and fragments on three-by-five cards to the wall beside his desk; Georges Perec, who had worked as an archivist in a scientific laboratory, likewise yielded to the "temptation towards an individual bureaucracy" and developed a complex filing system, using his index cards for most of his literary publications.[24]

Despite this respectable lineage (itself reconstructed from excerpts of excerpts), the card index figures mostly as an anonymous, furtive factor in text generation, acknowledged—all the way into the twentieth century—merely as a memory crutch. (In 1981, when the Internet consisted of just 256 computers, Bob Kahn, co-designer of the TCP/IP networking protocol, was in charge of issuing Internet addresses and carried around index cards in his shirt pocket to keep track of newly issued addresses.) Because scholars are expected not just to reproduce knowledge but to produce innovative thought (figured not just as a recombination of good quotations but as opening new arguments and lines of investigation), their knowledge management tends to be a private matter, with rare exceptions. But the question remains whether there is indeed a departure from the "neolithic mind" Claude Lévi-Strauss glosses over in an interview, when he admits that his own memory "is a self-destructive thief" counterbalanced only by his extensive use of a card index:

> I get by when I work by accumulating notes—a bit about everything, ideas captured on the fly, summaries of what I have read, references, quotations. . . . And when I want to start a project, I pull a packet of notes out of their pigeonhole and deal them out

like a deck of cards. This kind of operation, where chance plays a
role, helps me revive my failing memory.[25]

In his subversion of the rigorous constraints of memorial order by dint
of chance and play, Lévi-Strauss seems to allow that the notes may either
restore memory—or else restore the possibility of contingency, which
gives thinking a chance under the conditions of modernity. That hyper-
text may instantiate such an epistemology of chance and play on-screen
is therefore no innovation; the encoding and deciphering practices of
computer-linked textuality merely recapture what had been possible
already with the primitive means of note cards, or playing cards. Hence
the temptation to claim them for hypertextual ancestry.

Suggesting encyclopedic fulfillment and yet accessible only in constant
dispersion, hypertext has the potential to radicalize literary production.
Writing was never simply a means of data storage; as it inscribes and
erases traces of textual work, of memory and anticipation, it seems as if
literalizing this structure as hypertext could approach the most exalted
hopes of literature. The bulk of critical commentary tends to focus on
the question of hypertext reception, but insight into textual production
complicates a careful archeology of the self-reflective poetics of literature
written under the conditions of the personal computer. Just as early cinema
lagged behind the aesthetic possibilities of theater when it imitated its
devices, hyperfiction tends to lag behind the poetics of prescreen literature.
As with many technological innovations, at first hypertext appeared to
spell the end of the book, the end of literature, the end of the humanistic
constraints of perception. But instead of an immense extension of aesthet-
ics, as media optimists envisioned, computing technologies soon turned
out to have an *anesthetic* effect, threatening to turn the user of a tool into
a mere consumer of anachronisms. Despite the widespread digitaliza-
tion of all media, most attempts to put computers to literary use restrict
themselves to hypertext, and the result more often than not falls back
behind much modern prose. To be sure, hypertext can pose significant
challenges to the conventions of canon, author, reader, and text. That
does not prevent philologists from using hypertext for their analyses.[26]
Even the most skeptical media critics demonstrate increasing technical
competence.[27] On the other hand, numerous cultural commentators who

seek to establish the renewed relevance of their particular intellectual lineage claim prescience when it comes to this knowledge system and interface. Vilém Flusser called Champollion a computer *avant la lettre*, because he cracked the hieroglyphic code.[28] Friedrich Kittler considers Hegel's notebooks "hypertextual" and Babbage a "precursor of the computer," and with Lacan, he identifies the "first machine" based on empty placeholders as Pascal's invention of the arithmetic triangle in 1654.[29] As mentioned already, Lacan called cybernetics and psychoanalysis parallel instances of the same thought experiment.[30] With hindsight, everybody knew all along. Recollection becomes oblivion, and the interface principle WYSIWYG becomes WYSIWYF: what you see is what you (for)get. Such parapraxis slips into the discussion of hypertext and the Internet wherever you look. One might say that the symptom of new media studies is this screen memory. As long as we remain blind to the texture of this symptom, we seem to get over it simply enough: hypertext will have been nothing but the metalanguage that never presents itself and remains folded in. One contemporary side of this symptom is search engine optimization and other soft censorship; the other side is WikiLeaks and the revived desire for a reliable index of adaptable permalinks.[31] Context hides directly beneath the surface, always a click away; information is the logarithm of the number of possible symbol sequences, and there is no world before stochastic communication systems. In the age of digital modification and insufficient version control, the screen is the horizon of memory.[32]

By far the most enthusiastic reception of hypertext in all its dimensions was extended by cultural theorists: at long last, all the promises of their approaches seemed to have come into their own, be they hybridity, nomadism, polyphony, intertextuality, or discourse analysis. Hypertext was going to prove Foucault, Iser, Barthes, or Deleuze right.[33] Whether the attention paid to hypertext is seen as confirmation of rhizomatics, actualization of semiotic theory, or a return with a vengeance of reception aesthetics, all these modes fail to recognize a basic and pivotal fact about the precarious status of hypertext: programs can be called writing, but in order to run, in order for text to be displayed properly, to be distributed and received, they need to be translated into other codes.[34] Despite the obvious misgivings that a grand narrative of textual and theoretical innovation might smuggle traditional hermeneutics back in through the

back door of technological determinism, it has been claimed as belated support for certain poststructuralist and semiotic claims. Derrida indeed wondered "whether the digressive, complicated, parenthetical, sophisticated structure of this discourse, which seems to include notes within notes, infinitely *en abyme*, derives from the fact that I wrote it on a computer."[35] George Landow was among the first academics to claim a "convergence" of hypertext and the theoretical micrologies of the last three decades.[36] He identified the key feature of hypertext as the link, and he presented it as a kind of parodic hypertrophy of the footnote. Landow's identification of Derrida's writing as hypertextual *avant la lettre* itself exhibits this sort of drift, if we follow the notes: Landow cites Ulmer, who refers to an interview with Derrida regarding one passage from Derrida's *Glas,* in which citations from the French *Littré* dictionary are listed. Across the Atlantic, Norbert Bolz agreed—calling both Wittgenstein's *Philosophical Investigations* and Derrida's *Glas* hypertext *avant la lettre.*[37]

Mention of Wittgenstein invites scrutiny of a peculiar aspect of such contagious retrospective anachronism. His papers, dispersed between Britain, Norway, Austria, and elsewhere, presented the executors of his estate with a conundrum when they found a box labeled ZETTEL, containing numerous loose pages and fragments. Anscombe and von Wright numbered no fewer than 717 such "scraps," the earliest dating from 1929, the latest from 1948 (the bulk were dictated between 1945 and 1948). Were they excess material, occasional ideas, sources, and excerpts? Should the typescripts and handwritten notes be published, destroyed, classified—and according to which criteria? A closer look demonstrated that they constituted a card index and offered clues on the ways in which Wittgenstein's writing relied on fine-tuning and copying; version control after his death proved to be extremely difficult but on rare occasions very informative. Far from presuming to reconstruct what Wittgenstein had meant to say in unfinished works, the editors simply ordered and published what they deemed the significant finds from this card catalog. Throughout, Wittgenstein's cut-and-paste practice was integral to his writing method to an extent that puts the avant-garde claims of hyperfiction to shame: "Usually he continued to work with the typescripts. A method which he often used was to cut up the typed text into fragments ('Zettel') and to rearrange the order of the remarks."[38] As von Wright

reports of the Wittgenstein papers, some cuts of longer texts are still extant, others were destroyed, and yet other fragments never made it into print. A typescript of 768 pages (called simply *The Big Typescript*) was dated to 1933, and it had been in the estate's control since 1951, but only in 1967 did they discover the "Zettel" from which it was made. Despite extensive cut-and-paste, the end product was always a linear argument, not a multidimensional arrangement.

Another important twentieth-century thinker to rely extensively on index cards was pioneering media theorist Harold Innis.[39] Indeed, as with Wittgenstein, the executors of his estate ended up publishing as a book a tome called *The Idea File*, composed of eighteen inches worth of index cards, with another five inches of reference cards.[40] Near the end of his life, Innis had a selection of handwritten index cards typed up and numbered, 1 through 339. As the editor notes, the cards themselves appear to be lost. It is certainly unclear from the published materials whether Innis's ruminations on television and art, communication and trade, secrecy and money, literature and the oral tradition, archives and history were meant to become a book project; the decision to publish the cards balances between the putative will to posterity of an author and the potential embarrassment of presenting incomplete work. Similar concerns accompanied the posthumous publication of a Nabokov novel, or scraps for one, which is extant on index cards.[41]

Above all other unwitting forefathers, Landow and other adopters of the convergence hypothesis claim that Roland Barthes anticipated hypertext.[42] Be it Proust, the daily newspaper, or the television screen—to Barthes, it was all text, and in the age of the Internet, it was going to be Barthes who had always already anticipated its structures and strictures.[43] Admittedly Barthes's writing lends itself to such pretexts, because he often read in a manner that generated, despite all categorical, classificatory zest, a kind of constant déjà vu effect.[44] In *S/Z*, Roland Barthes goes so far as to claim that, faced with the impure communication or "intentional cacophony" that is literature, one must accept "the freedom of reading the text as if it had already been read," and he goes further in asserting that faced with the plural text, there is no such thing as forgetting its meaning. Indeed, Barthes believes that one truly reads only in such quasi-forgetting.[45] (One might say with Adorno that the retroactive injunction *already to*

have read takes the form of a reprise.[46]) Reading would be a certain kind
of constructively modified forgetting; inversely, it might mean that one
reads only as if one had already read. Here, click theorists and critics of
digitextuality find themselves in agreement with the impresario of the
Desktop Theatre of Amnesia.[47] Interestingly, reading Barthes is experiencing
déjà lu, too: the distinctions Barthes made in 1960 between writerly and
readerly texts return in 1968, and his semiological definition of text crops
up in his arguments from 1963 through 1976. "Though most of Barthes'
now 'canonical' formulations on textuality occur in the period from 1968
to 1975, the issues that pushed him toward it were organizing his writ-
ing much earlier," observes John Mowitt, "in essence adumbrating the
move that directed his attention to the work's status."[48] Mowitt notices
how *articulation*, Barthes's term in "The Structuralist Activity" of 1963,
"reappears eight years later in the Preface to *Sade/Fourier/Loyola*," and
such continuities abound:

> Though I might be accused of stretching the point, it is also worth
> noting that in order to exemplify the procedural category of "dis-
> section" (articulation's twin) Barthes has recourse in this essay to
> the sonoric distinction between s and z—precisely the distinction
> that Barthes later exploited in his most ambitious demonstration
> of how one might read "textually," namely, *S/Z*.[49]

Faced with such textual echo, Mowitt concludes, "It becomes difficult to
dismiss this tangle of associations as merely fortuitous." The reason became
evident to the public when the Centre Pompidou opened an exhibition
on Barthes's work: he had worked, every day of his intellectual life, with
an extensive card index. In an interview, Barthes described his method:

> I'm content to read the text in question, in a rather fetishistic way
> writing down certain passages, moments, even words which have
> the power to move me. As I go along, I use my cards to write down
> quotations, or ideas which come to me, and they do, curiously,
> already in the rhythm of a sentence, so that from that moment on,
> things are already taking on an existence as writing.[50]

From 1942 to his death, Barthes amassed 12,250 note cards, constantly rewritten and reordered. He had given an outline of this intellectual tool in an interview, but it was only when his papers were opened by the manuscript researchers of Institut Mémoires de l'Edition Contemporaine that the scope of his card index could be studied. "There is a kind of censorship," Barthes said, "which considers this topic taboo, under the pretext that it would be futile for a writer to talk about his writing, his daily schedule, or his desk." As for his own habits, Barthes confessed, "I have my index-card system, and the slips have an equally strict format: one quarter the size of my usual sheet of paper. At least that's how they were until the day standards were readjusted within the framework of European unification." But Barthes found solace about his mental health in this unwelcome change: "Luckily, I'm not completely obsessive. Otherwise, I would have had to redo all my cards from the time I first started writing."[51] Almost all these cards, a quarter of letter-size paper, were written in pencil or blue ink; sometimes words or phrases are partially crossed out or corrected. Barthes marked a group of cards simply by noting the category on an upright card, and the rectangular cards that followed it contained quotes, observations, or diagrams. In the left or right top corner, he sometimes noted the date and often the page numbers of his publications where he used the information contained on the card (e.g., a fiche on "acting out" refers to *S/Z* pages 71–72). Several of the cards exhibited showed more than one use, including the passages noted by Mowitt.[52] There are no obvious techniques Barthes used to refer from one card to another beyond underlining, or sometimes circling, a word, term, or topic taken up on another card (some cards list up to three such links). For Barthes, outing his card catalog as coauthor of his texts was "an anti-mythological action," as he said; "it contributes to the overturning of that old myth which continues to present language as an instant of thought, inwardness, passion, or whatever." As one of the editors of the exhibition catalog concluded, Barthes's *fiches* were not the carcass of an unfinished project; there are no missing works by Roland Barthes, despite his sudden death in 1980.[53] "I know that everything I read will somehow find its inevitable way into my work," he had said confidently. However, the last course Barthes taught was called *La Préparation*

du Roman, "Preparing the Novel." Spread over two years, it simulates the exercises leading up to a novel; a week after the last class, Barthes was run over by a bus. On one hand, his death may have prevented him from actually writing his novel; on the other hand, the entire course, now published as a notebook, marks the novel as a lost object from the start. These notes are quite condensed and fragmented, just as the short sections of his *Lover's Discourse* were; Barthes had planned to include a postscript to that book, discussing his card index and method of writing. But that plan was abandoned, and the postscript was found only later among his papers.[54] All of Barthes's papers are now available at the Institut Mémoires de l'Edition Contemporaine; the one thing that can be learned from the manuscripts is his tendency to pare, to erase and efface certain words, especially pronouns, pruning his writing of autobiographical and self-referential elements while retaining a novelistic propensity. For Barthes, information was "meaning at its degree zero, that is, a kind of minimal condition for the ideological work of signification."[55] However, we must not confound the exposition of text design with what makes up the core of the card database: the so-called content.

If Landow's convergence hypothesis is to be tested in its reliance on Barthes as a model, the question is to what extent the card index, not the footnote, constitutes the precursor and technical model for hypertext in general and hyperfiction in particular.[56] Admittedly, some experimental storytellers mimicked the gloss of Talmudic annotation, Queneau and Calvino made their mark with the quasiformalist poetics of Oulipo, and some novelists and even a few poets intersperse their texts with the occasional footnote. Yet although annotation remains crucial for the documentation of philological or bibliographical accuracy, or for the demonstration of philosophical or pedantic veracity, it is only rarely a poetic model. However, there is a poetics of erudition and concealment around reading and writing, as long as there remains a vested interest in the appearance of originality or creativity, in preparing a novel or other literary form as well as in new media art. One need only think of Chris Marker's *Immemory* or Olia Lialina's *Anna Karenina Goes to Paradise* for intelligent use of the database form; George Legrady's art makes the structure even more obvious.[57] Pursuing data conversion in new media art further, perhaps one may add the eleven-hour "memory dump" of

home computer RAM converted into video of Cory Arcangel's *Data Diaries* here as well.[58] As Galloway speculates,

> If net art was cinema, then JoDi would be Godard—fresh, formalist and punk-rock to the core. Entropy8zuper! would be Tarkovsky—lush, magical and complex. Etoy would be Verhoeven—hyper modern, sexy and a tad fascistic. And this leaves Cory, playing in the rec room with his Pixelvision camcorder—all dirt-style, geekcore.[59]

Contrast their work with the notably low-tech approach of David Bunn, who found what he calls "subliminal messages" in the discarded card catalog of the Los Angeles Central Library—art work that straddles installation and database in pursuing fingerprints, pencil marks, and other contingent traces.[60] As if offering to make a connection between the Barthes exhibit and David Bunn's work, Christian Marclay also mounted index cards so as to fill the walls of an art gallery, calling it *White Noise*.[61] But more on transcoding and on Marclay in chapter 3.

A famously more conspiratorial example in the art world of the use of index cards involves Mark Lombardi. His drawings, based on his own index card catalog of public sources, trace relationships between powerful financial and political figures, such as oil companies, the Bush family, the Bin Laden family, and various banks. It is said that a few weeks after the September 11, 2001, terrorist attacks, an FBI agent called the Whitney Museum of American Art and asked to see a drawing on exhibit there.[62] Using just a pencil and a huge sheet of paper, Lombardi had created an intricate pattern of curves and arcs to illustrate the links between global finance and international terrorism. Lombardi had committed suicide the year before the attacks. However—and this is the most poignant index card moment in the anecdote—a collector instead tried to tender a direct offer to the show's curator, Robert Hobbs, a professor of art history at Virginia Commonwealth University, for the purchase not of any drawings but of Lombardi's extensive index card collection.[63] Thus it appears that a poetics of intellectual capital can be embodied in the card index, and perhaps hypertext goes no further than to make recursive legibility more explicit than before. Already in 1951, Prussian writer Ernst von Salomon had published a novel that takes its shape as a questionnaire; to

read it is to construe it as text generator in following commands to jump recursively from questions to answers and page to page.[64]

It was Walter Benjamin who announced, "The card index marks the conquest of three-dimensional writing, and so presents an astonishing counterpoint to the three-dimensionality of script in its original form as rune or knot notation."[65] Arguably, the true forefather of the Web is not the footnote of yore but the vision of Belgian bibliographer Paul Otlet, whose fantastic project of a Universal Book was to manifest the connections each document has with all others and to open this referential structure to further annotation and restructuring by each user. Since 1895, Otlet had envisioned a master bibliography of the world's libraries but found one fatal flaw all systems shared: they stopped at book titles. Otlet wanted his system to penetrate that boundary, to link up the substance, sources, and conclusions of all books. Long before Vannevar Bush or Ted Nelson laid claim to radicalizing knowledge management with memex or hypertext, Otlet developed a scholar's workstation that was, in essence, a database using millions of index cards.[66] He imagined the *réseau* would eventually be accessible by telephone lines, retrieving facsimiles projected onto a flat screen. Today as in Otlet's vision, hypertext foregrounds one feature: it tends to present itself as the sum of its links. However, the defining trait of hyperlinks is not just a web of self-annotation; they set in motion the three-dimensionality of letters that Benjamin saw mainly in the typographic innovations of advertising. It is important to note that under the efficiencies of the networked computer, hyperlinks in effect may also result in a poetics of the database. With this realization, new perspectives have been opened for the presentation and production of meaning. Few commentators accept this, however, surmising, again with Benjamin, that the new media spell the end of narration. As the limits and combinations of the new machines were tried and applied, the conventions of time–space perception are challenged and transformed. Film still maintains an affinity to linear narration, it also marks a significant departure from its conventions, by dint of cut and montage, fast-forward and slow-motion. In a note for his storyteller essay, Benjamin articulated the fear that

> one might consider these things eternal (e.g. storytelling), but one can also see them as temporal and problematic, dubious.

Eternal things in narration. But probably totally new forms. Television, gramophone and so forth make all these things dubious. In essence: we don't want to know all that. Why not? Because we are afraid that everything is repudiated: narration by television, the hero's words by the gramophone, the moral by the next statistics, the storyteller by what one knows about him. . . . *Tant mieux.* Don't cry. The nonsense of critical prognoses. Film instead of narration.[67]

Perhaps under the conditions of computerized society, the assumption that literature is the highest form of human language may seem obsolete. There is no Turing test for literature. Mathematician Alan Turing became famous for the unsolved test, which was to show statistically that the distinction between human language and computer-generated language is beyond human capacity. (Turing usually referred to this as a game; only twice does he call it a test.) Arguably, if this game of imitation is to be decided this side of eternity, it must be stopped by someone who occupies the position of external observer. Turing himself became literary material, for instance in work by Ian McEwan and Alan Hodges, and artificial intelligence advocate Marvin Minsky even published a science fiction novel about Turing.[68] But before we hasten to the conclusion that the introduction of computers turns "even the most intelligent poetry into myth or anecdote," as Kittler mocks, the fact remains that the new systems are used not only for the technical documentation of airplane construction and open-heart surgery but also for the writing of poetry.[69] In fact, poets have been trying for a few decades to generate experimental computer poetry, referring to William Carlos Williams, who seemed to grant them permission when he asserted that "a poem is a small (or large) / machine made of words." Of course historically (and systematically), the first electronic texts were computer programs, and without them there could be no hypertext. But there is also plenty of serious work on literary software. In 1962, the software "Auto-Beatnik" was introduced by R. M. Worthy in *Horizon Magazine,* "Auto-Poet" and "Scansion Machine" followed, and in 1984 *Scientific American* reported on "Racter," the first prose generator.[70] It uses a vocabulary database to generate complex, grammatically correct sentences. By now, numerous such programs are available on the Internet; among the best known are "Eliza," imitating

a psychiatric conversation, and sentence generators such as "Prose."[71] Many commercial Web sites now use customer service bots that interact with visitors handling standard queries and complaints. Search engines parse natural language to better determine the exact nature of your question. A program, it turns out, is just a text that generates text. With this development, the task of the critic seems impossible. How can the reader recognize an object as belonging to a class of objects, such as poetry, in such a way that it does not resemble the other members of that class too closely, as in plagiarism or direct imitation? One solution would be to distinguish between dissimulation and membership in the class. Twenty years ago, literary critic Hugh Kenner collaborated in the development of a "travesty generator," a software that would imitate literary texts. He concluded that all texts already followed his travesty principles, and language itself follows the rules of his software.[72] But impossible anteriority leads into paradox. One way to address the issue is to remind ourselves that not every text about literature is literature; not every text generated under the conditions of the machine is machine-generated text.

Of course, computers have no need to distinguish between a poem, a portrait, a video file, or a chunk of Unix code; sounds, images, and texts all disappear into binary states and are only simulated on screen. The readability of hyperfiction relies on HTML and its extensions like JavaScript, on the server software and its integral and occasional components that make the Internet possible, and on the operating software the computers run. Thus in the final analysis, literature on the computer is simulated literature; seen this way, there is no "hyper"-fiction, there is no "Net literature." But before this is seen as belated confirmation of the greatly exaggerated news of literature's death, informed hypertext criticism requires competence both in the aesthetics of literary expression and in methods of programming.[73] The true challenge of multimediality or hypermediality and interactivity is that the integration of sound and image tends to distract from the fact that ultimately, they are all code—and they are integrated only to the extent they are compatible on that level. As for hyperlinks, they challenge policies covering citation and fair use only to the extent that they go beyond the confines of a web or net of references internal to a text; rather than radicalize the poetic possibilities of creation, the whole tangle of questions is reduced to a matter of user

interface design. What few commentators care to address is how the practice of, for instance, Proust, Joyce, or Arno Schmidt demonstrates the transition from an extensive card index to a complex textual montage. The next step would be to recognize which lessons their exploration of the frontiers of textual production may yield for writing and reading under the conditions of the computer. On either side of this equation, the technologies of data processing and poetics surely go back further than to Modernism. Nevertheless, it is against the yardstick of twentieth-century writing that digitextuality is mostly measured.

One twentieth-century German writer often claimed as forefather of hypertextual literature is Arno Schmidt.[74] Voraciously citing, inveterately punning, Schmidt distilled his card index into literary texts, published as complex typescripts, photomechanically reproducing his montages without editing. Between 1963 and 1969, Schmidt worked on his 130,000 cards for up to sixteen hours per day, producing a text of 1,130 pages, 13 by 17.5 inches, and managed to publish it as *Zettels Traum* the next year. But he sought recognition not only as creative writer but also as a theorist of linguistic and stylistic elements of modern prose. According to Schmidt, only diaries constitute a serious attempt to deal with internal human processes; they help recollect, just as a photo album does, and Schmidt calculated the graphic dimensions of his textual arrangements so as to assist you in following certain associations and connections. Critics even speak of Schmidt's guidance "luring the reader into identification, into the *déjà vu* conviction that these recollections are his own."[75] Joining impulses from Joyce and Freud, among others, Schmidt documents how literature springs from less than divine sources. *Zettels Traum* is an extended essay on Edgar Allen Poe; over the course of twenty-four hours, the four protagonists discuss Poe's works, and Schmidt arranged his text in three parallel columns: the center column contains the action, the left one contains the Poe discussion, and the right column is made up of comments, footnotes, and auctorial opinions. Although much of *Zettels Traum* is devoted to discussions of E. A. Poe, its title is an open Shakespearean allusion to Bottom's dream. Page (or card) 914 of this proto-hypertext contains the passage most critics view as the key to this gigantic structure.[76] Each of the four characters in this card index fiction is spaced out on Schmidt's pages in a collective score, and here the book

is allegorized as a quartet of voices: the voluptuous unconscious, the mean superego, the observant ego, and a fourth instance, something that, according to Schmidt, accrues to men in their fifties, when the sex drive wanes and gives way to what the detached, smiling alter ego of the author represents. Like Derrida's *Glas* or Joyce's *Finnegans Wake,* often claimed as proto-hypertexts that court unreadability, Schmidt's book earns its inclusion here not by virtue of any such purported or real difficulties but simply because it dares declare itself made, not always already fully formed.[77] Such unforgivable artifice stands in the way of naive investments in make-believe, auctorial inspiration, or genius.[78] Similar textures are also evident in Benjamin's *Passagenwerk,* in Butor's *Mobile,* or in Nabokov's *Pale Fire,* a self-declared novel that falls into four parts: a preface, a poem, a lengthy annotation, and an index focusing almost exclusively on the notes.[79] In the preface, Nabokov recommends that readers start with the annotations, then return to them after cursorily picking the poem apart; he even goes so far as to suggest taking the book apart in order to cut and paste pages together at will, or at least buying a second copy to read them side by side. The poem itself is said to be written on 80 index cards of 14 lines each, as the preface dryly describes.[80] Over the moon, Jules Verne's writing is equally illuminated by the reflected light of a card index, in that the source code for his science fiction output was a box of some 20,000 excerpts and notes from scientific journals and books.[81]

The palimpsestic structure of such cosmic writing presents itself differently, again, in the twenty-four books of *A,* by Louis Zukovsky: "A / child learns on blank paper, / an old man rewrites palimpsest."[82] In this self-interpreting long poem, lines here gloss other lines there, allusions there become references here, and the whole successfully stages what many experimental hypertexts aspire to: a fascinating textual machine that explodes the pages of a book and yet holds together aesthetically. Zukovsky's poetry implicitly uses both Wittgenstein and Benjamin, whom he had read carefully; but when he was working on *A,* as he records in *Bottom: On Shakespeare,* he had also acquired the habit of performing, for himself, Shakespearean texts.[83] As for Schmidt, Bottom is for Zukovsky the performative weaver, the character who wants to play all the parts for fear that the audience might take the play for reality. In their craft, both Schmidt and Zukovsky hone a Shakespearean attention to particulars,

scraps, contingencies. But unlike the work of Schmidt, who in his punning ways always sought out vernacular spellings and colloquial phrases, Zukovsky's writing is not an imitation of speech but written to be performed. If some of Schmidt's spellings disgorge their single and double entendres only when read out loud, Zukovsky's poetry has other ways of straining against typographic convention. Despite such partial confirmation of a convergence hypothesis, it is certainly not satisfying to offer Joyce or Schmidt, Zukovsky or Nabokov as advanced hyperfiction writers, if by the same stroke their writing is rendered (virtually) illegible under the burden of theoretical proof. At the same time, it remains questionable whether even the most accomplished new media art could or should be measured against high modernism, as Max Bense and his students, for instance, still held for text under the conditions of computing.[84]

Finally, the hypothesis of convergence must be tested inversely: if hypertext instantiates what cultural theory knew all along, can a theorist's work be presented hypertextually? This has been tried with the silicon sociology of Niklas Luhmann's recombinant excerpts from an archive of excerpts.[85] His card index, Luhmann confessed, cost him more time than the writing of his numerous books: little surprise, then, that they demonstrate a certain amount of systematic redundancy.[86] Shortly after Luhmann's death in 1998, a dictionary and a glossary appeared to facilitate access to his thought, and an interactive database is offered on disk, marketed as "Luhmann on your computer." To be sure, nearly everything Luhmann read and wrote was part of his extensive card index, and his theory is incorporated in it perhaps more even than in his numerous books. The question, as in the case of Barthes, would be whether from the depths of such a memory bank further texts could have been generated or still can be. Users of the Luhmann CD-ROM may try their hand at emulating his arguments within the recursive parameters of his system theory.[87] The assumption of such an introductory multimedia tool, even without Luhmann's examples or a decent full-text search function, is that the theory comes alive, lives on, in its card index. Exploring the referential complexities of observation and differentiation, of circularity, structure, method, contingency, of communication and autopoiesis, the user navigating the database is held to make distinctions of increasing complexity while exploring the concepts and questions along their

converging paths and definitions. Luckily for the uninitiated, the CD-ROM offers more than just continuous jumps; at the bottom level, one finds an introductory essay on the historical development of Luhmann's system theory, and most screens also display an alphabetical menu, thus firmly anchoring the hypertheoretical drift in an encyclopedic project.

A different approach to Luhmann's associative indexing is explored in another collaborative database tool, developed by a Swiss team of programmers.[88] Called nic-las in homage to the late sociologist ("nowledge integrating communication-based labeling and access system") and billed as a "software prototype of an *autopoietic* knowledge landscape for social systems," it is basically a cooperative digital space for research groups, made up of textual components and Java objects. Shielded and organized by a multiuser access portal, each team can decide to what extent their collaboration is visible to outsiders and to what extent their notes, citations, exchanges, and other documents are made available to search engines. Anonymous use is possible at least in principle, but experience has shown that the thirty or so research collaboratives currently using nic-las tend to express themselves in the idiosyncratic ways of a typical academic gathering, with concerns over attribution, credit, and accreditation still extant. New entries or modifications of existing entries are recognized and dynamically linked to relevant other notes in the system. An intriguing feature is that deleted elements end up, for a while, in a digital unconscious; they remain accessible to certain search operations and can even return in unforeseen ways. The system distinguishes between a Freudian and a Deleuzian unconscious; whereas the former pushes some deleted objects back onto the documentation surface, the latter generates a random selection of deleted and undeleted objects in the form of new virtual index cards. Whether this is seen as new media art or as a software tool for academic work, and more importantly whether this succeeds in inscribing theory in software or vice versa, is ultimately a matter of the user experience, not just of the user interface. Here, as in other single-user or multiuser hypersystems, if the archive is intricately linked to the institution that authorizes it, then the law of selection, inclusion, or exclusion appears to be a dark outside.[89] Although this law is

itself implied in the archive, it decides what is represented and what is not. Yet hypertext's champions still claim that it accomplishes a virtually universal memory, as envisioned by its pioneers, Bush and Nelson.[90]

The paratext to Ted Nelson's influential *Computer Lib/Dream Machines* details the way the bidirectional tome is composed of juxtapositions, cuts, illustrations, fonts, quotes, and references, and the entire text grows from this mixture of preface, disclaimers, titles, jacket copy, and dedication.[91] Nelson undermines any easy classification of such liminal devices and confounds their distinction from a main body. It is remarkable that the reception of Nelson's coinage should have been so enthusiastic in the theoretical humanities, where his influential position in the study of computer culture is linked above all to the term *hypertext*. On one hand, Nelson argues against unnecessary verbiage at the outset of *Computer Lib/ Dream Machines*; on the other hand, his creative neologisms have a lot to do with the reputation the text soon acquired. Coincidentally, another influential subversion of textuality was published in 1974, the year the first edition of *Computer Lib/Dream Machines* appeared: Derrida's *Glas*.[92] They look astonishingly similar and argue parallel points. Both books are the product of radical textual montage, using elaborate cut-and-paste strategies that caused problems in getting into print; both were reissued in the 1980s and hailed as influential for an entire generation. Nelson and Derrida were vigorously misrepresented by acolytes and detractors and unfairly associated with exclusively text-based approaches to contemporary media. Nelson claims,

> The transclusion paradigm is a fundamentally different way of thinking about almost all computer issues. If we use more conventional terminology, it will anchor our thinking in a different system of conventions, and it will be harder to understand this fundamentally different paradigm.[93]

Nelson's penchant for neologisms such as *structangle, docuverse, teachotechnics,* and *showmanshipnogogy* illustrates this attitude. By contrast, Derrida argues in favor of keeping the old name, despite radical displacement and grafting of its connotations. Remonstrating the fundamental

impossibility of transparent immediacy, Derrida advocates the historical expansion of writing:

> To leave to this new concept the old name of writing is tantamount to maintaining the structure of the graft, the transition and indispensable adherence to an effective intervention in the constituted historical field. It is to give everything at stake in the operations of deconstruction the chance and the force, the power of communication.[94]

In the early 1990s, George Landow declared *Glas* "digitalized, hypertextual Derrida," and Modern Language Association president J. H. Miller associated it with "the new multi-linear multimedia hypertext that is rapidly becoming the characteristic mode of expression both in culture and in the study of cultural forms."[95] Whereas Mark Taylor argues that "deconstruction theorizes writerly practices that anticipate hypertexts," Geoffrey Bennington advises that if writing had a privileged empirical form for Derrida, it would be the computer—yet on the other hand, "hypertexts can just as well be presented as a fulfillment of a metaphysical view of writing."[96] Gregory Ulmer argues that Derrida's writings "already reflect an internalization of the electronic media," and Mark Poster holds that "computer writing instantiates the play that deconstruction raises only as a corrective."[97] Under the weight of such claims, both *Glas* and *Computer Lib/Dream Machines* came to be considered either illegible or always already read, yet the inscription of textuality into a worldwide net of computer-mediated communication will not simply have "always already" have taken place; it remains unforeseeable, its technicality must be interrogated without reducing such an interrogation to a participation in the same order. Hypertext is not the sublation of a system of traces and marks into fully manifest context but rather an extension of the same structure. As Shannon analyzed the transmission, manipulation, and use of information, it pivots on the problem of separating a signal from interfering noise in communication systems, although no amount of data smoothing can entirely overcome the distortion and noise sources. Computerized communication, if we retain that word, is no mere transference of meaning but inscription or grafting, and its effect is a dissemination that

is irreducible to the mere polysemy that hypertext supposedly embodies.

Claiming to have foreseen in 1960 the development of personal computing, word-processing, hypermedia, and desktop publishing, Nelson protests that nobody had yet understood how this structure can organize every connection and use of information, beyond inclusion or exclusion—hence his neologism *transclusion*.[98] Transclusion would enable one to reuse information with its identity and context intact.[99] However, just what the identity of context would be is the question; arguably, such a limitless memory of "intertwingularity" would not be a memory at all but infinite self-presence, while memory constantly revives the aposemiological corpse of the sign in referential paraphrases to recall its necessary relation with the nonpresent.[100] This "diadeictic" relationship presupposes, as Lyotard writes, "the empty gap, the depth separating shower and shown, and even if this gap is referred onto the table of what is shown, it will there be open to a possible index, in a distance which language can never signify without a remainder."[101] Hyperlinks alone do not allow one to surmount this obstacle. If every word were its own index, referring to something else—another word, another meaning—it does not follow that the word index, even when it appears in an index, is already that index.

That the exclusionary meaning of the word index, in the sense of an instrument of censorship, can never be excluded, even in the most efficient file management, is illustrated amply by the computer art installation *The File Room* (1994) by Antonio Muntadas, which indexes cases of governmentally suppressed speech, from classical Greek drama to contemporary journalism.[102] It includes works censored throughout the history of art because of their sexual orientation content, and it directly addresses freedom of speech; when the project opened in Chicago in May 1994, it contained 400 cases spanning twenty-five centuries, from Aristophanes to Salman Rushdie. Viewers could ponder Diego Rivera's dispute with the Rockefeller Center over his depiction of Lenin or TV moderator Ed Sullivan's request to the Doors to change one line of their lyrics in "Light My Fire." The architectural refinement of the installation belies the immense amount of information compressed into its representation of censorship; in its dark chambers of bureaucratic compartmentalization, containing black file cabinets and low lamps, viewers

browse case histories—or indeed add their own case to the archive. For the presentation in Chicago, 138 file cabinets of four drawers each were placed around the ground floor of the Cultural Center; seven color monitors installed in various networked file cabinets invited the audience to point and click through case histories, sorted by location, time, medium, and reasons for censorship. A centrally located table with another computer allowed the entering of new cases. Chicago high school students reported the confiscation of pamphlets about teen sexuality; entries were also made possible via the Internet. Hypertextual case management allowed the integration of images and other data from the Internet into *The File Room*—hundreds of users logged on daily and explored notorious or half-forgotten incursions into private or public lives. Thus *The File Room* earned its reputation as pioneering "net art."[103] But although such computer-mediated extension seems to explode the frame of the project, the installation remained site-specific in another sense: Muntadas had chosen the Cultural Center in Chicago because it had originally been built as a city library in 1897. Foregrounding the precarious and unfinished nature of archival processes, *The File Room* attempts a reintegration of the exclusions of the archive into the institution that has been shaped by censorship as much as by preservation.[104] In the final analysis, *The File Room* can never be closed; its promise to render invisible images and make unreadable texts legible must remain in permanent deferral. By the same token, with the inclusion of formerly censored art and literature now widely available online, the specificity of Muntadas's hypertext project is in peril of paling into the grand nowhere of the Internet, an unremarked irony for an art installation that, despite (or because of) the intentionally claustrophobic atmosphere of its physical setting, sought to transcend certain limitations of time and space. Muntadas's *The File Room* is clearly indebted to the conceptual works of the Art & Language collective, particularly to card index systems such as *Index 01* (1972), consisting of eight tall file cabinets of variable dimensions (appearing like columns topped with drawers) and photostats; *Index 2* (1972), consisting of a similar installation and surrounded by a wallpaper of index cards, plus file boxes on a table; and *Index 5* (1973), offering "Instructions for reading the index."[105] Although net art may disregard the modernist ideal of the artist who originates or perfects a single skill or style, it still differs

from conceptual art in that it often suffers a separation of interface and content; projects such as the *I/O/D Webstalker* (1997) strive to make that gap of digital representation the main theme.[106] Full comprehension of the influence new technologies have on literature and literary studies in particular, and on our culture and its self-representation in general, may seem to recede perpetually into the distance. But although popular views of distance remain cathected with forgetting and repression, distance is arguably nothing but the medium of appearing: as long as simultaneity equals noise, distortion, incomprehensibility, the delays and processing cycles of human or machine intelligence remain necessary. Shannon devised a measure of information content in terms of the probability of that event. However, it has become evident that information in fact lies dormant until it is accessed through an interface, yet that same interface may distort the information, obscuring its sources and perhaps even its crucial processes. This kind of information hiding is at work in every machine and in the recesses of the very code that carries hypertext, yet it is what database art seeks to foreground.[107]

Since Hegel, writing and calculating machines are understood as a threat because they interrupt and disperse the cultural fabric of sublation, recollection, idealization, and the history of spirit; the mechanical prevents any recuperation into complete and infinite self-presence. Neo-Luddites and technophiles share the assumption, enthusiastically or apocalyptically, that machines are omnivores, imploding all referentiality and excluding humans by means of their illegibility. Katherine Hayles praises the "impressive advances" made in meeting challenges posed by electronic textuality; Fredric Jameson worries that no society has ever been as oversaturated with information as ours.[108] No doubt, qualified net critique beyond mere consumerism requires new competencies and access for all; one may learn Fortran, C++, Unix, and Java, yet one must still concede that most programming is a synthetic group effort, not a critical analysis. And it is somewhat anticlimactic for new media studies to beat a retreat to interface design if it means giving up the crucial access to what interfaces only cover over. At times, this retreat is even dressed up as progress, as in the demand that a filmmaker, for instance, "needs to become an interface designer," as Lev Manovich urges: "Only then will cinema truly become new media."[109] Surely the political, technological,

or economic impulses of new media will have aimed higher than at generating mere screen memories for the bureaucratic entertainment of an interface culture.[110] In the end, preserving access beyond user interface design is a necessity, as the index card has demonstrated many times over since the French revolution. Although it is clear that computer programs and hypertexts by themselves will not revolutionize textual production or digestion, the archeology of multimedia reminds us that fiction and technology converged long before the age of the personal computer, when their convergence turned into an ever more technologized fiction. To observe the issues at stake is to observe how literature and the human sciences observe themselves and each other.[111] This mutual second-order observation of information hiding becomes legible only if you are able to access systems such as those that the novelist *manqué* Barthes, the collector Nabokov, the accountant Schmidt, the lawyer Luhmann, or the schoolteacher Wittgenstein all knew as a reliable tradition of archiving and handling the knowledge they would use for their craft as writers and scholars. Thus to study media is often if not always to study the political economy of an open secret. Although secretaries in seventeenth-century France or Italy were forbidden to speak of their work in public, their confiscated speech never dampened their drive to express the master– medium dialectic of their employment. And as Foucault demonstrates, doctors (not unlike confessors) were figured as stenographers of the clients' secrets, until the birth of the clinic forced them out of their secretarial role. Discussing the documentary system of police surveillance, Foucault points to a "partly official, partly secret hierarchy" in Paris that had been using a card index since 1833 to manage data on suspects and criminals. In a note, he dryly remarks, "Appearance of the card index and constitution of the human sciences: another invention the historians have celebrated little."[112]

2

TERROR AND PLAY, OR WHAT WAS HACKTIVISM?

Only a fool rejects the need to
see beyond the screen.

—Don DeLillo, *Libra*

It is to be strongly established,
from the beginning, that the myth is a
communication system, is message.

—Roland Barthes, *Mythologies*

AS WE WITNESS numerous government and corporate initiatives around the globe to restrain the free use of networked computers, knowledge and discussion about these and parallel measures are increasingly withdrawn from public discourse. Social power is already so diffuse that Adam Smith's market metaphor of the invisible hand has become pure nostalgia. Authoritative power is dispersed as global organizations transition from corporations to networks, and citizens of information society are governed less by concentrated coercion and more by ideological power, as manifest in the symbolic practices and norms of cyberspace.[1] But at the same time, media policy is increasingly determined exclusively by profit-oriented actors, transforming the legal and political frame of cyberspace.[2] These developments may soon have put an end to critical media practice and conceptual Net art; resisting this closure, tactical art "signifies the intervention and disruption of a dominant semiotic regime, the temporary creation of a situation in which signs, messages, and narratives are set into play and critical thinking becomes possible."[3] Once *cyberterrorism* is redefined to include any use of technology to disrupt,

sidestep, destabilize, or subvert any officially condoned user interface with technology, the tropes of computer culture as the triumph of bricolage will have been criminalized.

Pop culture no longer celebrates hacking as the generally innocuous but occasionally very profitable pursuit of the computer hobbyist. As television has stopped romanticizing the obsessions of talented nerds, the press no longer touts the bootstrapping spirit of digital capitalism. Instead, TV and print journalists have been selling the specter of hacktivism as an irreducible systemic threat of digital media.[4] To comprehend the precarious balance of secrecy and access in information policy, it is necessary to combine psychological, theoretical, and technical insight, as Shannon has already emphasized. This chapter takes issue with three of the most unfortunate misunderstandings in the standoff between old and new media.[5] First, hackers tend to be portrayed as immature scofflaws, and the remedy usually sought is greater disciplining power for the authorities, with the inevitable backlash. Second, once the protection of privacy and free speech is hollowed out by surreptitious data mining and invasions of data privacy, activism becomes all too easily equated with cyberterrorism, turning into enemies of the state anyone who dares question some of the more insidious consequences of a pervasive commodification of the network infrastructure. Third, the assertion that greater secrecy ultimately yields greater security is wrong, and the cult of secrecy leads to a global resurgence of irrational rumorology online. When conspiracy theory takes the place of critical Net culture, public debate over code and law is impoverished.

IF IN THE PAST FEW YEARS one wanted to follow nuclear tests in India, antigovernment protests in Arab countries, the fate of indigenous Mexicans in Chiapas, protests against the World Trade Organization, the handling of prisoners in Guantanamo, or demonstrations against the Republican National Convention, one was underserved by TV and print journalism and probably turned to the Internet. Human rights advocates, energy policy activists, sympathizers of the Zapatistas, antiglobalization protesters, and other groups likewise sought to attract attention to their causes by disrupting or defacing Web sites associated with Indian nuclear research, the Mexican government, the World Trade

Organization, or conservative think tanks. Internet users alerted to the concept of Echelon, an electronic communication scanner filtering all satellite, microwave, cellular, and fiber-optic traffic, had to wonder why and how capitalism had morphed into a fully integrated surveillance apparatus that could treat the world like a company town. To pull the veil of secrecy and ignorance aside, activists coined the notion of Jam Echelon Day, trying to disrupt the surveillance and alert the public to its presence in one stroke. Chinese computer hackers launched attacks on U.S. Web sites in protest against NATO's bombing of a Chinese embassy in the Kosovo war. Sweatshop critics, techno-libertarians unhappy with certain politicians, and people harboring curiosity or vested interests in commercial, military, or trivial secrets stretch the limits of the legal in cyberspace every day. A concerted denial-of-service attack on American e-commerce Web sites in February 2000 coincided with an atmosphere of growing unease about the dot-com boom—on the sides of those who knew nothing about it and of those who lived by it. The attack meant less online shopping for a few hours, but the story made the covers of half a dozen weekly magazines and numerous daily papers. One quote from me made it into *Newsweek* on a page that not very subtly parried the challenge with an opinion piece titled "Why the Market Will Rule: With Money at Stake, E-businesses Will Fix This Glitch." In the space of one magazine page, the panicky cover story about hunting for hackers turns into a mere glitch for hypercapitalism.[6] The media were eager to characterize companies such as Yahoo and eBay as victims "crippled" by the dastardly work of "vandals"; it did not matter that no permanent damage was done to these sites. It was "cyberterrorism" to distract any-one from the giant shopping-channel-experiment-on-steroids—pumping up the American economy on anabolic expectations that people would be doped up by the rapturous possibility of spending entire paychecks, with a click of a mouse, on stuff they could see only in pixels. In each case the authorities succeeded in making the Net a safer place for business transactions, but by the same token noncommercial uses of the Internet came under the sledgehammer of mercantile paranoia. Discussing early computing culture, Barlow warns that "cracking impulses seemed purely exploratory, and I've begun to wonder if we wouldn't also regard spe-lunkers as desperate criminals if AT&T owned all the caves" (but more

on the cave metaphor in chapter 4).[7] Once the innovations of the digital age were fully commodified, every space, online and off, was increasingly saturated with booming, busting business. Disregard for profit angles has become increasingly suspect, a vestigial virtue from an era when time was a plentiful resource, not a trace element of commerce. Even universities, once bastions of research as disinterested pursuit that ultimately benefits all, are trading the pursuit of knowledge for its own sake for whatever short-term profit mirages they hallucinate in cheapened distance education. Once it seemed that the Internet had to be made safe for commerce above all else, guaranteeing its security became a prime occupation of both business and government.

Hacktivism is a controversial term. Some argue it was coined strictly to describe how electronic direct action might work toward social change by combining programming skills with critical thinking. Others use it as practically synonymous with malicious, destructive acts that undermine the security of the Internet as a technical, economic, and political platform. Yet others associate it specifically with expressive politics, free speech, human rights, or information ethics.[8] Even the spelling of the term that combines hacking and activism has become controversial. If one wants to emphasize a technological legacy, *hacktivism* draws on the hacker attitude of hacking as exploring, testing, and creating solutions to technical limitations; if one suspects radicalized activism, *hactivism* might be the preferred spelling.[9] No common goal or motivating movement allows us to understand hacktivism in its social or political context; it is insufficient to warn that the "government has already criminalized the core ethic of this movement, transforming the meaning of *hacker* into something quite alien to its original sense."[10] Although the high-tech arsenal may comprise writing a computer virus, defacing a Web site, constructing false mirror sites and diverting Web traffic, or flooding servers in denial-of-service attacks, the ends for such actions are almost never reducible to a common cause. Sit-ins and virtual blockades, e-mail flooders and computer worms declare themselves interactive digital art projects. Some observers concur and call hacktivism—for example, in reaction to the Kosovo conflict or in solidarity with the Mexican Zapatistas—"conceptual net art."[11] Carnivore, a surveillance tool provided by the Radical Software Group, has traits similar to those of the eponymous FBI software (now

called DCS1000) and consists of a server that taps into the data stream of a local area network, allowing artists to provide client applications that display data in various imaginative ways.[12] The collective known as the Cult of the Dead Cow (cDc) created a distributed collaborative privacy network, dubbed "Peekabooty," to enable users to circumvent Internet censorship. The Electronic Disturbance Theater and others staged a week of disruption during the Republican National Convention 2004 in New York City, conducting sit-ins against Republican Web sites and flooding Web sites and communication systems identified with conservative causes.[13] More recently, Ricardo Dominguez turned his basic distributed denial-of-service attack against the headquarters of his employer, the University of California, at http://www.ucop.edu. An applet requested files named "Justice," "Freedom," and "Human Rights" so as to visibly return the error messages "Justice not found," "Freedom not found," and so on.[14] Other hacktivists managed to access computers at the Bhabha Atomic Research Center in India to protest against nuclear weapon tests; they set up Web sites such as McSpotlight.org and Bhopal.net to criticize multinational corporations. Yet others disabled firewalls so as to allow Chinese Internet users uncensored access, or they worked to slow, block, or reroute traffic for Web servers associated with the World Trade Organization, the World Economic Forum, and the World Bank. Hacktivism can be a politically constructive form of civil disobedience or an anarchic gesture; it can signal anticapitalist protest or commercial protectionism; it can denote spammers or anti-abortion activists, countersurveillance experts or open source advocates.[15]

Furthermore, the same bricoleur's tool kit, from port scanning and packet sniffing to hardware exploits and interface manipulation, has long been co-opted by state agencies and transnational corporations. In 1995, RAND presented a scenario that had Iranians bribe an Indian software engineer for Airbus to compromise a guidance system, triggering a plane crash over Chicago.[16] The NSA not only snooped on the "security risk" that was Princess Diana but also routinely directs employees to intrude into NASA computers to test vulnerability of their systems.[17] Canada has assembled a hacktivist team from computer science and political science to combat Web censorship in countries such as China, Cuba, Iran, Saudi Arabia, and Uzbekistan. The team studies the filters used in places such as

the United Arab Emirates and Syria and develops circumvention technologies.[18] German authorities have tried to mandate blocking foreign Web content by Internet access providers. German Secretary of State Schily reportedly considered state-sponsored denial-of-service attacks against Nazi Web sites hosted in the United States.[19] The German Internet task force would resort to means routinely labeled cyberterrorism in the U.S. media, possibly forcing an international diplomatic scandal. Although a spokesperson for the German government defended such actions as a legitimate way to prevent any undermining of the national rule of law by international media, no cases of such state-sponsored "cyberterrorism" from Germany have become known. As the CIA Red Cell special memorandum "What If Foreigners See the United States as an Exporter of Terrorism" emphasizes, any such censorship would probably be seen as a human rights violation, regardless of whether it comes from or is directed against Internet service providers or government agencies. But there is little evidence that terrorists have actually been using computers for imminent cyberspace attacks rather than for recruitment and propaganda. *Cyberterrorism* is a term that was popularized in the press after U.S. legislation in 2001, but it has not been used in the courts since then. As the Congressional Research Service warns, "Some fear that the recent WikiLeaks issue may push the pendulum back toward more restricted access to Internet-based capabilities and less information sharing between organizations"; the same report even notes that the "terrorism" label may be misplaced in cases that produce annoyance, not terror.[20]

It was the spirit of playful exploration of new technologies that led to a majority of computing innovations and business ideas for several decades. Until the late 1980s, a hacker was someone who, by trial and error and without referring to a manual, ended up successfully operating computers. Yet only five years later, experts on computer culture began to warn that hacking posed "a serious and costly problem."[21] For the longest time, commentators on digital culture had focused on access, learning, privacy, and free speech. Yet in a sudden sea change in popular opinion as well as legal and economic policy regarding network technology and education, alarmist commentators began to demonize those who tried to access more than the official, limited interface allowed, at times even suggesting that unruly computer users might end up influencing foreign

policy, diplomacy, and international law. A decade later, even *The Wall Street Journal* had to concede that "the threat of cyber-attacks has been exaggerated by those with a vested interest."[22] The Net had promised to turn a medium of distribution back into a medium of communication, as Brecht had demanded of radio.[23] But shortly after the end of the Cold War released new media technologies of mass distraction into general circulation, the network was reined in by the trifecta of privatizing the backbone of the Net, closing computer operating systems, and censoring cyberspace. The general direction for achieving this closure appears to be security through obscurity and vilification of anyone who doubts the wisdom of blanket secrecy. This tendency only grew once the messianic promise of e-commerce was debunked, the Clipper chip that would have granted federal authorities surreptitious access to all personal computers was fended off, and major corporations co-opted the rhetoric, if not the spirit, of open source software. As the promise of an open digital culture yields to a control society where code is law, hacktivism figures as agency panic, as the ill-conceived actions of the disenfranchised in a world divided between placeless power and powerless places. Computer-mediated communication enables marketers and data-mining companies, the U.S. Department of Homeland Security, and its globe-trotting bigger brother, Echelon, to cross-reference and search every imaginable kind of database, combining video and audio surveillance with intercepted Internet traffic, medical and employment records, school and library files, credit ratings, tax and criminal data, shopping and travel patterns, and more. Our only solace might be, as optimists used to argue, that this personalized inquisition has "the bludgeoning sophistication and accuracy of customer profile questionnaires," but for a growing number of people, anonymity in the techno-crowds is an illusion. Even the hacktivists who rushed to the defense of WikiLeaks at the end of 2010 under the collective name "Anonymous" found that they were anything but anonymous. Their "Operation Payback" against domain name registrars and banks who refused to work with WikiLeaks called for volunteers to participate in a distributed denial of service attack against PayPal, PostFinance, VISA, Mastercard, and Amazon.com. The tool the "Anonymous" group offered is called "low orbit ion cannon," an Internet Relay Chat–accessible application that in fact does not mask the IP address of users who initiate

its attacks. Thus Galloway goes so far as to assert that "the limits of a protocological system and the limits of *possibility* within that system are synonymous. . . . To follow a protocol means that everything possible within that protocol is already at one's fingertips. Not to follow means no possibility."[24] As the citizens of media society grow more transparent, networked power becomes increasingly opaque, giving rise to conspiracy theories. And no doubt much hacktivism is borne of the same mentality, indulging in fantasies of outright manipulation of the little man that serve as justification for all manner of attempts to poke holes in the screens of secrecy and to unmask the powers that be.

CONSPIRACY THEORY is so popular on the Internet that it practically constitutes the native mode or code of thinking online; not only is it one of the more prevalent discourses of the medium, but it also reflects a dominant tendency of discussing the origins of networked computing. Conspiracy theories provide alternative narratives that tend to virtualize history and politics whenever official accounts appear too selective or tendentious. On the other hand, as Jameson shows, conspiracy theory has to be recognized as an insistence, however degraded, on the readability of our world and its ever more complex technologies. There is no vantage point in contemporary media society from which the new media do not seem deeply suspicious. This fosters a culture of paranoia that goes hand in hand with gadgets that simultaneously isolate and connect. Paranoid stories about subversive hackers or omnipotent corporations are the flipside of a neurotic identification with a central power that would explain and manage the decentered society.

The study of conspiracy theory tends to fall into two camps: one pathologizes paranoia; the other celebrates it as populist cultural expression. The problem with such an opposition is that these identifications are usually made by the other side, as a way to commence criticizing the existing literature.[25] "The Net is a medium not for propaganda but for conspiracy," as Dyson puts it; "there is so much stuff out there that no one has the time to contradict all the errors."[26] Circulation of a rumor, even in the form of denial, can be a way of legitimating it. This has led some to scoff that "conspiracy theory is the sophistication of the ignorant."[27] Yet the interesting thing about conspiracy theory is surely not only that

it represents a paranoid expression by normal people but that it is also, in fact, a mode of theorizing.[28]

Then there are those who surmise that "on the Web, we get what we wish for—an inclusive public—and that's precisely the problem."[29] This position either goes hand in hand with a didactic call—"Unfortunately, we as a society have not learned 'Net Literacy' yet"[30]—or it suggests, interestingly enough, that the "Web actually endangers the ideal of the public because it eliminates the possibility of the secret." The irony of this position becomes apparent when the conspiracy logic comes full circle, asserting that "the public sphere has its early roots in secret societies," and Julian Assange famously inverts the opposition of state secrecy, giving rise to conspiracy thinking when he asserts that "plans which assist authoritarian rule, once discovered, induce resistance. Hence these plans are concealed by successful authoritarian powers. This is enough to define their behavior as conspiratorial."[31] WikiLeaks sought to destroy the conspiracy of secret state authority by making it so paranoid of itself that it can no longer conspire. The amorphous network engenders a nagging hope that if and when all data are ordered and comprehended, truth and meaning might emerge. This ancient utopia is of course accompanied by the realization that it is endemically unattainable. Thus conspiracy thinking allows one to take perverse refuge in the comforting thought that something important always will remain hidden. Some of the most striking examples of anti-intellectual tendencies can be seen in the American mainstreaming of conspiracy and government distrust, indulging in *Capricorn One*–style allegations.[32]

Beyond an unproductive opposition of cybernetic control versus a multitude of dispersed subcultures, the urgent questions of security and secrecy, freedom of speech and data control in digital culture create a need for sustained analysis of conspiracy phantasms. As the JFK assassination conspiracies demonstrate, even the most far-fetched theorizing remains remote-controlled by a kind of Frankfurt Preschool. The prevalent modes of such theoretical production combine vulgar Marxism (fingering the Mafia and anti-Castro paramilitary—i.e., capitalism and reactionary forces) with vulgar psychoanalysis (the oedipal jealousy of Lyndon B. Johnson and J. Edgar Hoover combines class envy with sexual resentment).[33] More recently, this plot was repeated as farce when the Taiwanese president

survived an assassination attempt on the eve of his reelection on March 19, 2004. Whereas the Warren Commission set out to refute conspiracy theories about Kennedy's demise, the Taiwanese legislature appears more interested in the symbolic power resulting from encouraging rampant speculation that the event was staged. And a re-creation of the Kennedy assassination as a video game, timed to coincide with its anniversary, was designed to provide perspectives inaccessible to witnesses of the president's murder in Dallas. One commentator even went so far as to claim that "other centuries have only dabbled in conspiracy like amateurs. It is our century which has established conspiracy as a system of thought and a method of action."[34] If JFK conspiracies can be "understood" only from an angle that Zapruder could not see, the symptomatic formations on the grassy knoll remain stuck on amateur video, and conspiracy theories after 9/11 have taken to mapping the covert connections of an invisible world online.

If conspiracy theory allows expressions of a drive to master the "totality" of an inscrutable and traumatically ungraspable world picture, then this need not mean that conspiracy is the only authentic popular reaction to online realities.[35] Conspiracy theories are too readily appropriated as populist counterpropaganda, and the default critiques of conspiracy theory are too easily attacked as condescending to mass culture.[36] Indeed, conspiracy thinking may help organize inchoate fears about new media. But radicalizing the issue, we can point out the specific history of computing and networking that, at the very origin of the Internet, instituted conspiracy as its native code. As Friedrich Kittler and Paul Virilio both argue, conspiracy is part and packet-switch of the prehistory of the information superhighway, since before the Cold War was declared. Truman and Churchill agreed in Potsdam, so the story goes, to keep the critical success of the colossi of Bletchley Park secret from Stalin, feeding him instead the legend of super-spy "General Werther." And Stalin, although addicted to conspiracies, did not catch on to the plot, so the Allies from then on eavesdropped on Moscow and Vladivostok instead of on Berlin and Tokyo.[37] From its origins in linking listening posts to computer decryption, this cover-up of all V-days soon comprised distributed radar positions connected to computers and strategic weapons. However, it is just as plausible, by extension, to see conspiracy thinking in Kittler's

conclusion that since 1941 wars have been victories of machines over other machines. Paranoiacs characteristically try to date the onset of their symptoms to establish a causal narrative. The historicist drive to date the first piece of evidence, to fix the fixating moment, raises the possibility that an obsession with a secret history of technology may itself be a profoundly paranoid gesture. The military history of signal intelligence alone, from radar plotters and cathode tubes to integrated circuits and fiber optics, is an inadequate critique of new media if it does not also shed light on the psychological slips and accidents at their origin. Indicating what is at stake in studying the complexity of our complexes about networks, Paul Baran's diagrams help visualize how quickly and efficiently the complexity of a distributed net escalates. Ordering events and their multiple conditions into a linear, monocausal chain offers a relief that has never been more welcome than under the conditions of the database and the distributed network.

Automation and resource sharing across a network promised relief from repetitive and routine tasks, and interaction with machines was supposed to lead to a human–computer symbiosis. Yet with the invention of the graphical user interface (GUI), the cyborg rhetoric of the 1950s soon gave way to tool metaphors, making the innards of the computer as invisible as possible. Oblivious to software, hardware, and their interaction, users manipulate a surface, constrained by the metaphors granted by the GUI. Yet on the Net, routines and objects have to be enabled at all times, and the interface must not get in the way of that interaction between machines. Consequently, once such tasks are delegated to bots and subroutines, they are no longer evident to the user. Not surprisingly, paranoia and its therapy were early models for how computers interface. Around 1965, scientists at MIT created a natural language program known as Eliza, or the Doctor, that is still extant in most versions of Unix (including Apple's OS X). Its recursive patterns of generative grammar imitate a psychotherapist by using certain staple phrases that invite free association by the person interfacing with it.[38] Around the same time, psychiatrists at Stanford sought to model the paranoid mind with the aid of computers and wrote Parry.[39] In 1973, when the ARPAnet comprised no more than forty computers across the United States, Parry the simulated paranoid was connected across the "packet-switching communications network" from

Boston to Stanford via Los Angeles to Doctor, the simulated shrink.[40] The amusing transcripts of the dialogues between these forebears of today's bots and agents form part of the lore of Internet history. It is therefore no coincidence that the issues of gender, sexuality, and race that dominate the discourse on "Net culture" are directly linked to prominent features of paranoia, such as anxieties about androgyny, gender swapping, and other identity ambiguities. An illicit desire is awakened and by the same token denied and projected, as Freud had it. (Of course, one must not take too literally Freud's emphasis on homophobia: the problem is desire of sameness, of being liked by those one likes and wants to be like, and surely a complex desire and denial of sameness is plausibly heightened under the conditions of digital culture.) On the other hand, paranoia and psychotherapy were successfully modeled by computers because they represent a closed mind-set. Powerful as it is, this kind of closure eventually succumbs to a peculiar circular logic that is its own undoing. The recursive pattern is nowhere more in evidence than when software is presented as relief from the limitations of human brainpower: "The only reason we have not yet succeeded in formalizing every aspect of the real world is that we have been lacking a sufficiently powerful logical calculus," Eliza's inventor Weizenbaum boomed.[41] Yet, as critics had to retort, it is this same ideological tendency that locks people into instrumental patterns of habit, of rules and obedience.[42] Thus Weizenbaum's Doctor was able to simulate the recursive patterns of transference only because it was, like psychotherapy, "clothed in the magic mantle of Science."[43] We may need to believe that once computers start talking to each other they will be more reasonable than we are, but the expectation is itself an unreasonable extrapolation. Once comprehension of our media world seems possible only through media, critical reflection has to go beyond the paranoid "assertitude" that technical media simply *are* power and that their power is no longer localized, addressed, contradicted, or held in check.

The greatest advantage of conspiracy theory is that as one expresses suspicions one avoids being considered naive and perhaps appears smarter than the average consumer. The anonymous, amorphous power behind screen and keyboard, folder and file, client and server, code and compiler, and so on, never shows itself—or it shows itself only as such,

as the apparatus. Suspicion is a favorite mode of media theory because signs or images always both show and cover something.[44] Behind the message are technical devices (paper, film, computer); behind these are production processes, electricity, economy; and behind those we can suspect something else in turn. The letters and pages of a book cover up what makes its distribution possible. The computer screen covers over what is on the chipset. Behind televisual programming is a technical program. Behind all these technical setups lurks a political agenda. And so on. This conundrum of the dark side of the media is the eternal fountain of media theory. The logic of the event, biopower, globalization—theories from Jean Baudrillard's giddy simulation to Michael Hardt and Antonio Negri's militant resignation construct narratives of covert manipulation. Contrary to Popper, common sense alone is not enough to debunk conspiracy theory. Construed as the antidote to theoretical thinking, common sense is most susceptible to carrying unreflected and unsustainable positions precisely because it does not allow for a rigorous self-examination. Theoretical modes, whatever their transgressions against the principle of parsimony, will in the end benefit from the power to harness reflexivity for the kind of insight that may, with time, become common sense—but rarely without clashing with it first.[45] Nevertheless, to graduate from the Frankfurt Preschool, media studies needs to aim beyond modes of theorizing that find culture and industry always already in cahoots with the obscure motives of special interests. "Distraction as provided by art presents a covert control," in Benjamin's formula, "of the extent to which new tasks have become soluble by apperception," and so although it is true that each sign tends to obscure the conditions of its appearing, it does not necessarily follow that as one focuses one's attention on an image or a text, one is deceived about the conditions of its possibility.[46] Illustrating how paranoia is still productive as a symptom, cinema has also long mined the rich ore of superstition and conspiracy theory, and even as digital technology began to transform and undermine the Hollywood business model, the conspiracy flick was granted a new lease on shelf life with the advent of personal computers. In the 1999 film *The Matrix* there is a "glitch in the Matrix," a déjà vu triggered when the machines alter the digital reality that almost all inhabitants believe is real; it is illustrated when the protagonist, Neo, sees a black cat walk by

twice. Exploits such as those of Ronald Austin, who hacked into Penta-
gon computers, or Kevin Mitnick, who hacked into NORAD computers,
provided iterations of a script that perpetuates the same stereotypes of
hacking as teenage flirtation with crime, depicts data space as an arcade
game, and reduces its hormonally adolescent male protagonists to gadget
lovers. It is the ultimate irony that the sequel to the aforementioned sci-fi
conspiracy theory pastiche, *The Matrix Reloaded,* is the one movie in the
entire schlock genre to show a realistic hacking scene.[47] Eschewing for once
the usual antics of visualizing cyberspace as a vertiginous flight through
the dim canyons of a Data-Manhattan, the movie shows Trinity, neither
male nor a teen, working at a keyboard instead of some futuristic interface
contraption, using an actual piece of software ("nmap," a routine port
scanner on the command line, known to system administrators around
the world) to scan a computer grid for weaknesses.

ON INTRAPERSONAL and interpersonal levels, the secret assumes a pivotal
function: to regulate access is to balance sharing and keeping. Although
the omnipresent sensurround of technical media seems to promise instant
disclosure, their structure also harbors at its core the asymmetries of pri-
vacy and its monitoring, of surveillance and its screening over, of archives
and their preservation.[48] The dynamic of secrecy has to be decoded differ-
ently from the way it is encrypted. The excluded must be represented in
the interior, namely as the mark of exclusion. Although often articulated
as a lesson of computing in wartime, this insight is not new: the social
power of secrecy, of preserving and sharing insights into the structure
of our media world, also marks a continuity of all so-called new media
with the oldest stories known to humanity. The cryptographic imaginary
is a pivotal force in the history of computing. Shannon announced that a
system is unconditionally secure if its a priori and a posteriori distributions
are identical.[49] But this would mean the only safe way to encode would
be to use a key the approximate length of the message. Shannon lacked a
concept that would allow him to distinguish between the absolutely secure
and that which is practically secure—a necessary consideration in modern
cryptography. And despite some persistent rumors about the origins of
the Internet in postnuclear scenarios, oral history projects have amply
demonstrated that the Net is not exclusively one of military technology,

nor is its history reducible to something that can be understood outside the context of secrecy systems throughout the ages.[50] The forgetting of origins is a staple in fabricating myths—indeed, it is the opening move of fabulating about any origin. Arguably, this secret now resides in the terminal hookup to screens as our main knowledge interface.

The initial designs for secure distributed networks offer a sharp critique of "the problem of the Secrecy about Secrecy," as Baran put it in detailing his Distributed Adaptive Message Block Network. "Present security concepts appear to be based upon an implied assumption that any 'cleared' person must be trusted, and that any 'uncleared' person is a potential spy," Baran pointed out; "further, information is either classified or it is not. From time to time a disquieting occurrence causes us to wonder if these 'binary' attitudes are really valid." Consequently, he strongly and publicly insisted he did not want a cryptographic security clearance because it would prevent him from discussing the matter: "Avoiding a touchy subject by falling back on edicts rather than rationality may automatically insure the continued existence of the touchy subject." His memo was expressly written as an unclassified discussion of secrecy, for "unless we can freely describe the detailed workings of a proposed military communications system in the open literature, the system hasn't successfully come to grips with the security problem." Instead of blindly pretending that anyone outside the apparatus of secrecy is a spy and foolishly assuming that anyone inside is trustworthy, Baran suggests raising the price of espionage to an excessive level by combining end-to-end and link-by-link encryption within networks to combat unavoidable leaks. Thus, even if the network operates in a hostile environment, it should remain unreasonably difficult for anyone to interfere with the operation of the network. Baran's RAND memorandum expressly solicited hacking:

> We are concerned lest a clever and determined enemy find an Achilles heel. As an acid test, we elicit and encourage a response from the reader who will "don the hat of an enemy agent" and try to discover weak spots in the proposed implementation. Such an enemy is assumed to have a limited number of highly competent cohorts plus all the equipment he can transport. Further, it is assumed that the fundamental human inadequacies of our, or any

security clearance system will permit infiltration by some at least minimal number of enemy agents who will gain a complete and detailed understanding of the workings of the system. Inasmuch as few people have ready access to the crypto keys and since the keys are changed on a short-time basis, it can be assumed that the subversive agent will generally not have access to more than a portion of the key—unless he resorts to force in obtaining the key, thereby tipping his hat.[51]

This is not to say that one may easily reappropriate hacking as security testing, as rather loosely managed research and development, or as a kind of nontraditional educational practice. Hacking and its heavy-handed suppression equally relate to a culture of secrecy, positioning the law as preventing "unauthorized" access—prompting the question, "Whose interests are being served by such powerful myths of closure?" Hacktivism interrogated the assumptions behind a politics of conceal-ment that would withdraw knowledge and shore up access in a last-ditch effort to maintain centralized powers of command and control over an increasingly decentralized situation. As a collective computer-mediated resistance, hacktivism is not only a predictable response to technocracy but also a logical extension of the same structure.

Thus studies of Internet communities in general, and of hacktivism in particular, cast the concealed definition of that collectivity around the double logic of the secret.[52] If technology is the genesis of secrecy, then access to concealed knowledge is possible only in breaking the illusion that positions this object outside discourse.[53] This veiling mode of controlling access is sheer power; its necessary side effect is the desire to preserve the identity of the secret and yet know about it at the same time. The pivotal moment must be at the same time withdrawn and displayed, concealed and known. This, in a nutshell, is the dynamic of groups organized around a techno-fetish. What is really at stake in sifting through informa-tion, screening, scanning the reserves of storage, and packet-switching behind multiple screens is the articulation of a certain deferred revela-tion.[54] The group psychological meaning of secrecy is a relation between knowledge and ignorance: as the group configures its group dynamics around a secret, its cohesion depends on the maintenance of an illusion.

Behind the newest, coolest gadgets one can recognize the ancient logic of the fetish. "The euphoria of secrecy goes to the head very much like the euphoria of gadgets," as C. P. Snow warned.[55] It is a truism that old means of production initially dominate any new form of production, and collective wishes arise in which the new and the old intermingle. A dialectical fetish effect produces consciousness, and this production answers to unconscious fears and wishes. Critiques of fetishism usually proceed from the assumption that it must be unmasked as a necessary illusion that covers the truth like a screen memory. However, this is itself a fetishistic gesture in that it makes the critical gaze a substitute for the absence, or insufficient presence, of the object. Even the more perceptive theories of fetishism tend to install themselves as a last fetishism of the fetish, unveiling while preserving the veil. Computational systems present the apotheosis of automation whose systemic opacity borders on self-concealment, shutting out the user of any interface from the inner workings of the machine.

Lamentably, computer hackers have entered the popular imagination as nerds working out teenage issues online.[56] The reasons for equating the probing of technological strictures with oedipal structures lie in the lure of a myth that promises an easy analytic diagnosis of hackers' oblique desires. The oedipal reading suggests that the primal connection the Internet taps into is a potent reversal of the destiny of automation and that it "contains and transmits relations of long distance, relations with the long distant."[57] Therefore, if psychoanalysis as a mythological mode were to serve as a user's manual to our ongoing technologization, this concealment and preservation withdraws only partly from the scene of signification, of circulation and substitution. The myth of Oedipus triangulates concealment in human relations. The father here figures as the first object of mourning but also as the first intruder, the "first third" disrupting an immediate dual connection. Of course, beyond this plot of burial and signification, oedipal myth also opens up a bundle of concurrent readings and interpretation, not just along the lines of riddles and their symptomatic solution but in terms of the readability of media as symptomatic. At the interface of cultural theory, pop culture, and group psychology that the Internet has become, the nerd is the gadget lover whose privileged relationship to technological innovation comes into

focus. In current vocabulary, a nerd is no longer the odd creature first mentioned in the children's book *If I Ran the Zoo* by Dr. Seuss (1950) but a socially inept male adolescent addicted to technology. Consumed by access to and through gadgets, the nerd desires others who are like him, but he cannot interiorize them or assume their likeness or be assimilated by them as a like-minded group. When nerds go online, they try to connect, with the help of prostheses (aliases, pseudonyms, handles, avatars), to like-minded people, their connections crackling with the static of inhibition. The nerd is transformed by the group into a mascot whose totemic asexuality allows it to fit back into the group. As the excluded inclusion of group formation, consigned to the sterility of inner exile, playing *Dungeons and Dragons* when not coding Java or Unix, the nerd is the group's interface with technological replication and facilitates their connection to the transferential other side.[58] This resistance against familial authority allows for the leverage the hacker craves: the future always had all the time to change. In fast-forward mode through the history of secrecy, the vilification of every new technology as a "beast without hands" becomes recognizable on the screen of today's interfaces as an ancient monster: the secretive Sphinx demands answers to hard questions. As long as science commands the awe of the ignorant and the respect of the masses, the Sphinx's reign of terror is founded on impenetrability: her face denotes beauty; her wings, reach; her claws, the fearful grasp on the secret of knowledge. But lame-footed Oedipus solved the riddle by subtracting and adding limbs. The animal that has first four feet, then two, then three, and finally four again is man. Different ages in the history of writing are also figured by adding or subtracting a limb: from handwriting to ten fingers on a keyboard to dictation software and writing without hands. Once the riddle is solved, the monster is slain and carted off by a donkey—because once something is understood, any ass can handle it.

There are three stereotypical representations of oedipal desire in computer-mediated communication: phone phreaks seek to establish a free connection to the long distant, warez crackers revert intellectual property in software to a ruinous culture of the gift, and network hackers rescue the mother lode of information from the vaults of secrecy to which a centralized information society would consign it. In all three modes, the thrust of the fantasy seems to be going back in time to before one's birth

to preempt the law of the father and get closer to the (m)other. Hacking, this popular reading then suggests, is to reprogram one's psyche in order to make it compatible with a melancholic, future-driven mind-set. Nerds make machines work in a time frame that takes them toward the symptom. If one had one's posterity in the past, the inversion must take one toward the moment of encryption, the enshrining of the secret, or the incident that gives rise to repression. As the new media play back and to an extent reverse the history of mechanical development as McLuhan's "extensions of man," they seem to invert the development of literacy and social organization in the cool metamedium of the connected computer. McLuhan hoped this would engender just that shock of unfamiliarity in the familiar that is necessary for the understanding of media culture. But this is once again investing media technology with an agency that disenfranchises and manipulates people. "Far from enslaving us to these fantasies, and thus turning us into de-subjectivized blind puppets," as Žižek corrects this mythological reading, cyberspace "enables us to treat them in a playful way, and thus to adopt to them a minimum of distance."[59] Thus to criticize the fantasy of an oedipal construction of cyberspace, in all its psychotic immersion or neurotic mediation, is not to dismiss the interpretive power of a myth going out on a limb—yet we must not forget it remains myth. The dispersed, decentralized nature of the Net need not signify the dissolution of patriarchal order. The mythological reading in fact merely installs the group mascot of techno-culture as the neurotic upholder of cyberprotocol.

IN HIS STRUCTURAL STUDY OF MYTHS, Lévi-Strauss suggests the use of playing cards in order to systematically lay out the constituent elements of a myth. An observer of a card game, he argues, or of a fortune-teller using a tarot deck, should be able to reconstruct a system from the practice observed, for each card shows a link, a relation. In isolating and identifying such links, Lévi-Strauss emphasizes that his anthropological software design aims for an economy of explanation achieved only with the aid of greater processing capacity, teamwork, and technical help, from mounting boards to "perforated cards, which in turn require IBM equipment, etc."[60] Analyzing individual myths requires one to break them down into the shortest possible statements, writing each on a card. "The true constituent

units of a myth," Lévi-Strauss writes, "are not the isolated relations but bundles of such relations," and observing synchronic, structural bundles and their diachronic, narrative links, he studies blood relations and incest taboo, for instance, in the myth of Oedipus. However, once the anthropologist wants to inscribe variants and version control in his system of cards, it requires three-dimensional representation in a database. "A logical treatment of the whole will allow simplifications, the final outcome being the structural law of the myth." What this endeavor aimed to produce is a sense "that the same logical processes operate in myth as in science, and that man has always been thinking equally well; the improvement lies, not in an alleged progress of man's mind, but in the discovery of new areas to which it may apply it unchanged and unchanging powers." This conclusion is surprising, since it could be precisely the invention of data automation that produces such anachronisms. Lévi-Strauss seems to suggest that innovative data processing systems are needed while arguing that such innovation is already found in myth. But it is indeed an ancient insight that the structural complacency of any system, the more binary or digital it writes its own principles, is vulnerable to a rupture, where the necessary construct is its own undoing.

Thus the hacker as engineer of innovation is a myth, told by those who maintain, with Lévi-Strauss, that it is not a matter of progress but of applying variants of ancient logic, found already in myth. There is no key myth that would decode mythology, and there are no sources of myths that the processing of data bundles might disclose. Furthermore, where Lévi-Strauss deduces from his structural analysis of the Oedipus myth that the incest taboo is universal, he describes it as natural, yet as prohibition it is also cultural, therefore undermining the distinction structural anthropology tries to base on it. Thus metaphysical reduction is based on the very binary opposition it reduces, so that digital short shrift is systemic and irreducible. The inevitable tension between play and mortification means that a secured center is impossible. The exact same system promises and undoes any and all totalization—think of draft cards, business cards, or identity cards, singularly clumsy as media, until their functionality appears and simultaneously disappears once they are integrated in automation systems of information processing.[61] As Vannevar Bush formulated his regret over the complexity of data

processing," all this complication is needed because of the clumsy way in which we have learned to write figures. If we recorded them positionally, simply by the configuration of a set of dots on a card, the automatic reading mechanism would become comparatively simple."[62] And yet from Vannevar Bush's memex to Apple's HyperCard, from the earliest systematic library catalogs to the computer database, and from HTML to XML, the symbolic invention at the core of data systems is withdrawn, and the periphery is sanitized for your convenience.

Nevertheless, and to that extent Lévi-Strauss is proven correct, the use of playing cards to observe, understand, and enter a complex data structure is indeed an open secret in history (see chapter 1). In 1775, Abbé Rozier laid the grounds for modern libraries when he devised a filing system based on playing cards in order to classify all publications of the Royal Academy of Sciences in Paris between 1666 and 1770. American library reformer and catalog pioneer Melvil Dewey not only met his wife on board a boat to the United Kingdom in 1877 but also learned to play cards on this trip, which led to the information systems developed by the American Library Association.[63] If the invention of the Internet is not directly owed to the limitations of the paper-based card index, it is nonetheless relevant that networked computing is widely used to that end. The database is at the concealed core of the distributed server structure of the Net, as well as at the core of each end user's black box. But the problem that arises when a computer is just represented as an opaque box is illustrated perfectly by the arrest for fraud of a New Jersey couple a few years ago. The purported antiterrorism device (called the C-BAND, for Chemical & Biological Alarm and Neutralization Defense System) they had offered to airports and shopping malls was actually nothing more than an empty filing cabinet with flashing lights and a siren on top. A C-BAND news release had touted the device as a self-contained unit that could be installed in airports, malls, and sports arenas to alert people when it detects a "harmful bio or chem-agent." It would also "isolate and neutralize the harmful agents" by "using a series of high electromagnetic frequency signals."[64] If the mere visual display is capable of taking the place of access, it is more than ever crucial that we be allowed to look into the cards, even if it turns out that the structural laws of our newest myths send us back to the most ancient ones. The

pivotal feature of myth is that it allows one to switch from fear to stories about fear, from play to observations of play.

As hacktivism ties into the cryptographic imaginary, its public image oscillates between terror and play. In this antinomy we may recognize a mythological formation. We can thus appreciate about hacktivism exactly what the mainstream found suspicious and threatening: the relaxed, loose, playful approach to "control and communication," that is, to cybernetics as social power. The tyranny of closed systems is most unsettled by those who seek root or radical access to its structure. Wherever hacktivism is being discussed, the antinomy of myth is invoked as a pivot for defining an otherwise completely dispersed phenomenon: it is terror or creative expression, in the interest of fear or freedom, expressing a need for greater homeland security or for enlightenment. Frightening and fantastic, the myth tends to serve those who call hackers "terrorists" and ignore all evidence by computer users defending the free play of ideas and information.

This story is as old as the hills, which is how myths communicate their appeal. Regardless of whether hacktivism is figured as cultural escapism or as a self-helping of common sense, and regardless of whether fear of hacktivism is seen as an old wives' tale or as national security dogma, recognizing the myth allows one to articulate something beyond fear-mongering. Depending on how the myth joins the polar tensions of terror and play, its reception can be a passive or active engagement. One may avert one's eyes when faced with mass media hysteria about hackers in pursuit of untold secrets, or one may seek to comprehend (and to make comprehensible) how such group psychological effects are structured—as secondary orality. Myths proliferate in oral cultures. Literacy complicates the transmission of sensitive information because writing could betray the message to anyone. When Goody and Watt address the qualitative difference between orality and literacy, they bring the survival of oral societies into the twentieth century into focus.[65] For Havelock, literacy became not only the way in which orality is reconstructed—out of old texts—but also how it is formed and interpreted.[66] As a consequence, the distinction between a primary and a secondary orality made by Ong may be extended to an analysis of the gossipy character of life online.[67] The global village is nothing but a big forget-together of those who tell the

story of the global village to each other. Version control, authentication, and data integrity are not among the core features of this structure; it is marked by hearsay, rumor, storytelling, which goes against the command-and-control efficiencies of the administration of power.

Critics of hacktivism admonished that the lack of a clear agenda made it a politically immature gesture, whereas conspiracy theorists hoped to see an attempt to precipitate a crisis online. On both sides of that debate, public opinion was formed by characterizing any disruptive event on the Internet as "terrorism." One of the earliest documented hacktivist events was the Strano Network strike directed against French government computers in 1995, but that was a virtual sit-in, not terrorism. One of the more notorious examples of hacktivism was the modification of Indonesian Web sites with appeals to "Free East Timor" in 1998 by Portuguese hackers, but that was defacement of media space, not terrorism.[68] These kinds of events make headlines not for their political motivation but merely for the spectacle of vigilante computing. In stories such as those, it becomes evident that the media are also misusing the word *journalist*. For among definitions of *terrorist* in the *Oxford English Dictionary*, one finds the following: "1b. Any one who attempts to further his views by a system of coercive intimidation. 2. One who entertains, professes, or tries to awaken or spread a feeling of terror or alarm; an alarmist, a scaremonger." The front lines of journalism have been manned by scaremongers since the end of World War II. Alarmist attitudes won the Cold War, and we currently experience an assault on the freedom of citizens to process information without the use of trademarked software programs that proffer only homeopathic doses of access and comprehension while effectively closing all systems. In keeping with economies of surplus and scale, the greater the reach of a network, the lower its saturation with information; conversely, the more differentiated the information, the smaller its area of distribution. Although military, academic, and business communications achieve integrated networks of high information density, the general public is often shut out. The more a medium correlates noise with profit and profit with noise (even and especially at the highest levels of production value), the more vacuous it tends to become.

To take the real threats of cyberterrorism seriously is certainly not alarmist, but it is irresponsible not to distinguish between a Net sit-in and

the failure of an ATM network, between conceptual Net art and attacks on a hospital generator, between a cable TV outage and the potential damage by electromagnetic bombs, or between dragging down Domain Name System servers and hijacking airliners. To call the computers supporting the Domain Name System "critical nodes" of the Internet is to fool people into thinking "malicious code" could actually damage the entire Net, despite the well-established fact that distributed networks are designed to withstand just that. To equate the security of airline Web sites with the vulnerability of air traffic control or to lump the real importance and value of medical or credit information together with the mere loss of marketing opportunities is indeed to engage in coercive intimidation.[69] This is not to deny the importance, to the military, of information operations conducted during times of crisis or conflict to achieve or promote specific objectives; they may indeed include strikes against nodes and links of computer networks; the design, denial, and protection of intelligence; perception management and psychological warfare; or the exploitation of software-based attacks on information systems.[70] Yet hacktivism, in reaction to conflicts and interventions from Chechnya to Chiapas and from Hong Kong to Hamburg, never set off an electromagnetic bomb. Hacktivists are neither secret agents nor soldiers, neither terrorists nor netwarriors. Hacktivism aims to capture attention; it is calculated for maximum media effect, trying to raise the awareness of citizens regarding certain rights and liberties, including free speech, privacy, and access. An act of hacktivism can involve many people or only one; it can forge links and coalitions between people whose politics run the gamut. Essentially, hacktivism translates into the digital realm what disruptive or expressive politics have been using for centuries: demonstrations, sit-ins, labor strikes, and pamphlets. Denial-of-service attacks exploiting the processing rhythms of certain system resources are nothing more or less than digital demonstrations. If one can tie up one server process for 300 seconds, or five minutes, by starting (but not completing) a three-way TCP handshake, that is technically speaking not an attack but a very slow way to interact with the other computer. Hacktivists have generally taken care not to affect the Net at large. The point is that in singling out one server, it becomes apparent to the untrained eye, to the public who are not computer experts. Such manipulations by end users insist,

in the final analysis, on access to knowledge about codes, procedures, and routines that are hiding behind trade secrets, copyrights, and other protection mechanisms. This analysis of communication technology opposes the analytic mind-set of computer literacy with the formulaic state of mind of oral culture, just as Havelock and Ong did: "In nonliterate cultures the task of education could be described as putting the whole community into a formulaic state of mind."[71] And thus "lengthy verbal performances in oral cultures are never analytic but formulaic."[72] Their thesis of historical progress from the chirographic handling of text via the formalizing typing of text to the polymorphous implications of word processing gave rise to the assumption, popularized in media theory after McLuhan, that a recurrence of orality can be recognized in the third phase, returning, in some ways, to the oldest techniques of storytelling and mythmaking. It will have been the task of media studies to interpret how much programming routines rely on an analytic frame of mind yet so often seem to insist on putting everyone else into a formulaic state of mind. No doubt the insistent techniques of concealment on the level of code will push users, as consumers or addressees of code, forever into trying to interrupt, disrupt, or disperse the apotheosis of automation.

3

NOISE FLOOR: BETWEEN TINNITUS AND RAW DATA

> The claim is that one is opening music
> to all events, all irruptions, but one
> ends up reproducing a scrambling that
> prevents any event from happening.
>
> —Gilles Deleuze and Félix Guattari,
> *A Thousand Plateaus*

> Random corruption should not be
> confused with random generation.
>
> —Laurie Spiegel, "An Information
> Theory Based Compositional Model"

WHAT HAPPENS to music making under the conditions of networked computing? Just what is it that makes the bleeps and clicks of laptop music so different, so appealing? Our digital media culture is predicated on communication efficiencies to an extent that can obscure or veil the sources of noise, as faults, glitches, and bugs are too often relegated to the realm of the accidental. Yet glitch electronica puts precisely this raw material to creative use. Reduction of complexity is a highly successful strategy in the experimental laboratory, in system theory, and thus in many academic disciplines, but it points to a pivotal problem in digital transcoding of audiovisual "raw data," regardless of whether the reduction at issue is an aesthetic strategy or a technical constraint. How much image can be omitted before an image is no longer an image? How much music can be compressed in lossy sampling before it ceases to be music? And conversely, how much information can be stored, processed, and

transmitted without changing the frame of reference for visual arts, for music? Information theory is one approach to answering these questions; the ultimate data compression is the entropy, H, and the ultimate transmission rate of communication is the channel capacity, C. However, this does not account at all for the success of glitch electronica in particular, nor indeed for the success of music in general. Tuning in to what is ordinarily filtered out, this chapter will investigate ways in which our signal-processing age has come to cope with raw data. In contemplating digital culture between a hermetically rule-bound realm of programmed necessity and efficient management of the totality of the possible, one can situate a realm of contingency: distortions in the strictest signal-to-noise ratio, glitches and accidents, or moments where what does not compute is condescendingly ascribed to error.

> It is from the "failure" of digital technology that this new work has emerged: glitches, bugs, application errors, system crashes, clipping, aliasing, distortion, quantization noise, and even the noise floor of computer sound cards are the raw materials composers seek to incorporate in their music.[1]

As our digital culture oscillates between the sovereign omnipotence of computing systems and the despairing agency panic of the user, digital tropes of perfect sound copies are abandoned in favor of errors, glitches become aestheticized, mistakes and accidents are recuperated for art under the conditions of signal processing. It is interesting to take a closer look at how this takes hold in music and sound art in an age of networked computing.

Beyond the realm of traditional instruments, music has advanced rapidly by way of exploring the potential of storage, processing, and transmission of acoustic material. This soon led not only to the emulation of known sounds and patterns but to experiments with sonic expressions that had been either impossible or suppressed as noise and error. But this still begs the question how we distinguish between signal and noise in a musically meaningful way. "Noise does not have to be loud, but it has to be exclusive: excluding other sounds, creating in sound a bubble against

sounds."[2] Though arguably musical, an orchestra tuning up is generally considered to be noise, but the clapping of an audience, a form of white noise, is taken to be meaningful and, hence, signal:

> There is no absolute structural difference between noise and signal. They are of the same nature. The only difference we can logically establish between them hinges on the concept of intent on the part of the transmitter. A noise is a signal that the sender does not want to transmit.[3]

Of course, such a distinction would still privilege message over channel, intention over chance, and one may well object that musical practice has undermined such easy distinctions for centuries.[4] However, the specific step that motivates the present argument is to see how the generative potential of computers is harnessed for electronic music, radically expanding the timbres and structures of creative sonic expression. Alva Noto's work, for instance, is organized around the tension between polyrhythmic glitch textures and a singular focus on the timbre of noise. Alva Noto is an alias of German visual artist Carsten Nicolai.[5] In his music, he relies on mathematical processes to govern rhythm, and he uses modems, telephones, and fax tones to compose atonal, syncopated soundscapes; he "recognizes and embraces the fact that it is impossible to maintain perfect integrity in the communication of any information and instead focuses attention, not on the information transmitted, but on the enigmatic character of the system of transmission itself. The predominant sound materials in his music are the noises of imperfect systems: clicks of electromagnetic interference, ground loops, dither noise, aliasing and vinyl noise and so on."[6] And Stefan Betke, recording under the name Pole, made a name for himself in electronic music when he began using the crackles issuing from a broken analog filter, captured and looped on DAT into minimal click dub.[7] Making music with the byproducts of new technologies is a way of maintaining a space of playful exploration.

The history of recording and reproduction offers ample illustration of how the introduction of digital technology has shifted but not overcome certain endemic resistances of our media culture.

Added to the story of sound production we always find the traces of sound recording as well, including information on the location, type, orientation, and movement of the sound collection devices, not to mention the many variables intervening between collection and recording of sound (amplification, filtering, equalization, noise reduction, and so forth).[8]

Focusing media history on materiality as a condition of possibility for programs as executable content, Poster humorously dissects the private utopia of the audiophile listener:

The obsession to recapture the musical language of the past slides into the production of a new manifold of information. . . . More and more time, care and money is invested in the medium of sound reproduction; more and more effort is expended to control the listening environment. Even the electricity coming into the house is suspect as a possible source of distortion.[9]

The very condition of possibility of sound reproduction and amplification is also a constant source of contamination, and the history of audio recording and reproduction technology can seem to align along a progressive pursuit of transparency into the inaudible.

The history of the development of different audio formats from wax to vinyl to tape to CD, indeed, seems itself to be driven by a single-minded, stubborn desire to render the communications system or medium entirely transparent (or inaudible, rather) and to eradicate entirely any interference coming from the system or the medium itself so that we can instead focus solely on the pure audio content of our choice.[10]

Yet, long after the advent of the compact disc promised "perfect sound forever," the audio formats kept coming, and the current audio world is replete with Super Audio CD, Audio DVD, Blu-Ray discs, dueling compression algorithms, and ever more sophisticated digital–analog converters that seek to repress or eliminate jitter, latency, and other

artifacts of the digital as well as the analog realm. Of course, loudspeak-ers and amplifiers, recordings and their manipulation have also become music-making tools in their own right. By the very same token, then, it cannot come as a surprise that musicians in the course of a long century of mechanical reproducibility have made wide and varied use of techni-cal failures and even elevated scratches, clicks, and glitches to the status of sonic raw data.[11]

To be sure, this is not simply a linear media–historical index; indeed, assumptions about progress are complicated in an aesthetic fold. On one hand, a notion of the "rawness" of data corresponds to ever-increasing expectations from audiovisual resolution; on the other hand, this selection can recuperate elements that conventions exclude. What is perceived as a lapse in frame rates on screen might earlier have been considered part and packet-switch of earlier interactions on networked screens; what is heard as noisy clicking on a sound file might have gone unnoticed in the scratchy days before standardization of vinyl production quality and cartridge sensitivity. But what Lev Manovich describes as an accelerating aestheticization of information tools covers up the very material fact that aesthetic choices in audiovisual arts encompass the computing equivalent of the roughness of a brushstroke or the hairy attack of bow on string: constraints are effects at one's disposal, not simply noise to be canceled. Yet arguably, the era of noise canceling really takes off with the advent of digital technologies.

The extension of allowable sounds allows one to avoid simplifications in distinguishing between music and noise. "In the twentieth century, noise has become a resource, was incorporated into musicality and re-jected musicality, while all the while occurring in the place of music."[12] However, the development of new technologies for sound generation, manipulation, and recording is only one axis to consider here; another is the conceptual framing of what distinguishes one sound from another. "The division between sound and musical sound is negotiated and po-liced in terms of a traditionally established axis irrelevant to most music," although that dividing line is as crucial as it is unacknowledged.[13] Among the art forms that may be said to suffer from the hegemony of a narrow operating definition of *music* is sound art, and it should be noted that sound art now relies extensively on computing hardware and software.[14]

Yet as Kahn notes, "only recently have individuals begun to describe themselves as sound and installation artists, audio and radio artists."[15] In conversation with John Cage, Marina Rosenfeld raises an important objection to such a division:

> The visual—when you are interested in it and you make music, you're now supposed to be a sound artist. The sounds you make are suddenly categorically metaphorical. OK, I hereby reject the entire category (I've already done this for a couple of years, actually) and embrace music.[16]

Rosenfeld is perhaps best known for developing a distinctive sound using "dub plates," custom-made one-off acetate records of fragmentary sounds she mixes and manipulates in performance. Similarly, Christian Marclay erases the boundaries between sound artist and DJ with collages and performances that exploit the materiality of vinyl records, foregrounding skips, pops, hiss, and other surface noise.[17] More recently, Ralf Nuhn's *Glitchy & Scratchy* took this concept up in an installation that allows users to spin two records via a touchscreen. The turntables (with vinyl record) on either side of the screen follow the spin direction and (variable) speed of the respective virtual record. Pressing the left or right button at the front of the screen repeats the most recent scratching pattern of the respective record.[18] These practices of artists and turntablists illustrate how faults and errors in technologies of sound reproduction indeed bring forth innovative artistic practices, as did John Cage with his tape piece *Williams Mix* (1952) and Fluxus artist Milan Knizak with reassembled vinyl in *Destroyed Music* (1963).[19] This is evident in a number of parallel traces: in music theory and compositional practice, in advancing recording technologies and means of reproduction and distribution, and in aesthetic and critical thought about the potential for creative expression under the highly technologized conditions of contemporary life after two world wars. As with the paradox of characterizing hypertext as a radical break while claiming canonical ancestors, a similar move is found in accounts of noise, laying claim to radical innovation while also name-dropping influences from both Western art music and from the annals of punk and industrial music. Short of pointing to the Italian futurists,

one invokes Walter Ruttmann's 1930 "film for the ears," *Wochenende.*[20] Coining the notion of musique concrète in 1948, Schaeffer made looped samples that embraced the sonic givens of the modern lifeworld, rejecting the abstractions of musical composition without abandoning musicality.[21] Stockhausen asserted that "instrumental and auditive associations divert the listener's comprehension from the self-evidence of the sound world" and sought to valorize electronic sounds.[22] Punk, plunderphonics, and industrial music rely on noise samples spliced into performances; groups such as Einstürzende Neubauten and Throbbing Gristle inspired scores of noise records, as did Merzbow and SPK.[23] Many consider the screeching, squawking feedback of Lou Reed's 1975 double album *Metal Machine Music* a seminal event, rescued from obscurity by critics such as Lester Bangs.[24] Reed's two guitars, droning through five Marshall tube amps in series, were recorded at different speeds with Sony, Uher, and Pioneer reel-to-reel tape recorders.[25] *Rolling Stone* magazine infamously called the result "the tubular groaning of a galactic refrigerator," comparing it to "a night in a bus terminal." In his liner notes, Reed referred to minimalist composer LaMonte Young and laid claim to "symmetry, mathematical precision, obsessive and detailed accuracy and the vast advantage one has over 'modern electronic composers.'" Today, its endless groove takes pride of place in record collections, and indeed *Metal Machine Music* was just reissued on 180-gram vinyl, Blu-Ray, and audio DVD, remastered for quadraphonic high fidelity.[26] It is worth noting that *Metal Machine Music* was originally released in the same week as Brian Eno's *Discreet Music.* The two albums bookend the extremes of the ambient genre:

> on one side, beatless, wordless, unashamedly spaced-out beauty, stripped of incidental interest and climax, eventually evolving into trip-hop, electronica and math-rock; on the other, beaten, furious bitterness tearing time apart, eventually evolving into punk, industrial music and techno, with both ambient styles meeting somewhere in the middle of trance, post-rock and glitch.[27]

Both art music composers and postpunk influences continue to fertilize the discourse on laptop noise, one of my favorite recent examples being *COH Plays Cosey,* with Russian sound artist Ivan Pavlov turning a

correspondence with Throbbing Gristle member Cosey Fanni Tutti into a noisy homage in 2008.[28] Yet if experimenting with noise and distortion was an avant-garde notion until the 1960s, that strategy was soon "exhausted at the point when no audible sound existed outside music."[29] It thus comes down, without oversimplifying the point, to a process of selection: filter it out or amplify it.

> While technological failure is often controlled and suppressed—its effects buried beneath the threshold of perception—most audio tools can zoom in on the errors, allowing composers to make them the focus of their own work.[30]

One has to wonder: how does this appropriation of all kinds of "raw" sounds come to pass? Why reissue *Metal Machine Music* now? And what allows musicians and cultural historians to contemplate what might have happened yet did not?

As a functional requirement for a fundamental shift in the availability of audiovisual entertainment and arts, reproducibility implies a process for transforming material traces representing sound into the sound itself. Furthermore, the traces are not merely oscillographic curves or other representations of vibration, frequency, amplitude; they function as conservation of what had been considered ephemeral. More than merely denoting loudness and pitch, attack and decay, rhythm and sonic combinations, or styles of delivery—all of which may be contained in notation—a recorded sound affords very specific aspects of interaction and manipulation.[31] For instance, whereas a musical signal is conceived as having to do with a temporal flow, a recording is reversible; its indivisible continuity becomes divisible, so that it can be arbitrarily cut and recombined.[32] And in theory, materializing the sonic object so it can be repeated at will appropriates any and all sounds that are reproducible; if you can capture it, why not use it? The notion of a systematic notation of glitches is of course a paradox. Yet once both visual and aural information are turned into computer data, they become fungible in ways that open up new possibilities. For instance, in mastering *Cyclo,* an album by Ryoji Ikeda and Carsten Nikolai, a phase meter device (routinely used to test the accuracy of a recording's proper encoding) was thrown for a loop,

literally, when the pair's microscopic sounds showed up as triangles, squares, and rotating three-dimensional shapes on the test screen, instead of the normal oblique lines bisected in the middle to demonstrate correct input.[33] This accidental discovery pointed Ikeda and Nicolai to the concurrent practice of visualizing computer glitches and to transcoding practices that sonify images and depict the proportions of sound files.[34] In *Dataphonics,* another project by Ikeda (commissioned by Radio France Culture in 2006–2007), various nonaudio data became the material for an hour-long composition.[35] Emphasizing the spatial nature of music for a Whitney Biennial performance in 2010, sculptor and sound artist David Schafer transcoded floor plans and elevation drawings for the museum by architect Marcel Breuer into sounds via Metasynth, mixing them with a voice actor's recording of a Marcel Breuer text describing the architect's vision for the Whitney Museum of American Art and playing them through a speaker cabinet modeled in the form of the building. The cultural history of sonification is marked by two aspects: on one hand, it makes audible something one would not get to hear without its data being transcoded, that is, without the use of media technology that can store, reproduce, and transmit data in a number of ways. On the other hand, this variable access to data can lead to insights that otherwise are hard to come by: examining light or color or humidity or temperature as sound waves, as practiced both in sound art and in experimental contemporary music.[36] Thus Andrea Polli renders climate data as sound installations, and Alva Noto's album *Unitxt,* for instance, sonifies software code from common PC programs such as Entourage, Excel, PowerPoint, and Word.[37] In short, transcoding is testament to our data age, but it simultaneously gives rise to interesting aspects of a kind of raw material resistance of the digital.

DEVELOPMENTS in atmospheric and diegetic film sound also relied on the inclusion of noise in an aesthetic vocabulary by historical avant-gardes after World War I (Luigi Russolo's 1913 manifesto on the art of noises was followed by a chapter on the noise of war in an eponymous book on the art of noise).[38] In addition, the dissolution of harmony in dodecaphonic and atonal music coincided with the technological possibilities of experimental music, to the point where "the evolution of music seems to be a methodical violation of previously accepted rules."[39] Beyond a

drive to break rules and innovate, which is the pivotal Modernist affect, what repeated departures from convention demonstrated is that dogmatic foundations of music making were not confirmed by psychological experiment, thus drastically expanding the allowable sonic material. This emergence of new objects and methods, fostered by geometric increases in the number of hours of music that became available in public concerts, radio broadcasts, and mass-produced records, soon allowed no qualitative distinction between sounds. Composers and performers started to separate the necessary ingredients, such as some measure of pitch or periodicity, from the contingent, such as structures and strictures of Western musical form that had been merely statistically imposed. By the end of the twentieth century, it had become obvious that "the sound is just the data, the raw material in a process that Hip Hop scratch mixers have made cliché: the cut-up or repeat sample."[40] Thus a scratchy noise becomes part of an aesthetic vocabulary, then turns into an overused and predictable effect, briefly falling out of favor before achieving some retro charm and reasserting itself. Perhaps our historical loops processing sounds as innovative–predictable–out–retro are growing shorter; certainly some observers of the music scene seem to feel a digital noose tightening around the creative mind, cutting off the influx of new ideas.

Nonetheless, or all the more so, the focus here is on tracing the generative rather than the reproductive. Despite Adorno's declaration that "there has never been any gramophone-specific music," both Stravinsky and Moholy-Nagy suggested great generative possibilities for the phonograph; technologies of recording and reproduction from records and radio to tape reels and digital editing went on to have a significant influence.[41] Extending this line of thought from Stravinsky and Moholy-Nagy to the twenty-first century, it is not so much that "contemporary sound art has come under the influence of digital simulations" but that sound has been explored for decades for its potential, and computer synthesis has led to some surprisingly fast and widespread adoptions of new sound material.[42] Music is not "electronic" if it merely reproduces known sounds and forms; a new sonic world requires new artistic ideas, new concepts and forms of expression, gained directly from an exploration of the raw data. Pivotal is not just the technical layer but what can be done with new technology.[43] Moreover, just because a lot of electronic sounds

are beyond conventional musical notation does not mean that they are disconnected from critical reflection informed by historical consciousness. On the contrary, it is a fascinating aspect of the history of digital technology that despite marketing hype about "perfect sound forever," it also and by the same token sought to repeat and recover the imperfect, glitchy, error-prone predecessors, and even to outdo them in terms of manipulations. Indeed, the "fixity of the digital recording (its 'perfection') is shown to be infinitely malleable."[44] For instance, when Yasunao Tone was asked to record a CD, he considered none of his works suitable for fixed digital reproduction.[45] Instead, he conceived a medium-specific piece by transcoding an ancient Chinese poetic text, first into images based on Chinese characters, then into digital files by scanning the images, so that the histograms could then be processed as sound waves by the computer.[46] In Tone's own description of that process, from an essay he wrote on John Cage and recording, "According to information theory this is none other than noise, and as the French word for information noise, *parasite*, indicates, it is parasitic on a host—that is, message. But in this case there is no host, only parasite on the CD. Therefore this CD is pure noise."[47] Thus, in a curious fold that doubles media history onto itself, various modular and numeric properties of music come to the fore as an ancient yet digitally renewed angle on media culture.[48] The digital age is marked by Cold War obsessions with secrecy and invisible communications, and thus it is hardly coincidental that we should encounter a synthetic music that scrambles the vocabulary of sound, going far beyond the pattern inversions and structural transformations composers had used in past centuries. "Forged in the studios, universities and computer labs of a shattered Europe and a paranoid USA, post-war electronic music is a quest to build new worlds of sound liberated by the white spark of electricity."[49] Indeed, it took a while for electronica to shed the nerdy, academic patina of computer labs and move into dance clubs and transitory headphones.[50]

There is hardly an area of contemporary culture that does not bear witness to the algorithmic revolution, whether one looks at art and architecture, business and transportation, communication and science, or literature and music. As an artificial observer or listener, a computer can explore the statistics of the forms we call aesthetic and thus assist in musical analysis. A statistical theory of aesthetics was proposed as early as

1932 by Birkhoff, suggesting that the aesthetic measure M relates directly to a proportion of complexity and order, as in $M = O/C$, whereby the most beautiful of a class is that which exhibits as much order with as little complexity as possible.[51] After World War II, Bense replaced complexity C with information H of the selected signs, and order O by redundancy R, since "each order of elements is a phenomenon of redundancy, of the return of the same, the predictable, thus not innovative information."[52] In his formulation, order became statistical redundancy, and complexity became statistical complexity of information; the aesthetic score of a work of art, Bense felt, increased if it had no readily recognizable style so as to maximize the improbability of its elements. (Attali still subscribes to this ethos in his book on noise: "With noise is born disorder and its opposite: the world. With music is born power and its opposite: subversion. . . . Music—pleasure in the spectacle of murder, organizer of the simulacrum, masked beneath festival and transgression—creates order."[53]) As Serres puts it, "Noise destroys and horrifies. But order and flat repetition are in the vicinity of death. Noise nourishes a new order."[54] Beyond the capacity to assist with such quotients, computers were also found to be helpful in amplifying the kind of complexity found in works of art, or in developing an aleatory or permutational principle, as computers are able to generate and evaluate calculations and combinations that would strain the patience and capacity of most composers and performers.[55] In harnessing the database and calculations of computing, finite means of expression in play can offer multiple solutions to a musician's goals. Indeed, in 1640 Athanasius Kircher had already recognized that his *Musurgia Universalis* could recombine sequences of notes in a table so as to embody compositional rules, but this rudimentary computational composing device was never realized. Kircher also imagined a pneumatic automaton that would serve as his artificial orchestra for synthetic music. As early as 1906, Thaddeus Cahill's invention of the Telharmonium or Dynamophone used additive synthesis to generate polyphonic tones from simple frequencies. It should be pointed out that synthesis and composition are perhaps the same concept in two languages, Greek and Latin, respectively, although we still tend to view musical composition as artistic and sound synthesis as artificial. The two terms are united when computers are used both for composition and as synthesizers of sound.

As the story goes, Max Mathews and his boss at Bell Labs, John Pierce, on the way back from a piano recital decided to see whether computers could do better.[56] Pierce, who was one of the inventors of the transistor and a pioneer in satellite communications, had sufficient clout at Bell Labs to ensure that Mathews got enough access to computing time, which enabled the development in 1956 of Music Compiler I, a software program devoted to generating structured synthetic sounds. Its descendants are still in use for musical composition. Mathews's algorithm impressed Stanley Kubrick, who made his spaceship computer HAL sing in *2001: A Space Odyssey*. However, in that film it is not a Bell-programmed computer that helps HAL sing but a German ELTRO, an "information rate changer" manipulating tape playback using rotating heads—something that becomes clear when HAL's voice glides lower in pitch as the last astronaut gradually removes the computer's memory chips. The famous scene in turn has spawned a veritable subculture of cover versions of the old Harry Dacre song "Daisy, or A Bicycle for Two." Two of my favorite musical renditions are the ones recorded by the English band Blur and the German electronica outfit Rechenzentrum. That Bell Labs could make a computer sing is all the more remarkable when one reminds oneself that the physical modeling instrument in 1962 ran on an IBM7094 with thirty-two kilobytes of memory, a processor that ran slower than five hertz, a punchcard device, and magnetic tape for storage. Elsewhere, computers were used to control a printer to play a melody, and soon a revolution in musical culture was under way.[57] Across the Atlantic ocean, BBC recordings from as early as 1951 were found capturing the Ferranti Mark 1 computer rendering versions of "Baa Baa Black Sheep" and "In the Mood" in Manchester. Schaeffer considered the RCA Electronic Sound Synthesizer "the most general orchestra that exists" in that it could generate any imaginable sound; next to personal computers, synthesizers are now the most widespread musical instruments worldwide.[58] This rush of innovation had multiple consequences for the human–computer interface in music. For instance, MIDI was a way to code musical notes so as to be represented to a synthesizer, a standardization scheme for an interface. Yet as synthesizers turn from cheap laboratories of noise into prefab keyboards of a predictably limited range, the immense freedom of raw data has been black-boxed and effectively lost. By the same

token, we now have to confront the surmise that under the auspices of computer-mediated communication, "people are becoming like MIDI notes—overly defined, and restricted in practice to what can be represented in a computer," as computing pioneer Lanier put it.[59] His fear of cybernetic totalism is based on the observation that the dominant formats of computer-mediated interaction try to squeeze humanity into marketing categories and multiple-choice identities. Moreover, MIDI is essentially note-centric and of little help with timbral experimentation. In this vein, musicologists and historians have certainly come to regret the easy assimilation of synthetic sound into popular culture: "You use what Roland, Yamaha, Moog and Steinberg handed to you; music has the imprint of the factory, and tries to eradicate the possibility of errors or spontaneous combustion."[60] As true innovations that rival the inventiveness of prior composers in the end yield to repetitions and imitations in an ossified and limited register, the synthesizer turns from an experimental setup to a starkly limited black box.

However, just when computer-generated sound seemed relegated to the clichés of film effects and pop samples, it was reclaimed by a generation of amateurs and experimenters on the fringes of popular music. Appealing here was no longer the theoretically unlimited new frontier of sound generation but precisely the charm of the limited palette of bleeps that denoted the advent of personal computing and gaming: "There are vast contemporary 8-bit music communities (such as Micromusic.net) based entirely on producing music on emulators or surviving models of the early home computers of the 1980s, such as Atari or Commodore."[61] The nostalgic appropriation of a limited sound palette that harks back to the dawn of personal computing now comes with a generational patina that distances itself partly from what it pulls close: the conditions of possibility of raw sound synthesis in the computer (a typical example being the recent DVD compilation *Reformat the Planet*, documenting the influence of videogame culture on a range of art forms, including chiptune music).[62] Although computing pioneers may have boldly asserted that "a computing machine is usually noiseless in that it cannot be allowed to make a single mistake, since this mistake would render all subsequent calculations invalid," the practice was one of breakdowns, frozen machines, blank screens, and error messages.[63] Noting the inevitable

failure of computers, artists soon came to embrace the crash and to appropriate the hiss and the glitch into new forms, where rather than undermine order or subvert the frame of reception, they are subjugated into the all-encompassing logic of modularity, transcoding, and layered loops that shape digital culture. The glitch betrays the simulation. Sound artist Ken Goldsmith, for instance, refers admiringly to contemporaries: "Japan's Ryoji Ikeda and the Austrian group known as Farmers Manual, are doing some truly stunning work by shaping mountains of raw digital information into compositions rife with narrative and form."[64] Although CDs do not actually skip the way vinyl can, they too can be manipulated to produce textures of disruption.[65] Whether the process of manipulation is low-tech mutilation of data carriers or high-tech circuit-bending or coding, aesthetic recuperation marks the use of noise, clicks, and glitches in audio entertainment.

> The click is remainder, the bit spit out of the break. The indigestible leftover that code won't touch. Cousin to the glitch, the click sounds the alarm. It alerts the listener to error. The motor fails, the disk spins down, and against pained silence there sounds only the machinic hack of the click. It is the sound of impatience at technology's betrayal, fingernails tapped on the table while waiting to reboot.[66]

If computers can become equal performance partners via complex self-referential processes of digital signal processing for musical composition and audiovisual display, then "the separation between man and machine disappears in the proliferation of transactions where the artist neither acts nor navigates interactively," as one glitch pioneer conjectures.[67] If this mode has come to be considered an elementary cultural technique, far beyond what Mauss described as bodily techniques but still along the same axis of interactive performance, then it substitutes for a strict separation of signal and noise the concept of their recursive processing.[68] Indeed, "glitch composition is a meta-discursive practice: rather than writing new music inspired by older recordings, it constructs new music inspired by the technological conditions and limitations in which those recordings emerged."[69] We can thus conceive of audiovisual

human–computer interactions as organized around the glitch rather than the smoothly finished sound, a perspective deployed to great effect in a range of electronica genres, sampling scratches and clicks and other "erroneous" noise to comprise rhythms and danceable beats.[70]

> Errors and accidents crystallize. The pearl is an error, a glitch in response to purity. The error is the aura. Just as Hip Hop records sample scratched vinyl to lend an aura of authenticity, the click creates a kind of anti-aura, lending a pearl finish to failure.[71]

Thus clicks and glitches come to undermine the tightly controlled, layered loops of electronica. But of course, in a recursive system where differentiations between data and programs are obsolete, it comes as no surprise that there should be a Glitch plug-in for audio software that chops up audio files and applies a variety of effects, depending on how much you tweak the controls. With unremarked irony, the Web site for that Virtual Studio Technology software plug-in warns, "This version of *Glitch* is still just a prototype and contains a few bugs—obviously I am working towards fixing everything as soon as possible."[72] Thus it becomes clear that even with a software routine that can be directed to apply randomized effects, human–computer interaction remains predicated on an interpretation of control that tends to bar artists from finally taking the place of contingency.[73]

AT THIS JUNCTURE, it becomes necessary that one try to draw a clearer distinction between signification and information. Generally, information adds to a representation; a measure of the quantity of information is bound up with a measure of unpredictability, the unexpected, the new or original.[74] Information must be considered as a quantity, and sound transmitted via telephone, for instance, has the two dimensions of frequency and intensity to communicate. Yet it seems entirely intuitive for us in using any artificial channel to separate noise from signal, to filter the transmission. This is often taken to mean that noise and distortion are a mere inconvenience owed to material resistance and that we can assume progress toward a noise-canceling or purified future of perfect communication. "Music does not function as a carrier of messages but

offers nothing but empty signification and resists any attempt for decoding."[75] Yet there are significant aspects to what we call noise or distortion that should not be overlooked so easily. It is not just that, as Hainge writes, "a certain amount of noise may actually be either nondestructive to the semantic content of the message or even desirable because the admission of noise into the signal may allow for greater compression of the signal and hence gains in the efficiency of the communication channel and system as a whole."[76] There are ways to distinguish semantic information from aesthetic information, with different implications for repetition and redundancy for music as a time-critical, feedback-controlled, interpretive cultural system. As Heinz von Foerster cautions, information theory is just about beeps; only when understanding begins in the human brain, "then information is born—it's not in the beeps."[77]

An important objection to casting the process of glitching or circuit-bending in an aesthetic dimension is that it might seem as if to a layperson, static is just static, so that different kinds of glitches would be indistinguishable.[78] This could potentially be taken to mean that avant-garde art necessarily transcends an individual's perceptual capacity, as repetition reduces originality and increases accessibility; because forms are intelligible, they reduce unpredictability.

> Mathematically, white Gaussian noise, which contains all frequencies equally, is the epitome of the various and the unexpected. It is the least predictable, the most original of sounds. To a human being, however, all white Gaussian noise sounds alike. Its subtleties are hidden.[79]

Indeed, this argument can be radicalized to comprise both pattern and timbre. Compositions must keep their entropy within the bounds of human ability to make real-time distinctions. If humans have a bandwidth of less than forty bits per second, the freedom of expressing a rapid sample of amplitudes is wasted if they sound uninteresting and indistinguishable. Thus a banal tune tends to have highly redundant structures that make it easy to apprehend, and a higher degree of complexity results from the avoidance of such patterns. In this horizon, music always seems to be resisting the semantic and foregrounding the aesthetic possibilities.

Although transformations such as transposition and inversion may make the semantic information of a written sentence hard to discern, music has long drawn precisely on such methods to vary its formal expressive register. Cover versions and parodies of songs remain recognizable, and citations and mash-ups pay homage to their predecessors. Doing the same with linguistic material stretches the limits of comprehensibility. Thus, "although sub-perceptual editing is designed for glitch control, it can be redirected towards constructing sounds/words from the inside out and towards semanticizing glitches."[80] Certainly some music can assume a semantic role: through situational coding, an advertising jingle or theme song may become synonymous with a statement or product. However, this exhausts the aesthetic dimension of that piece of music; conversely, if one wanted to isolate the aesthetic dimension, one might attempt to lose all semantic aspects. This would include the recognition of a melody; in music, semantic information is connected to the modulation of duration, to rhythms shaping the contours of a tune. "If music is a language devoid of meaning, then inversion of music cannot destroy its meaning."[81] Nonetheless a composer or musician tends to expect some degree of development, evolution, or form that can articulate sameness and difference, anticipation and prediction, surprise and disappointment.[82] Syntactic or syllabic inversion destroys the meaning of speech but affects a melody or series of sounds far less directly; the resulting music may seem unfamiliar, but it remains intelligible as an articulation of sonic objects. These procedures are radicalized when artists such as Throbbing Gristle apply Burroughs's text experiments to audiotapes—playing tapes at different speeds, splicing tapes, and deploying frequencies that disturb the human body, although they go somewhat outside the range of normal hearing—seeking to make people listen to even the inaudible.[83]

Yet the question remains how this will be heard. For nothing in the sonic field is stretching the physiological as well as aesthetic limits further than the types of bleeps, drones, scratches, or minimal clicks that the "genre" of glitch electronica, if it is one, accumulates into rhythmic patterns. Thus the basic conceptual challenge of glitch electronica is arguably how it draws the clear distinction from mechanical errors and environmental noises that elevates it to the status of music, however minimally defined.[84] Consider Audiac, a pain management technology

developed by computing pioneer Licklider; it was supposed to become a headphone application used in dental offices.[85] Or consider why a sound art expert's definition of noise might easily pass for an accurate description of your love of music: "Sound is noisy when it deafens my ears to anything but itself."[86] In short, what one hears when listening to Oval or Pole (or indeed Cage or Stockhausen) is first and foremost one's own hearing: with only slight exaggeration, this scenario might be reduced to the question of tinnitus, or the perception of whining, buzzing, hissing, screaming, humming, beeping, whooshing, whistling, ticking, clicking, or roaring sounds within the human ear. By extension, one also hears the speakers, amplifiers, and data carriers involved in reproduction or performance, including all their shortcomings or flaws—especially in the case of music that requires these technological devices not only for mass reproduction of performances but for every one of its performances.[87] Again, their malfunctions may or may not be easy to tell apart from what the signal chain presents as today's entertainment; nonetheless, one is tempted to speculate that a truly statistical or stochastic music might be more consistent yet duller than what electronic musicians are actually doing.[88] Thus the selection of a message in a set of possible messages to be observed in a noisy channel comes down to our acculturation to media technology, which always includes a reserve or resistance to its totalizing closure. The next step, as not only Attali surmised, was to be a future phase of populist composition and performance, centered around deterritorialization of the means of production, distribution, and reception. Indeed, with the advent of netlabels and cheap digital storage, software audio editors and emulators, there has been greatly increased access to new tools and new sounds over the past two decades, yet an "explicitly glitch- and error-driven scene rapidly became assimilated by the wider fields of electronic and popular music production."[89] Ironically, market forces in the music industry and social aspects of consumption collude in segregating this most technically accessible music, something that almost anyone with a laptop and free software might start to make, into categories of art and popular or high and low, yet even the most radical moves are all too easily recuperated for mainstream electropop.

However, does this mean that information theory can serve as a theory of contemporary electronic music? The generality of such a claim

would shift aesthetics and form toward statistics to an extent that prob-ably troubles musicologists and cultural historians, who would correctly insist that music is not simply a kind of intuitively applied statistics. Nonetheless, suppose that we could accept the question for the time being, provocative as it is.[90] Many studies of twentieth- and twenty-first-century music and sound art furnish methodological questions for an approach to information theory as a kind of aesthetics of calculable proportions of redundancy and message. It is certainly feasible to cast an analysis of sonic raw data in terms of encoding, channel capacity, transmission, and information rate.[91] Yet it would seem ill-advised to advance just one theory of electronic music in the digital age, even if—or perhaps even precisely because—that theory seems to fit with the overall context of digital culture. Indeed, an important objection (perhaps first raised in a sustained way by Pierre Boulez) is that one may even object to labeling or categorizing altogether what has been happening with digital technology in music.[92]

> Noise not only designates the no-man's-land between electro-acoustic investigation, free improvisation, avant-garde experiment, and sound art; more interestingly, it refers to anomalous zones of interference between genres: between post-punk and free jazz; between *musique concrète* and folk; between stochastic composi-tion and *art brut*.[93]

Insofar as any theory of sound art or music sets up for itself a sonic ob-ject, the labor of thought cannot deny that it seeks to give this object a proper place or function, a definition or value. This theoretical program is joined, in computer music, by the logic of the computer program, which draws on a database and a principle of selection in articulating a temporal sequence. The conjunction of a theoretical and a computer program in music forms what one may call a genre: computer music in the widest sense of the word, whereby computers are used in synthesiz-ing, generating, and editing sound under the auspices of musicality. For such a genre, if it is one, it may be possible to establish a set of aesthetic norms, but every new provocative glitch would immediately undermine such a staking of boundaries.

It seems unlikely that all designated operations and elements would

be comprised by one software program, although they may well be circumscribed by an aesthetic program.[94] This would hold most obviously for software written by people who also have serious credentials as musicians and composers, such as Miller Puckette (Max/MSP, Pd) or Robert Henke, also known as Monolake (Ableton Live). Some media theorists welcome this kind of convergence, like Kittler, who wants to "succeed in hearing the circuit diagram itself in the synthesizer sounds of a compact disc, or in seeing the circuit diagram itself in the laser storm of discotheques."[95] Markus Popp, also known as Oval, agrees that "the most important feature responsible for how my tracks end up musically is probably just the Mac OS itself," and some of his sound installations let users interact with his Ovalprocess software.[96] But it nonetheless raises the question whether software as executable writing advances or eliminates musical composition. Examples to consider include software artist Adrian Ward's self-confessed "interface condescension" in projects such as Autoshop or Signwave Auto-Illustrator, or sound artist Scanner's use of plastic surgery instruments in his recordings and performances, including facelift lasers and the sound of liposuction: a pump removing tissue. "Access to and increasing control of digitally produced or processed music move computer music beyond strictures of existing musical convention, and almost inevitably, it seems, to the digital dismantling of music," as Hegarty argues, "and ultimately, to the dismantling of digital music."[97] It is questionable whether even the most complex software program could integrate every particularity of every sonic element, even though computing paradoxically has pointed musical practice in that direction. If each element, each sequence, takes on its meaning in relation to other elements or sequences, from their sounding together or after one another, then they remain in principle contingent. From this vantage point, a conceptual apprehension of electronic music in our digital culture would require a sense of the role of perturbation or destabilization in the constitution and configuration of such a program. Thus, a theory of accidents may be possible, *pace* Aristotle, as a theory of the glitch and its recuperation. This would unite criticism and practice, but not as ground and figure, or as genre and example; it would tap the generative potential of a theoretical program in practice, collapsing aesthetic and logical programs, so that neither has prevalence. An approach to such complexity can take

various routes: creating unpredictability, offering an aural analog to chaos, unleashing a creative potential that had been lurking, or even demanding a liberatory gesture from digital culture, just as guitarists did with distortion, feedback, and reverb via their amplification.[98] Any of these would promise what computer music pioneer Noah Creshevsky calls an "open palette," a means of sonically charting the multidimensionality of digital means of expression.[99]

In glitch, the signal/noise dialectic in human–computer interaction emphasizes more than ever a balance between error and control; both are needed for performance. This reminder of the imperfect, noisy, lossy nature of the machine counters our contemporary digital culture's positivistic faith in technology as providing order. As intervention and impetus for artistic work at the human–computer interface, it need not be cast in binary terms of either a counterhegemonic art strategy or mere toying with the rubble of our high-tech era. Instead, I would like to cue two clips, as it were, that allow us to historicize and theorize this spectrum, three decades apart: one of Elliott Sharp, one of the first musicians of the New York downtown music scene in the early 1970s to incorporate computers in live performance, counting on the inevitable system crashes of his Ataris; and one of media artist Alexei Shulgin, playing a cover version, with synchronized text-to-speech and MIDI synthesis, of Nirvana's "Smells Like Teen Spirit" on a 386DX personal computer on stage in 2001.

4

GAMING THE GLITCH:
ROOM FOR ERROR

Ever tried, ever failed. No matter. Try
again, fail again, fail better.

—Samuel Beckett, *Worstward Ho*

Historic contingency and the concept are
the more mercilessly antagonistic the
more solidly they are entwined. Chance
is the historic fate of the individual—a
meaningless fate because the historic
process itself usurped all meaning.

—Theodor W. Adorno, *Negative Dialectics*

DON'T WE NEED to write a ludology for losers? Computing culture is
predicated on communication and control to an extent that can obscure
the domain of the error. Between a hermetically rule-bound realm of
programmed necessity and efficient management of the totality of the
possible, this book situates a realm of contingency: distortions in the
strictest signal-to-noise ratio, glitches and accidents, or moments where
the social hierarchy of computer knowledge condescendingly ascribes to
"user error" what does not compute. Whether one sees the graphic user
interface (GUI) as a Taylorist discipline teaching ergonomic interaction
or as yielding to reductions of interaction to resemble what users had
already learned, the GUI is pivotal for our culture.[1] And the discursive
formation of computer games runs parallel to that of the GUI: interac-
tion revolves around perception, hand–eye coordination, and discern-
ing errors. But although a typical GUI—from the desktop metaphors of

Vannevar Bush's Memex to the Xerox Star or Apple Lisa, and beyond—aims for visibility and patient acceptance (or even anticipation) of user error, games probe the twitchy limits of reaction times and punish user error with loss of symbolic energy. Audiovisual cues pull users into feedback loops that a game might exhibit proudly, whereas other, perhaps less playful user interfaces tend to hide them in redundant metaphor. As our digital culture oscillates between the sovereign omnipotence of computing systems and the despairing agency panic of the user, glitches become aestheticized, recuperating mistakes and accidents under the conditions of signal processing: "Glitches can be claimed to be a manifestation of genuine software aesthetics."[2]

If one postulates that computer games are an adaptive response to the omnipresence of computing devices—and we do notice that gadgets often come with a game preinstalled so as to teach us how to handle them—then the fact that games afford users significant room for error is an important deviation from the common assumptions about the strictures of human–computer interfaces (HCIs). Some observers have even joked that if HCI practitioners were to try game design, the resulting game would have a big red button with the label "Press here to win!" But rather than discuss the tendency among game critics and designers to resist or embrace HCI, this chapter will opt for a more theoretical meditation on games as an enculturating force.

Games provide room for error; that room is typically understood to be the construction of the user. To the extent that this room for error, this playful sense for potential deviations and alterations, is an essential part of games, it pivots on the opposite or absence of complete necessity. As Cogburn and Silcox argue, "Our play-through of the game instantiates a property that could not be instantiated in a computer program, and hence that is not 'already there' in the lines of code that make up a finished game from the point of view of its designers."[3] Whether conceived as choices, as rare constellations, or as mere accidents, in opening that space where something is possible otherwise, those crevices in the continuity of experiential space are "revealing the folded-in dimensions of contingency, which included those of experience and of its description, very much in the non-causal and non-linear way in which the autopoiesis of systems takes place in the descriptions currently given of them."[4] In treating the

(near) future in terms of possibilities, we distinguish between the formal possibility of the imaginable and the objective possibility of what we can already anticipate. Gaming unfolds only as we play, and although gaming videos and machinima are becoming more popular now, archival records of actual gaming experiences are still uncommon. But by the same token, under highly technologized conditions, presence exists only insofar as past and future exist: the present is the form of the unnecessary past and the unrealized future.[5] Without such an opening to contingency and error, programs might seem to close off that room for play.

Computer game studies seek to describe how protocols, networks, codes, and algorithms structure gaming actions. Recent criticism has begun to consider the implications of the allegories of control inscribed in games and simulations.[6] The difference between playing a game and playing *with* a game is crucial to gaming culture: whereas the former teaches one the game through navigating the game's commands and controls, the latter opens up to critical and self-aware exploration. Like learning to swim, gaming means learning to learn and initiates us into training systems, but like learning to read, it does not stop at a literal obedience to the letter. Still, computer games tend to obey a certain set of design rules, chief among them efficiency, expediency, and mastery of interfaces and interactions—since we value such games to the extent that they "work." Indeed, we can trace the interface design of computer gaming back to Gilbreth's applied motion studies, which sought to transform the conditions of labor into the foundations of scientific management with the aid of chronocyclography and film.[7] This is not to reduce gaming to ergonomics nor critical game studies to an echo of early film studies; it is merely to point out that gaming still depends on controls and displays that are expected to be efficient while allowing for a lot of ludic latitude.

The mapping of abstract operations to an intuitive environment is a difficult task.[8] The GUI with its audiovisual registers is a more complex case for media studies than the keyboard, which similarly trains and constrains regular users of computers. (We are locked by history into the QWERTY keyboard of typewriters whose keys were too slow for our fingers. More than two-thirds of English words can be produced with the letters DHIATENSOR, yet many of them are not in easily accessible positions.[9]) One common example is the "desktop" interface, where files

are held in "folders" that can be "opened" or "thrown away." As Dennis Chao observes,

> Current applications often do not leverage the rich vocabulary of contemporary mass media and video games. Their user interfaces are usually austere, reflecting the limitations of the machines of two decades ago. Our rectilinear desktops feature a Machine Aesthetic, not a human one. There have been attempts to create friendlier interfaces based on familiar physical settings (e.g. General Magic's MagicCap and Microsoft Bob), but they have often been derided as condescending or confining.[10]

In glossing his playful critique of the GUI, Chao advocates an adversarial operating system that would throw into stark relief what the user faces rather than relying, as most commercial interfaces still do, on preconceived notions of accommodation and familiarity. (With reference to the previous chapter about sound, one might also think here about the auditory metaphors of the computer interface.[11]) Industrial designers argue that "a user interface is intuitive insofar as it resembles or is identical to something the user has already learned," yet it remains stuck on emulating work environments that are far less familiar to most computer users than games are.[12] As Chao jabs, "Children are now growing up on MTV and Nintendo and are therefore more literate in the languages of video games and mass media than in that of the traditional office milieu."[13] The design of the Xerox Star, inheriting notions from Bush's Memex desktop and accommodating the office environment of the late 1970s, aimed for redundancy: "an important design goal was to make the computer as invisible to users as possible."[14] Chao's critique, written as executable code, comes in the guise of using the computer game *Doom* as an interface for Unix process management. Under Unix, the "ps" command displays currently running processes, analogous to the MS Windows "tasklist" command. (A similar project, but for the Apple Mac, is Chris Pruett's "*Marathon* Process Manager," using the *Marathon* game engine by Bungie.[15]) The downside of *psDoom* as Chao describes it is that it is too easy to kill the wrong processes if monsters (processes) can kill each other, and of course, it is hard to tell whether users are working.

As Chao glosses his project, *Doom* was chosen because as a classic game it was widely known and had been released under the GNU General Public License. The former meant users found the interface intuitive (one can quickly assess machine load by seeing how crowded a room is; although command line methods to slow down and kill processes are different, *psDoom* unifies them), and the latter fostered the spread of this project in the sysadmin community. Aware of objections against violence in games, Chao surmises that turning the single-player game environment of *psDoom* into an online world might reduce the level of violence by increasing a sense of community.

Another example of a violent computer game turned to unexpected ends by exploitation of a glitch is Brody Condon's artwork *Adam Killer*.[16] Consisting of "a series of eight *Half-Life* mods," it shows multiple replicas of Adam, biblically pure in white slacks and a T-shirt, standing idle on a white plane, patiently inviting the player's interaction. Condon's artwork is available as a playable, stand-alone mod of the game or as a narrative-abstract machinima based on video documentation of his private performances of the work.[17] As Condon says, "White was an aesthetic decision, I felt it contrasted well with blood. As the characters were shot and bludgeoned with various weapons, an exploited glitch in the game's level editing software created a harsh trailing effect. This turned the environment into a chaotic mess of bloody, fractured textures."[18] In exploiting that software glitch, Condon's art installation juxtaposes a wry take on the rather bland advertising aesthetic of displays with the controversially popular transgression afforded by first-person shooters: a space where random acts of violence, up to and including needless killing, are possible over and over again.[19]

IF NECESSITY AND CHANCE are complementary, then one might expect not only games of chance but also games of necessity. Yet we can see that a fully rationalized game, such as a state-operated lottery that allows for play, minimizes risks, and benefits the commons with profits, is simply a fiscal and moral calculation that recuperates contingency into a legally sanctioned form of gambling that fills the state coffers. Borges is surely not alone in protesting that the lottery hardly lives up to its promise of an "intensification of chance" because in reality it is a tightly controlled

process of finite drawings and final decisions, almost "immune to hazard." It is worth noting that Deleuze picks up on Borges's suggestion, in this passage, of "infinitely subdivisible time," albeit without making a connection between that digital potential and an ideal game "in which skill and chance are no longer distinguishable."[20] Hacker lore points to filibustering as an asocial way of winning the prize in such contests: tying up the phone lines with automatic redialers to guarantee the winning call, tying up computer processors with requests to force the desired breakpoint, and the like.[21] Instead of opening iterative play chances, the contingency of a lottery holds out the totalized promise of one winner exiting the rat race, yet it binds the collective more firmly into the game of labor and taxes. In short, the fully rationalized game is indistinguishable from work, and indeed many players of massively multiplayer online role-playing games have come to regret the grind needed to move up to the advanced levels of exploration and play. As McLuhan warns, "Gambling pushes individual initiative to the point of mocking the individualist social structure."[22] If there were no intervening element of contingency, if play were totally rule bound and programmable, then its complete rationalization would direct play as an unfettered pursuit into the mode of discovery and exploration. For instance, the endgame in chess is much more calculable and circumscribed, because most pieces have been removed and thus the possible combinations of moves are much less complex. Nonetheless, the endgame still involves play, namely in finding the strategy that may lead to a win condition and force an end state. Certainly once chess becomes computerized (so as to be played between humans and machines), a formally represented tree of choices and consequences can be comprehended by a vast database of chess history and theory, but chess remains playable even against the computer, in the sense of not being entirely overdetermined by logical constraints. Therefore, it would be premature to assert that role play and imitation are less directly reliant on the wager as a mode to comprehend and manage the hazardous and the contingent.

The paradoxical aim of good game design is to strike a balance between the protection of play through regulation and game design on one hand (play as rule bound) and the protection of play as free, unfettered, and improvisational activity on the other hand. Accordingly, game designers

and critics alike have been calling for increased literacy about command and control structures that, like learning to swim or to read, enables us to move past fear and isolation into active engagement with the unknown and the incalculable. Put differently, key to what Galloway calls "counter-gaming" would be the quest to create alternative algorithms.[23] As he and others have diagnosed, many so-called serious games tend to be quite reactionary at the level of their controls, even if they cloak themselves in progressive political desires on the surface. Critical gaming would tend away from the infantilizing attraction of play as obedience to rules and toward a "progressive algorithm"—if there can be such a thing. In a primary mode it would teach its players the lessons of the game's controls; in a secondary mode it would build on the discovery and exploration of the game's regularities and irregularities and invite creative play with the game.

At this juncture, the discussion could branch out into how the structure of massively multiplayer online games must carefully calibrate and balance labor with appeal, both in time sinks and money sinks, to regulate their virtual economy. A classic online game, Lucasfilm's *Habitat*, already provided a system of avatar currency (tokens) and stores where items could be purchased. When a glitch in the program produced a virtual money machine, a small group of *Habitat* avatars became virtual millionaires overnight. Against the wishes of the "poor," the *Habitat* programmers eventually decided to let the finders keep the virtual loot.[24] But instead of looking generally at self-regulation of games in terms of a risky, lawless world versus a safe, riskless world, let us stay with the systemic place of error, particularly user error, in digital culture. Can simulation systems "think" their breakdowns if they are unable to predict them?[25] A recent example of how computer game technologies have come to be useful in precisely the kind of training and industrial production processes that made computer gaming possible in the first place is an adaptation of the *Unreal Tournament* game engine for a training simulation of toxic spills in chip fabrication. The mod, as described by project lead Walt Scacchi, replaces weapons with cleanup tools and in-game opponents in the popular first-person shooter video game with critical situations that would disrupt the highly expensive and automated microchip production.[26] Similarly, engineering students at the University of Illinois, with

a grant funded by the Nuclear Regulatory Commission, recently began modifying *Unreal Tournament* to simulate critical states of a reactor and train nuclear plant workers and emergency responders.[27] In such applications, contingency planning comes full circle: using game technology that only became possible—and cheap—with computer chips to train groups interactively for the kind of potentially very costly scenario that is otherwise too rare to train for effectively. By the same token, even as the potential of computerized gaming technology for training is recognized and deployed in the military and in education, we return to the question of how much playful freedom can be harnessed by rules and controls before the game ceases to be a game.

Here we see the premodern opposition of luck and virtue flatten out into the tension between unfettered, improvisational play and the grind as a "productive" mode of play that nonetheless has become nearly indistinguishable from repetitive labor. (We have perhaps all heard someone brag, "The harder I work, the luckier I get," reinforcing the common notion that labor and luck go together.) Yet gaming technology drew explicitly on the measurement of accuracy, timing, and fatigue. Baer's patent application from 1968 for "an apparatus and method, in conjunction with monochrome and color television receivers, for the generation, display, manipulation, and use of symbols or geometric figures upon the screen" built on time and motion analysis and coupled input devices with screens and users "for the purpose of training simulation, for playing games and for engaging in other activities by one or more participants."[28] At that juncture, some might argue about what differentiates simulations, as technically related to computer game mechanics, from interactive fiction. Indeed, fiction emphasizes contingency and gives free rein to the imagination of the writer. But arguably, narrative fiction in all its foregrounding of playful self-reflexivity may work with elements of chance and accident, yet their fictionalization is planned.[29] Knights may go errant and experience adventures, but the adventures are planned so as to become meaningful. This remains true for interactive fiction as a transfer onto the realm of spelunking in the computerized database, where metonymic decision trees aggregate patterns into quests of overcoming obstacles to redeem the labors and errors of a fictional world.[30]

Notably, the space of gaming, the conceptual and computational

frame that provides us with room for error, is often modeled on the ancient concept of the labyrinth. The challenge of the labyrinth consists in finding a method that allows one to access every spot in a network of meandering detours without knowing the overall plan of the labyrinth. Science solved this problem by mapping the topology of links and nodes as a graph; a path through the labyrinth traverses each edge (at least) once, in a series of decisions. (The history of mathematics gives pride of place to Leonhard Euler's thoughts on the seven bridges of Königsberg in 1735 as a founding moment of graph theory and topology.) Our ancient fascination with the symbolic architecture of labyrinths represents an extreme aesthetic state, a regular structure that includes within itself a highly irregular structure. The multicursal labyrinth affords many possible paths, entirely contingent on each selection. Given a certain palate of means and recombinatory elements to select from, the artistic process may be understood, at a basic level, to proceed as a series of selections that transform chaos into order, although it may seem easier to take the first step than to achieve the last one, the exit from the labyrinth. Whereas in Shannon's cybernetic rat maze it is in reality the maze that remembers, Bense's attempt to describe an entropic aesthetics distinguishes an intuitive or speculative path from a methodical or constructive path to the exit.[31] It is no coincidence that the *PacMan* layout resembles the same kind of maze, the kind also deployed by U.S. Army Mental Tests decades earlier:

> After touching both arrows, E[xaminer] traces through first maze with pointer and then motions the demonstrator to go ahead. Demonstrator traces path through first maze with crayon, slowly and hesitatingly. E[xaminer] then traces second maze and motions to demonstrator to go ahead. Demonstrator makes mistake by going into blind alley at upper left-hand corner of maze. E[xaminer] apparently does not notice what demonstrator is doing until he crosses line at end of alley; then E[xaminer] shakes his head vigorously, says "No—no," takes demonstrator's hand and traces rest of maze so as to indicate an attempt at haste, hesitating only at ambiguous points. E[xaminer] says "Good." Then, holding up blank, "Look here," and draws an imaginary line across the page from left to right for every maze on the page. Then, "All right.

Go ahead. Do it (pointing to men and then to books) Hurry up."
The idea of working fast must be impressed on the men during
the maze test. E[xaminer] and orderlies walk around the room,
motioning to men who are not working, and saying, "Do it, do it,
hurry up, quick." At the end of 2 minutes E[xaminer] says, "Stop!"[32]

Later, at MIT around 1960, one could play *Mouse in a Maze* on a TX-0 (an
early programmable computer that dispensed with vacuum tubes in fa-
vor of transistors and used a magnetic core memory), a game developed
by Doug Ross and John Ward that had the user draw a labyrinth with a
light-gun on a screen, then set a dot as the cheese that a stylized mouse
then sought to reach. When the mouse made a correct turn, it drank a
martini; along the way, it became increasingly inebriated.[33] One of the most
interesting games played in the space of the Dynamic Modeling Group at
MIT was the multiplayer *Maze*—"actually a legitimate test of a database
system the group used for a research project"—later seen as *Mazewars,* a
direct ancestor of *Doom, Quake,* and *Unreal.*[34] And Crowther said about
his seminal text game *Adventure* or *Colossal Cave* that when he let his kids
play, on his ASR33 teletype remotely connected to a PDP-10, it was meant
as "a re-creation in fantasy of my caving."[35] Indeed, guides at Mammoth
Cave National Park provide anecdotal evidence of first-time spelunkers
finding their way without assistance simply because of their prior experi-
ence of the game. (Montfort adds that students at MIT also engaged in
spelunking on campus, exploring off-limits sections and basements at
night.[36]) Successor game *Zork* was judged to be less convincing, although
it had better game mechanics; its underground setting was "based not on
real caves but on Crowther's descriptions."[37] It should be noted here that
Will Crowther was one of the original developers of routing protocols
for the Interface Message Processor that gave rise to the ARPAnet—the
very net that soon helped spread computer games. Even the creation
of the most popular layer of computer-mediated communication, the
World Wide Web, is said to have been inspired by interactive fiction and
the adventure game: CERN physicist Tim Berners-Lee describes *Enquire,*
the predecessor to his now famous proposal for a network interface that
"allowed one to store snippets of information, and to link related pieces
together" as a progress "via the links from one sheet to another, rather

like in the old computer game *Adventure*."[38] Other witnesses are quoted as remembering how "Tim made bits of labyrinthine hyper-routes in *Enquire* that served no better purpose than to exploit the program's capacity for making them. 'I made mazes of twisty little passages all alike,' he explains, 'in honor of *Adventure*.'"[39] Inversely (and this connection is of course relevant for chapter 2), Barlow warns in discussing early computing culture that "cracking impulses seemed purely exploratory, and I've begun to wonder if we wouldn't also regard spelunkers as desperate criminals if AT&T owned all the caves."[40] As Montfort notes, "*Labyrinth* was a hypertext catalog of the 1970 *Software* exhibition at the Jewish Museum," and Ted Nelson, who coined the term *hypertext*, called this catalog the first publicly accessible hypertext.[41] In short, between labors and errors, the labyrinth offers a powerful reduction of narrative and ideological complexity.

This allows us to read games as risk management. As an ancient cultural technique of coping with risks and accidents, with chance and fate, games are an exemplary resource for thinking about contingency. This may apply less directly to role-play and mimetic play than to the mode of scenario planning and anticipation that is characteristic for strategy games, from ancient chess to the most recent computer games. Nor would it apply strictly to games of skill, but it is evident that under the condition of the networked computer, all these game types increasingly rely on a skill set that is determined by computer literacy and a certain twitchy familiarity with joysticks, keyboards, mice, and screens. Nonetheless, computerized play does not necessarily mean higher accuracy or less room for error in play; in fact, meeting the expectations of rule-bound play with others in computer-mediated communication still means the experience of the contingency of gamers' competence, and even the contingently variable experience of one's own skill in relation to the performance of the other players. Contributing factors include applause and positive reinforcement on one hand, heckling and competitive pressure on the other—pride or shame. In short, one's own performance is experienced as contingent on a host of contextual factors; what opens up the topology of play is a voluntary acceptance of the fictionalizing realm of contingency: the game. There, play is rule bound as a way to circumscribe contingency, yet rules need not conform with moral or legal codes; they can model their own

artificial worlds, where each move is just an actualization of one among manifold possibilities. Playing with dice not only requires one to accept the element of chance, it also allows one to recuperate it into rule-bound play actions that modulate randomness into games. In short, rules leave room for play, both for the calculations and anticipations of the players and for contingent turns.

We call contingent whatever is neither impossible nor necessary; it might be, it could be otherwise, or it might not have been, it could have been otherwise.[42] The concept of contingency becomes interesting and fruitful where it diverges from the merely possible, the not-impossible or imaginable.[43] As Alan Liu writes, "widely espoused in contemporary cultural criticism and epitomized in the New Historicism, contingency is a philosophy of compromise between determination and random access."[44] But the concept also becomes difficult for productive thought where it ought to be differentiated from accident and chance. Systematic thought, whether as philosophy or theology, traditionally shied away from contingency; for religion, chance was blasphemy against sovereign divine guidance; for rigorously systematic thought, contingency is anathema insofar as it would undermine or even undo the logical stringency of necessity. Indeterminacy can figure in such systems only as failed necessity, and inversely, if there is chaos, accident, and chance, then it is unclear what real importance order and necessity have. Transfer of this setup to computer culture is fairly straightforward: input devices and operating routines must be tightly controlled, or they appear faulty. If my clicking or pecking can yield unpredictable results or create the (correct or erroneous) impression of a variable and perhaps even uncontrollable situation, then a fundamental principle of interaction is at stake: a peculiar blasphemy against widely held beliefs about designing human–computer interaction. Ted Nelson was not the only one to warn against the perils of installing a computer priesthood, for precisely these reasons. Inversely, if my user interface were chaotic and irregular (regardless of whether it is a browser window or game—or, for that matter, a buggy beta version or an intentionally artsy deconstruction of a browser or a game), then I would be highly unlikely to accord any value to such accidental elements; totalized contingency would indeed be the absence of meaning.

However, players tend to try to recuperate such moments. "Glitching"

Web sites aggregate discoveries in various games and advise on how to recreate situations that were discovered accidentally, turning exceptions into exploits:

> When you learn a glitch that can be used in actual gameplay you may be tempted not to attempt that particular glitch during gameplay (someone might kill you while you're trying to accomplish that glitch). But if you learn to incorporate that glitch during gameplay I can't tell you how effective that will be.[45]

This can be illustrated also by the work of European Net art duo Jodi, who programmed a browser, the quintessential Web interface, but taking the realm of Hypertext Transfer Protocol errors as a starting point, such as the notorious "error 404" that signifies that a file was not found on the Web; this protocol becomes the basis for a bulletin board that aestheticizes browser errors and networks.[46] As Schultz comments, "Error sets free the irrational potential and work out the fundamental concepts and forces that bind people and machines."[47] The list of examples might also need to include the Web site http://glitchbrowser.com, described there as

> a deliberate attempt to subvert the usual course of conformity and signal perfection. Information packets which are communicated with integrity are intentionally lost in transit or otherwise misplaced and rearranged. The consequences of such subversion are seen in the surprisingly beautiful readymade visual glitches provoked by the glitch browser and displayed through our forgiving and unsuspecting web browsers,

or indeed Net artist Heath Bunting's performance in Berlin of an actually nonexistent "web art project" (supposedly hosted on a server in Cuba) that returns only error messages.[48] The play of aesthetics shows itself in these examples as a reduction of contingency through form, harnessing adventure through aleatory or stochastic management of the event and the surprise. Another example is Jodi's game mod *SOD*, a modification of the classic game *Castle Wolfenstein* that retains the soundtrack but scrambles the visuals so as to render the screen a black-and-white abstract pattern

of glitchy, nonrepresentational patterns, appearing to make the user's computer run amok.[49] Yet another related example is the artgame *ROM CHECK FAIL*, a recent "independent" game predicated on the glitch as an aesthetic tool, shuffling around the elements of a number of classic 2D computer games.[50] Apparently random switching to alternative rules complicates the game mechanic and allows *ROM CHECK FAIL* to recycle an oddball assortment of arcade and console classics, to be navigated with arrow and space keys. Of course, this kind of eighties-retro game generator cashes in on nostalgia and aestheticizes the glitch. Going one step further in that direction is the commercial release *Mega Man 9*.[51] Though developed for recent consoles including the Nintendo Wii, *Mega Man 9* uses graphics and sounds harking back to the eight-bit era of the original Nintendo NES. A "legacy mode" emulates the lower frame rates of the game's ancestors, only partially renders sprites, and causes them to flicker when they crowd the screen; this degradation feature is achieved not via an emulator but using a dedicated engine that simulates an outmoded technology.

AESTHETIC EXPERIENCE has long been the traditional refuge of chance and accident from their philosophical and theological exclusion, and art remains the refuge of chance and accident in the age of new media technologies, whether instantiated with deconstructed browser windows, reprogrammed games, or distorted sounds. Here, we encounter a shift in the historical understanding of creativity. Premodern thought had opposed sovereignty and powerlessness: a divine power creates, and the created do not have any choice about being constituted otherwise, or not at all. Wishing to be otherwise would have been blasphemous. This rejection of contingency in premodern thought is readily illustrated in the Christian legends of the saints, precluding experience as a learning process and reducing saintliness to two modes: an undeterred allegiance to God even under the greatest duress or a turn away from God that is corrected by one redeeming turn back to God—in short, the martyr or the converted sinner. That hagiographic stricture was a reaction to the polytheistic personification of Fortune. Here we will instead prize multi-cursal labyrinths, precisely for the reason that they allow more than one turn. Moreover, accidental determination is also ascribed to things out of

human control, including illness and death, acts of nature, or "bad luck." This notion of contingency is what Kierkegaard derided as despairing of necessity in the absence of possibilities; it can also be described as one of the sources of metaphysical belief systems, in that they provide a means of coping with fate, and a reduction of contingency.[52] On the other hand, if contingency means something could always have been otherwise, this presents the dilemma Kierkegaard saw in an aesthetics despairing of possibilities in the absence of necessity; wholesale rejection of universal principles threatened to suspend art in a nauseating state of "anything goes." Arguably, modern and contemporary art practices exit from this dismal binary in games and adventures, as rendezvous with contingency. Modernity ascribed both sovereignty and impotence, both creativity and overdetermination, to humans. And now we find these ancient categories returning in new media technologies, where again it is not at all unusual to see placeless power ascribed to media and the subject located in a powerless place.[53] One of the most striking illustrations of this setup is found in computer games, where everything depends on a user interface that multiplies incentives for repetition and replay.

As discussed in chapter 3, arguments about lossy compression are too often hijacked by the kind of cultural conservatism that denies aesthetic dignity to any product of computing culture. Regardless of whether the reduction at issue is an aesthetic strategy or a technical constraint, each system will react to its own instabilities with a justification. As Foucault writes, the very first risk he took and his initial hypothesis was to ask,

> [What if] the very possibility of recording facts, of allowing oneself to be convinced by them, of distorting them in traditions or of making purely speculative use of them, if even this was not at the mercy of chance? If errors (and truths), the practice of old beliefs, including not only genuine discoveries, but also the most naïve notions, obeyed, at a given moment, the laws of a certain code of knowledge? If, in short, the history of non-formal knowledge had itself a system?[54]

Of course, computers are particularly helpful in playing through complex tree diagrams of what-if chains. Yet the kind of systemic closure Foucault

adumbrates—neither at the mercy of chance nor affected by error, other than by recuperating error into its order—would reduce the archeology of the human sciences to a code set of epistemological regularity. In demanding necessity throughout, speculative idealism knows, yet subsumes, the concept of an absolute accident.[55] Where systematic philosophy sought to eliminate contingency, media archeology expects to uncover contingency as that which is governed neither by divine providence nor by absolute reason. Thus instead of emphasizing coherence, totality, and continuity, media studies after Foucault foregrounds breaks, conflicts, and discontinuities.

Of course, it is evident that the glitch only becomes more palpable with the advent of higher expectations from audiovisual resolution. Chapter 3 already mentioned how an accelerating "aestheticization of information tools" covers up the very material fact that choices in the visual and audiovisual arts had to do with resistance, with the roughness of a brushstroke or the hairy attack of bow on string—as effects at one's disposal, not simply as noise to be canceled.[56] Arguably therefore, the era of noise canceling only truly takes off with the advent of digital technologies. It has also been discussed already that for computer-mediated communication, redundancy can turn from an attribute of security to an attribute of insecurity: when recurring noise patterns become signal sources as their regularity renders them legible and receivable, the systemic function of distortion doubles over as deterioration of message quality and as enrichment of the communication process. The same functions, "operating under the same rules, in one case lead to knowledge and in another to error; from the latter, only repeated and exhaustive examination can protect us."[57] Distortion is systemic, but it is not merely a matter of chance or accident whether there will be noise, nor is it simply a matter of fate whether one is being understood or intercepted. These situations are never completely impossible and always somewhat likely; it may seem reasonable to anticipate them, but to do so requires a concept that differs, if only slightly, from indeterminacy or accident, chance or fate.[58] The problem is that erroneously introduced or accidental noise is neither impossible nor necessary.

Fiction, art, interpretation, and irony are forms of knowledge that can convey contingency: as a kind of knowledge that implies an awareness

of its own contingency.[59] But although the executable codes of Oulipian poetics and prose generators or, more generally, the criticism and systematic study of possible worlds have tended to carve the space of imagination into analytic categories that can be harnessed in expressive form, criticism often proves unable to systematize that which is by definition unsystematic. In the age of cybernetics, it can seem as if human fallibility is what keeps systems from achieving their full potential—from systematic closure. Yet rather than our becoming abstractly "posthuman" in information society, one might instead argue that people, citizens, and individuals in fact become realized for each other and for themselves in unprecedented ways through networks of computer-mediated communication. For must we not recognize that new media necessarily involve the operation of human embodiment to close their feedback loops? Attending to the modes of embodiment of data in information machines, or focusing on technologies of inscription, allows close analysis of innovation in cultural technologies.

If we allow ourselves to conceive of human–computer interaction as organized around the glitch, it is not to smuggle a covert humanism in through the back door of technological determinism; rather, it is to emphasize what Galloway calls "the cultural or technical importance of any code that runs counter to the perceived mandates of machinic execution, such as the computer glitch or the software exploit, simply to highlight the fundamentally functional nature of all software (glitch and exploit included)."[60] One might conclude, however provisionally, that gaming glitches are part of the art form in the same way that brushstrokes are part of painting. Game developers may be tempted to brush this off as little consolation to a user who just had a program crash, or indeed to a programmer trying to debug the system. However, it may be a crack that can widen onto new vistas and better mistakes. A plain pedagogical imperative to "learn from our mistakes" seems to suggest that the shipwrecked ought to make the best travel guides, as Ortega y Gasset jokes.[61] But this sardonic recommendation might be all too easily appropriated in a culture of efficiency, especially after dot-com failures had to be reinterpreted in the résumés of a multitude of entrepreneurial types as a valuable life lesson.[62] Indeed, ancient myth already indicates that only the failure of guidance allows for a happy end. In what Pias

calls the most prominent narrative of the failure of cybernetics, the God Morpheus drips some water from the river Lethe into the eyes of Palinurus as he steers Aeneas's ship. Palinurus falls asleep and is washed off the deck into the sea. However, Aeneas later descends into Hades and meets his prematurely deceased helmsman there, only to learn that the attack on Palinurus was not aimed at thwarting Aeneas from reaching his destiny. It was just that the ship's commander had to die to make a happy ending possible.[63] Thus, perhaps the shipwrecked cybernaut does not make the best guide after all. Instead, what one needs to learn from mistakes is not to avoid them but something else altogether: to allow for them; to allow room for error.

To summarize this long story of glitchy computer-mediated communication, we may remind ourselves that in 1968, Licklider and Taylor could still assert that "men will be able to communicate more effectively through a machine than face to face."[64] However, it should also be remembered that their essay ends with the ambivalent prediction that

> unemployment would disappear from the face of the earth forever, for consider the magnitude of the task of adapting the network's software to all the new generations of computer, coming closer and closer upon the heels of their predecessors until the entire population of the world is caught up in an infinite crescendo of on-line interactive debugging.

The error remains the future.

5

MACHINIMA AND THE SUSPENSIONS
OF ANIMATION

Semantic aspects of communication are
irrelevant to the engineering problem.

—Claude Shannon, *The Mathematical
Theory of Communication*

Technology is making gestures precise and
brutal, and with them men. It expels from
movements all hesitation, deliberation,
civility. It subjects them to the implacable,
as it were ahistorical demands of objects.

—Theodor W. Adorno, *Minima Moralia:
Reflections on a Damaged Life*

MACHINIMA, a portmanteau for *machine/cinema,* is the recording of in-game action. It is a thriving form of digital animation or filmmaking in real time on the ordinary PC of the creator or viewer, as virtual cameras record performances inside an off-the-shelf game engine, without the need for render farms or other expensive postproduction facilities. Machinima has attracted a lot of attention as the film and game industries work hard on various points of convergence, from cross-promotions to trying out technical and narrative innovations of one in the context of the other. While digital capture, editing, postproduction, and distribution are now common in film and television, games use established cinematic camera angles to mark certain genres and borrow voice actors and film scores for game soundtracks. If video and computer games are a response to the adaptive problem posed by technology, then the historical record of explorative and emergent play are of interest to the cultural historian of

media; machinima offers to provide an archive of gaming performance and access to the look and feel of software and hardware that may already have become unavailable or even obsolete. As the previous chapter elucidated, innovations at the human–machine interface grapple with numerous challenges. Although the entertainment software industry keeps pushing the limits of immersive graphics and cinema explores 3D once again, this chapter also considers the space in front of the screen, where users now have far more sophisticated input devices at their disposal than QWERTY-legacy keyboards. Aside from the runaway success of WIMP (windows, icons, menus, pointer) as developed at XeroxPARC, it should be remembered that gaming started with keyboards on devices such as the Atari 400/800 and the Sinclair Spectrum, only to be supplemented with joysticks and controllers later; now mostly forgotten are the Nintendo PowerGlove and the Sony EyeToy. Numerous devices now harness the affordances of motion capture, whether it be touchscreens (from the Light Pen on the Vectrex in 1982 to the stylus of the Nintendo DS or a finger on the Apple iPad) or gestural interfaces (from the Pantomation in 1977 to the more recent gestural interfaces of the Nintendo Wii and Microsoft Kinect). Via networked cameras, gamers can manipulate real-time visuals using full-body gestures instead of twitchy fingers, such as moving left or right to steer a snowboard down a simulated mountain. This opens new vistas for the creation of machinima.

Arguably, machinima is to computer gaming what Brechtian epic theater was to dramatic and cinematic conventions a century ago. Moments and sequences of computer game play are interrupted and time-shifted into a different context, in adjustments that allow them to be recorded as significant, interesting, or entertaining independently of the immediate context of their production. This momentary halting of fluid technical and semiotic relations can make visible, rather than merely felt, what is at stake in machinima, and in a wider sense in digital culture. After discussing questions of interface design and usability in computer-mediated communication in general and gaming in particular, this chapter proposes that there are at least two reasons to look at the emergent practice of machinima from the vantage point of gestures. On one hand, gestures and their citability mark the performative space of theater or cinema that is cited by machinima. On the other hand, precisely calibrated in-game

gestures remain particularly difficult, even for highly accomplished examples of machinima such as Paul Marino's "I'm Still Seeing Breen," a music video using tools included with *Half-Life 2*, such as FacePoser, which allows the user to lip-synch new lines of dialogue.[1] Many of the digital assets that come with a particular game tend not to allow certain simple character movements, such as nodding, facial expressions, turning one's head, or pointing without a weapon in hand—as one can quickly glean from episodes of the long-running machinima sitcom series "Red vs Blue" set in the game *Halo*.[2] Thus a restaging of scenes from Franco Zeffirelli's *Hamlet* or from *Aliens* in *Halo* is arguably more than an experiment on the faultline between parody and performance art.[3] The difficulty in emulating a range of affective expression through gesture and facial controls is among the constraints of making machinima without modifying a game engine or digital assets.[4]

In machinima, there is a dual register of gestures: the trained motions of the player determine the in-game images of expressive motion. In this sense, machinima is not simply the recording of consumer-generated content in computer games, any more than speech is merely the consumer-generated movement of air through the larynx. Machinima consists of controlled gestures in a collective frame of reference in the history of technology and entertainment. PlayStation *Home,* an online environment built by Sony, offers machinima-ready tools in its "Stage Set," and machinima tools are built into recent games, including *Left 4 Dead* and *Uncharted 2: Among Thieves.* The *Unreal* engine was used by Lucasfilm for previsualization, and the History Channel used the engine for *Rome: Total War* to stage televisual battles. Other TV examples include "Game On," a Volvo ad by students at New York University's Center for Advanced Digital Applications, who spent the bulk of their $25,000 production budget on a state-of-the-art graphics card for a computer so as to stage much of their ten minutes of action inexpensively and in broadcast quality inside a virtual world; a series of machinima "Video Mods" on MTV2 produced by Alex Coletti and Tony Shiff, music videos set in computer games; or the UPN show *Game Over* and the Canadian children's show *ZIXX* on YTV. In short, machinima has become part and parcel of the way computer games are made, marketed, played, discussed, and used in unforeseen ways. Therefore, instead of reducing machinima to fan culture

or to contributions to an oral history of videogames, one ought to show how machinima's gestures grant access to gaming's historical conditions of possibility and how machinima offers links to a comparative horizon that informs, changes, and fully participates in videogame culture.[5]

Gestures are neither necessary nor natural; they are acquired wherever specific cultural tasks are to be performed, and the process of accommodation or acculturation creates the kinetic body.[6] A gesture is a manner of carrying the body, a controlled motion used to express attitude or emotion. Gestures communicate: each gesture is a bodily motion, but not all bodily motions can be understood as gesture. Involuntary movement (including posture, facial expressions, or even a mere reaction of the pupil of your eye) does not constitute a gesture: to the extent that gestures are taken as expressions of an intention, we assume significance and constantly read or interpret gestures.[7] We also know that gestures are readily imitated or cited, and if they seem derivative or kitschy, then they are less expressive. When it comes to the gestures of machinima, beyond the twitchy hand–eye coordination videogames require there is the motion of the camera itself inside game space. As recorded from the point of view of one player who thereby acts as the camera, game action may feature high jumps, teleporting, and seemingly impossible positions and angles, yet apart from (or indeed by dint of) such reminders of the technical capacity of virtual cinematography, the player tends to disappear from screen. Even as cut scenes, in-game footage, and ad campaigns for blockbuster gaming products such as *The Sims, Halo,* and *Grand Theft Auto* must imply a player, that player is invariably absent from the screen, which seeks to impress instead with the promise of spectacle.[8] This disappearance of the player offsets some of the advantages of real-time rendering that make machinima a new chapter in motion graphics. Here, what Agamben says of early cinema applies to the interruption of motion graphics that is machinima: "In the cinema, a society that had lost its gestures tries at once to reclaim what it has lost and to record its loss."[9] Arguably, machinima recoups the gestures of play, compensating for a loss of theatrical and cinematic gestures that seem difficult or impossible in videogames. In terms of this effect of alienation and distancing, Benjamin observes that "the more an acting subject is interrupted, the more gestures we have." Benjamin read the Brechtian epic theater as a systematic interruption of

the frame, of narrative representation and context, of myth and plot—of the very elements that since Aristotle had been considered pivotal for the dramatic genre. Weber argues that Benjamin's writing can be read as an instantiation of what he is writing about, "perhaps because the citability of gesture already entails a mode of writing."[10] Without customized game engines and video capture tools, machinima moves in jerks and jolts; rather than seeking to overcome this limitation, machinimators tend to accept it as something to toy with, something to mobilize for aesthetic effect. As Weber observes,

> This suspended animation, the interruption of the flow of everyday events, this bringing to a standstill of what we commonly think of as the "flow" of "life." And it is this *coming-to-a-standstill* that constitutes what, for Benjamin, from his very earliest writings to his last, can be designated as the *virtuality of media*, media *as* virtuality. The medium is never simply actual, never simply real or present, much less "the message" that it seems to convey. Rather, it consists in the suspension of all messaging and in the virtuality that ensues.[11]

Experimental animators working with game engines "have created a form of animation that exemplifies some of the possibilities for production and distribution that are unique to digital animation."[12] As motion-capture animation and inverse kinesthetics approximate our idea of human movement and gesture ever more closely, computer-generated imagery becomes legible as related to theater and cinema; just how these relationships are negotiated is something that may become clearer through a closer look at machinima.

The first decades of cinema raised the expectation that this new medium would extend and refine the expressive tradition of gesture from pantomime. Insofar as silent film was comparable to pantomime in its wordless expression, it did foreground a stylistic limitation that was a consequence of a typology of gestures, as a schematic reduction of affective communication. But on the other hand, if mimodrama chose silence as a means of expression, early film did not; it was less an artistic abstraction than a technical constraint. Just as silent film used writing,

with intertitles and subtitles guiding the viewer through the moving images, the expanding menu of in-game communications, particularly in networked gaming, pushes the possibilities of drama and interaction in gamespace. By the same token, if an emphasis on action as movement in space (in sound film as in many computer games) came at the expense of an expressive ballet of gestures, one might surmise that machinima is also a way of injecting the complexity of miming and gestures into the kinds of games that tend to reduce their elementary setup to something as easily summarized as a pantomime or puppet theater handout. Thus machinima can reintroduce some of the narrative potential that tends to be eliminated from the compressed standard plot that marks many first-person shooter, adventure, or strategy games, and it can elaborate on the rudimentary narratives that introduce open systems for gaming, such as *Second Life* or *The Sims*. Nonetheless, it is too narrow to define machinima as an exploration of modes of play as modes of production, because some games are already "designed to be manipulated and modified by the people who purchase and play them."[13] This is not to deny that machinima has opened up unforeseen avenues for creative expression using computer games. It is rash to claim, as some game critics do, that "film theory fails in the face of such tweaked-out technology," for if the digital animation made possible by computer games is used for short films, series, or even feature-length movies, then clearly the legacy of moving image forms may retain some relevance, especially if it includes traditions from theater and puppeteering.[14] On the other hand, it is equally valid to assert the fundamental departure from cinema in computer space, such as the simple fact that the computer image, now omnipresent in the production and editing of all manner of visual media, derives its point-and-click addressability from radar screens. Too often, anecdotal attempts to string together a history and typology of computer games fail to take into account the basic technical dispositive and its influence on the body—from Jacquard looms to Zuse's film, from oscilloscopes to Sutherland's Sketchpad, and indeed from the lurking style of early machinima such as "Diary of a Camper" (in *Quake* 1996) to machinima clips pushing the limits of in-game dance such as "The Man Who Can" (in *World of Warcraft* 2006).[15] Furthermore, whereas film theorists emphasize the immobilizing of their audience, the gamers' gaze is perhaps fixated on a screen or display, but in terms of

their twitchy virtuosity with a mouse, keyboard, joystick, or other input device, gamers are hardly immobilized. Yet Salen is right to associate machinima with a kind of déjà vu, for it cites not only game play but also many other media discourses. Conceiving cinema in terms of the reception of an event, Bellour called film an "unattainable" text, but today loops of repetition and mash-ups of moving images on TV, video, DVD, and computers have become common and make film easily citable as still image or clip.[16] Similarly, earlier videogames took place only as real-time graphics and were hard to stop, interrupt, cite, and archive; machinima is possible only because this is no longer the case. This situation in turn raises questions about the status of repetition and remixing, ranging from remakes and parodies to citations, allusions, video responses, and more. For instance, when machinimators such as Kendra Flemons remodel singer R Kelly's music video series "Trapped in the Closet," is that a video remix via *The Sims* or consumer-generated censorship that replaces steamy scenes with innocuous ones? When the physics experiments of Randall Glass's remarkable *Halo* machinima "Warthog Jump" cite the 1970s arcade game *Cannonball* and are in turn cited by a flash game on the Web ("Warthog Launch"), is it sufficient to celebrate a mass mediation of user-generated content?[17] Here, pseudostabilities are upset in an entirely different way, as machines are placed under the control of a new kind of subjectivity that is aligned not just with a technical setup but with its historical possibilities and impossibilities.[18] This underscores the point that cutting off videogames, arcades, and consoles from their conceptual and technical history across several media dispositives risks losing sight of what precisely makes machinima's cut-and-paste montages fascinating and worthy of popular appraisal (and academic attention).

Of course, reading machinima as cinematic is not to ignore its ludic aspects: interrupting, citing, and reassembling the game, machinima is a way of playing with the game (by the same token, it plays with cinematic conventions). As Jean-Luc Godard speculated, "Somewhere between the video game and the CD-ROM there could be another way of making films."[19] Although "on the one hand, images are the reification and obliteration of a gesture," as Agamben puts it, "on the other hand, they preserve the *dynamis* intact (as in Muybridge's snapshots or in any sports photograph)."[20] By analogy, because the collective memory of digital

culture is hampered by the impracticability of anything like a museum of hardware and software, machinima in the form of captured replays or as video of tournament games serves as one way of preserving (interrupting and fixating) the experience of game play—something that is otherwise irretrievably lost once a platform has become outdated.[21] Agamben writes,

> In cinema, a society that has lost its gestures tries at once to reclaim what it has lost and to record its loss. An era that had lost its gestures is, for that very reason, obsessed with them; for people who are bereft of all that is natural to them, every gesture becomes a fate. And the more the ease of these gestures was lost under the influence of invisible powers, the more life became indecipherable. It is at this stage that the bourgeoisie—which, only a few decades earlier, had been firmly in possession of its symbols—falls victim to interiority and entrusts itself to psychology.[22]

Drawing a parallel between Tourette's proto-cinematographic study of human motor coordination and Muybridge's photographic motion studies, Agamben asserts that "the element of cinema is gesture and not image."[23] Citing Deleuze's argument that sought to erase the fallacy of a distinction between image as psychic reality and movement as physical reality, Agamben developed his ethics and aesthetics of "gestural cinema." Deleuze held that cinematography consists of movement-images, and Agamben extends this argument to show how "cinema leads images back to the homeland of gesture."[24] It is not too much to infer here that reading machinima by its gestures may lead videogame studies back to the conditions of possibility of computing culture, to the triple setup of computer graphics, interface ergonomics, and database form.

To an extent, these three aspects correspond with experiences of embodiment as distinguished by phenomenology: from motor control and perceptive self-awareness, to the socially and culturally constructed body, to technological embodiment as it is observed, for instance, in film and computer games.[25] What this means for reading machinima through gestures is that there is no clear distinction between the controlling manipulation of gaming interfaces and the controlled in-game motions of avatars. The necessary but ultimately impossible distinctions between

controller syntax, avatar performance, and embodied player collapse once one asserts that the technological premise of gaming's audiovisual setup is indeed programmed by what makes the relationship between rapid finger twitches and 3D illusion possible—namely, that they mean each other, point to each other, supplement each other. This is observed not only in media history and film theory but also in the applied motion studies that underlie the discipline of scientific management and ergonomics.

Despite Deleuze's dismissal of phenomenology for film theory, it is worth mentioning that Merleau-Ponty's approach to cinema outlined a "sign language of gesture and gaze."[26] Whereas Deleuze considered the phenomenological account of media experience as merely derivative in relation to natural visual perception, Merleau-Ponty saw that the structures of cinema were refined and perceived in the cinematic experience: "The meaning of a film is incorporated into its rhythm just as the meaning of a gesture may immediately be read in a gesture: the film does not mean anything but itself."[27] And parallel to the phenomenological analysis of modes of embodiment via technology, applications of moving image technology also allowed for much more exacting study of bodily motion. A scientific attitude toward efficiency was already evident in the historical roots of film, such as in Marey's "stoppages at the moment of pose," and it inevitably became crucial for usability engineering, whether for work or for play.[28] For computer games to avoid the programmatic and inevitable fatigue of repetitive strain, behaviorist or Taylorist assumptions about efficiency of motion have to be complemented by a consideration of motivation. If one asks what allows games to continue for hours and what entices repeated play, then one has to ask also what enticed gamers, accomplished as they are in the interactive mode of interfacing with videogames, to switch into the archival mode of performance that is machinima.[29] Once one adapts to computing culture—graphics, interface devices, and dataspace—one finds a way of communicating with others about computing culture. What congeals in gaming and in machinima is a set of gestures that may be read as the epistemic program of gaming culture's technologies, institutions, and machines: from motion studies and management science, performance training for improving reaction times, hand–eye coordination, speed, and ergonomic efficiency; from army mental tests, problem solving in mazes and puzzles and scenario planning;

and from computer science, metonymic routing and database access.[30]

Although machinima can be made with the aid of just about any computer game, its early development owed not just to recordings of speed runs and other in-game performances but also to the increasing possibility and popularity of modifying game maps, skins, and tools for games such as *Quake* and *Doom*. Meanwhile, in late 2008 Machinima.com, seeking to position itself as an entertainment network, announced a $3.85-million seed investment to help fund expansion. With the proceeds, Machinima.com commissioned fifteen television writers to create game-based comedy shows for the online site, a talent pool that includes former writers of such shows as *The Simpsons, Futurama,* and *Family Guy*.[31] Moreover, the six original episodes of the *Terminator Salvation* machinima series focus on a female protagonist in a postnuclear Los Angeles. Set in the narrative interval between McG's installment in the *Terminator* movie franchise and the game based on it, the series is notable as the first long-form dramatic machinima produced by a major studio, and it was widely distributed on iTunes, Video on Demand, Xbox Live, and the Sony PlayStation Network as well as on DVD. Salen and Zimmerman argue that "the player-as-producer paradigm takes the modification of a game so far that the invented activity no longer resembles the play of the game at all. Such is the case with machinima."[32] However, whether one takes the earliest examples, such as speed runs, or the many clips surfacing each day on the Web and in digital film festivals, the fact remains that these are mostly dilettantish efforts at harnessing the power of a game engine, and few attain a level of visual and conceptual sophistication that rivals the more costly productions of the imaginary counterpart, the professional animation or movie studio experts. It is ironic how readily cultural studies academics have revived the eighteenth-century discourse of dilettantism as a direct challenge to the increasing specialization of knowledge and its organization into disciplines and professions; interviews with machinima pioneers such as Hugh Hancock and Paul Marino tend to portray them as zero-budget challengers to Disney and Pixar.[33]

Yet as students in my first machinima seminar a decade ago grappled with the vicissitudes of producing and evaluating their own clips, they were unanimously struck by the early Strange Company machinima clip "Ozymandias," because the Shelley sonnet it is based on concerns a

series of framed acts of reading: a sculptor reading a royal's face, a traveler discovering the statue, a narrative "I" listening to the report, and a reader encountering the sonnet.[34] Sure, it contains the act of reporting an ancient inscription that commands the reader to be in awe of a grand (yet fallen) ruler, yet it is quite evident that the sculptor's reading of the "hand that mocked them" and the royal visage already was no mere copy but also an act of ridicule and distancing, long before the statue falls into ruin. This seems lost on the lonely walker in the sand, as represented in the machinima clip; Strange Company seems to suggest that low-budget machinimation will be alive and moving on in the face of the ruined omnipotence and arrogance of Hollywood, without acknowledging that the machinima clip and the poem consist in a series of gestures pivoting around an imitation of that powerful point of reference. Shelley's poem offers a reading that is both faithful and resistant, both subservient and subversive. Its transfer and transformation of gestures and poses associated with power is not a succession or eclipse; the power of the ruin over the "traveller from an ancient land" certainly persists, and his contemporary scene is a vast wasteland. More recently, amateur production has come to be seen in opposition less to professionalism than to its side effects. Contrasting the managed process of a large professional animation outfit with ingenious inventions of the end-user amateur means ignoring the very structures and strictures of the computer in the production of audiovisual culture. The overhyped paradigm of user-generated content (so often associated with machinima in particular and with game modifications and fan art in general) is dissatisfying, precisely because its concept of "content" is so resolutely divorced from the technical and historical conditions of computers, networks, and media industries. As Enzensberger pointed out decades ago, what is new about the new media is the fact that they are no longer dependent on programs (in the sense of content scheduling).[35] It would be better, perhaps, to regard the impact of electronic mass media in terms of programming in the computer science sense, for in a very real sense what is generated by the technical setup of computer graphics, interface devices, and database structures is first and foremost the idea of the computer user. Instead of opposing a natural organic body to one conditioned by technology, we see that all bodies produce culture by interfacing with prosthetic devices: "the body

never springs forth fully realized but is instead shaped and constructed by the gestures that machines impose upon it."[36] As the small motor motions required by human–computer interactions can become inscribed as automatism or habit, they accentuate the body's originary articulation. Foucault has documented how handwriting, for instance, "presupposes a gymnastics—a whole routine whose rigorous code invests the body in its entirety, from the points of the feet to the tip of the index finger."[37] As machinima cites the gestures of gaming, it foregrounds and exhibits the timing and motion patterns acquired and necessary for advanced skills in *Max Payne* or *Counterstrike*—including, for the purpose of game play and concurrent recording, the ability to manipulate several game controllers simultaneously with hands and feet. Although PlayStation sports characters are not programmed to do anything but play their sport, a helpful glitch in *Halo* that makes a game character's head pop up when the gun is lowered all the way allows for a puppeteering index of talk. Thus, what animation pioneer Alexeieff observed still holds true for recamming and screen captures in game environments:

> For movie animators, the movement which happens on the screen for the first time is the one which makes the original work: contrary to the photo-film, which is satisfied with a photomechanical analysis of the real events that the synthesis of the screen recreates as déjà vu.[38]

In this way, computer games and the explorative or emergent play that includes the making and distribution of digital videos (or of code that would render, in the right engine, as a video sequence) are simply a way of learning to interface with computers—a way of coping with technology. Accommodation to repetitive tasks is a question of timing and motion patterns. Certainly the definition of computer workspace and human–computer interaction is deeply influenced by desktop logistics that normalize the motions of hands and tools, with drawers, folders, files, pens, rulers, and so forth all in their predetermined and standardized relation to each other. Two-dimensional document processing anticipates the screen metaphors implemented in the computer; data processing is the application of standardized tools according to industrial norms

in prescribed sequences of motions and calculations.[39] As psychologist Stanley Hall wrote in 1900,

> It is more and more evident that we have not hitherto understood the educational value of pictures. . . . The daily press, advertisements, posters, scientific knowledge . . . not to speak of the coming colored photography, all contributed what is probably slowly coming to be a new mode of pictorial thought.[40]

Time-motion study of repetitive labor, using film cameras and stopwatches, also laid the foundation for ergonomics and scientific management: measuring efficiency in such activities as bricklaying, Gilbreth found a different set of motions used for faster work than for slower work and accordingly developed the laws of a human motion economy. Another media-savvy roving consultant picked up where Gilbreth's innovative use of media technologies left off: McLuhan knew that "management training centers have long used games as a means of developing new business perception."[41] In turn, the Taylorist use of cameras became itself an object of cinematic observation in the 1950 movie *Cheaper by the Dozen,* based on the Gilbreth family; the Steve Martin remake manages to forget this industrial heritage.[42] Of course, it was Taylor's parsimonious charge that inefficient work resembled childish play, and scientific management was going to eliminate all kinds of invisible waste by establishing firm rules and metrics. Inversely, one may suggest, machinima is a form of emergent play in that it toys with the game and in that it records its own kind of time-motion study of the gamer, whether in speed runs or in quasidocumentary footage of other in-game performances, even as brought to light by the humor of Jim Munroe's walking tour of *Grand Theft Auto* in his magnificent (and deceptively simple) machinima clip "My Trip to Liberty City," where he finds parks, stairwells, and rooftop terraces in a quixotic quest to just explore the game's oft-touted open world in his innocuous "Canadian tourist" skin, against the pressures of the ostensible plot.

As popular machinima examples such as the restaging of episodes of the TV show *Friends* on a *Quake Arena* server or the in-game talk show "This Spartan Life" amply illustrate, machinimators can borrow from

the self-reflection of established formats while arousing curiosity among peers, fans, and academics.[43] Not all machinima needs to function as self-conscious commentary on the stereotypes about computer games, as it is too often said of "Red vs Blue." Most popular examples follow the narrowly circumscribed conventions of established entertainment media; that includes many documentary and archival approaches to game worlds, as well as clips mimicking TV, remaking film scenes (often using the original soundtrack), and the like. Also worth mentioning in this conjunction is the convergence of game-themed comics, or "gamics."[44] Yet here is the problem I see with a game like *The Movies*, which has been called "machinima in a box": because game play and the recording, editing, scoring, and distributing of digital clips coincide here, the results are inevitably kitschy afterimages of Hollywood fantasies and generic sets. Machinima is at its best where it is not merely *recording* a media setup but reconfiguring its parameters, for instance in juxtaposing immersion and reflection, as April Hoffmann's "The Awakening" and "The Strangerhood" by Rooster Teeth do in *The Sims*. Real-time animation such as the live puppeteering performances by the ILL Clan (e.g., "Common Sense Cooking" at the Florida Film Festival 2003, using a lightly modified *Quake*) is far from being improvisational, considering the highly constrained and circumscribed dispositive of networked gaming that is required even before any camera angles or shot sequences are hashed out. This is all the more readily recognized in approaches to machinima that interfere with the digital assets of a game, modify a game engine, or heavily edit and postprocess recorded game action.[45] Clearly, the player is both subject and object of play and may herself be played; machinima brings this to the fore, as does the work of Beijing artist Feng Mengbo, who replaced all *Quake 3* characters with his own likeness, holding a video camera instead of a weapon in machinima clips and canvas displays and in installations that invite gallery viewers to shoot at him.[46]

Thus it becomes clear that gestures are not improvisational or loosely user generated; rather, they are highly scripted. To understand the preparation necessary for machinima clips such as "Dance Voldo Dance," one might consider the dance notations that emerged around the same time as the time-motion study of manual labor; surely they do not constitute the invention of choreography, but they established a regulation of

motion that is not merely descriptive but openly prescriptive. Distilling elementary gestures and simple bodily actions from the sequences he observed, Laban sought to establish a holistic system of bodies in time and space.[47] This kind of kinetographic script (or "Labanotation") is not dissimilar from the way computer games make the hands of the gamer dance on the keyboard or game controls; like dance notation, a computer program can prescribe the gestures of its user, testing in terms of advances in gamespace whether they are precisely timed and executed in order. Interestingly, successful machinima music videos such as "Rebel vs Thug" for Chuck D or the portrait of a lonely robot in space, "In the Waiting Line," for the band Zero 7 face the constraints as artistically productive rather than seeking to overcome them in elaborate modding; a concise index of increased capability might be the elaborately choreographed "Cantina Crawl" machinima dance series that is the result of intricately staged and rehearsed multiplayer collaboration in *Star Wars Galaxies*.[48] What Agamben observed as a loss of meaning of certain gestures under the influence of mechanization also establishes new possibilities of social inscription by the technologies that make motion visible and "scriptable," with consequences for sports, theater, work, and everyday life. Just as telegraph operators had to practice until the encoding and decoding had become fully automatic, computer games train the player to acquire certain motor skills, after which, one need only continue the analogy, the transmission of communications has become possible. The mimetic dimension of playing "as if" is complicated by the dark compulsion to repeat over and over again, which tilts gaming and machinima beyond creative mimicry and into a performance that is as much a (dis) play as it is a test, a controlled exhibition that is training humans in the apperceptions and reactions required by living with technology. (Of course, Adorno scoffed that "art that seeks to redeem itself from semblance through play becomes sport."[49]) Machinima, the dance of gaming gestures, is a test both of games and of gamers, a performance in the context of art as in the context of sport. But beyond that, what machinima demonstrates is that computer games are ultimately not about adventure, strategy, speed, or violence so much as they are about usability as a precondition to communication. The necessary motor skills, hand–eye coordination, and reaction speeds equally apply to radar operation, flight

simulation, word processing, Web surfing, and playing (with) games.

This insistence on the formal, technical setup yields teaching moments in the historiography of digital culture. As McLuhan put it, game studies and information theory "have dealt with the information content of systems, and have observed the 'noise' and 'deception' factors that divert data."[50] Yet the point of looking at computing culture from the vantage point of gestures is not to introduce some kind of humanism through the back door of technological determinism. Certainly it is true that adaptation to the simplest tool already commences a tendency toward the machine. The increasing interpenetration of bodies and machines of course raises a question about the essential quality of gesture. Media artist Stelarc's "Movatar" exhibits the many ways in which the body can be constrained and programmed by the machine.[51] What is at stake in playing with game technology is much more than consumer entitlement: to believe so would be to forget media history. For too long, definitions of games and play have emphasized an exercise of freedom, following early Romanticism.[52] What makes machinima interesting, and what allowed it to grow so substantially over the past decade and a half, is much more than consumers' carefree explorative play, in ways more or less condoned by the programmers and marketers of computer and console games: arguably, machinima affords us access to pivotal themes in media history in general and game studies in particular. After a certain shelf-life, many games have been re-released with a relaxed license that encourages modification; as user-generated content is observed to enhance brands, this time-span is shrinking—another reason to debunk claims to a subversive or countermarketing ethic of machinima. Copyright law and contemporary culture converge in the conundrum of end-user license agreements for game engines, in-game assets, and computer programming as a kind of writing.[53] What is intriguing about machinima is precisely its citing, reclaiming, and incorporating gestures of disparate discourses of mediation, gestures of communication and information, of repetition and citation, of embodiment and accommodation in handling technologies that are increasingly pervasive.

Flusser's information theory of gestures holds that the less a gesture informs, the more it communicates; the more information it contains, the more difficult it is to read it as a mere gesture. Inversely, the kitschier a

gesture is, the less information it contains; empty gestures are pleasing insofar as they take no effort to decode.[54] Indeed, a theory of gesture should strip out any surmise as to a gesture's potential intentions, whether this is argued with phenomenology or with Taylorist motion studies, for to define gestures as expressions of an intention raises difficult matters of freedom and subjectivity. Avoiding the ontological trap, a better (if still rough) definition might be that gestures are bodily motions that betray no direct cause; that is, they are not reflexes or involuntary motions, they are part and parcel of our expressive, semantic culture. A formalized vocabulary of gestures was transferred from theater and puppeteering to early film, and now, in any cursory study of the computer history of gaming, one can discern not only the legacy of media discourses of communication and the rituals of art forms but also the legacy of Taylorism and of usability engineering, of army testing and flight simulation. Our ideas about acting as representation of human motion continue to change with each technological step, from sound to color to television, and from postprocessing to computer-generated imagery to the affordances of game engines. Flusser warns that conjectures about a general theory of gestures may tempt one to see it as a metatheory of communication, of art criticism, of a future theory of the absurd, and in fact as a metatheory of magic and of ritual—validity claims that are surely too broad and insufficiently deep. Nonetheless, Flusser goes on to suggest that we try to distinguish communicative gestures that are directed toward someone else; gestures of labor that are directed toward material; phatic, disinterested gestures that tend to be directed toward nothing in particular; and self-reflexive gestures that ritually refer to themselves. Game play tends to include all four types, juxtaposed and commingled to different degrees, and they are certainly inscribed in the genealogy of the technologies used in any computer and gaming setup; but it is in the last sense, in particular, that a gesture is "the exhibition of a mediality: it is the process of making a means visible as such," as Agamben writes. Precisely in this sense, machinima is a way of observing, commenting on, and archiving the mediality of our setup, citing the gestures of gaming as the gestures of computing culture.

* * *

THE NOISY CHANNELS of contemporary computer-mediated communication reverberate with contingent, accidental, and errant, yet constantly recuperated, aestheticized, and politicized data: creative expressions in text, image, sound, virtual spaces, and gestures, the unexpected remains vital for art and design as well as for social media and games, for education and finance as well as for entertainment and commerce.[55] Theoretical concepts and empirical insights from information theory still ripple across disciplines, modifying Shannon's and Wiener's seminal approaches to what a transmitted signal is and how it is encoded and decoded. Shannon's model follows a randomly generated message produced by an information source as it is encoded so that each possible message is a signal from a specific set; the received output is decoded according to decisions about the signal. Shannon sought to make the class of inputs as large as feasible while increasing the probability of correctly receiving them, which led to a search for suitable channels and for input with a low probability of error. Wiener's model assumes unencoded random input and a noisy channel and focuses on optimizing a decoder that produces an estimate of some property of the input to cope with the inevitable noise.

Invoking information theory is of course not to suggest that the humanities emulate the sciences, turn quantitative, or use computing to lend a scientific veneer to what they continue to pursue. On the contrary: the study of cultural technologies shows that it would radically impoverish our intellectual landscape to leave to the techno-sciences the salient interpretive and heuristic tasks that are the expertise of the humanities. Just as we rely on our cognitive models of people to interact with them, we rely on scaling up our models for collective social situations from basic assumptions that are tested by longitudinal data. Finance, for instance, has rational expectationalists who believe the economy naturally reverts to equilibrium, and seek "beta" in the wisdom of crowds, while reflexive behavioralists believe that the world persists in a state of fluctuating disequilibrium, and seek "alpha" opportunities in the madness of crowds. Media studies is likewise sundered between those who see crowdsourcing as the major force of transformation and progress—from the print and screen mass media of the twentieth century to the diversified mediascapes of the twenty-first century—and those who warn that

the dispersion of attention and the sheer noise of ever larger numbers of participants in media drown out what is most valuable, whether it be in news or in entertainment. This is not the place to try and arbitrate between these irreconcilable positions. The standard financial disclaimer that past performance is no guarantee of future results surely is an apt analogy for media history as well. Nonetheless, media studies can extract some benefit, though not as formulaic as an alpha or beta deviation, from not only recording history but also extrapolating trends. One major trend of the past five decades is undeniably a confluence of massive, high-speed computation with numerous variables, giving rise to pattern detection as it moves from data to image to data, and input and control devices that have greatly expanded the way we store, process, and distribute information as networked computers become the twenty-first century's epistemology engine, inheriting the role the *camera obscura* played for philosophers like Descartes or Locke.

Today, scholars approach the study of digital culture from multiple additional vantage points that are a legacy of their training, whether in law or sociology, literature or visual arts, communication studies or information science. Some prefer to approach new media from the viewpoint of older media (e.g., film studies), whereas others concentrate on digital or net art; some start as computer scientists or engineers who include humanistic inquiry or cultural issues in their work, others are grounded in theoretical modes in the humanities and approach the history of communication technology from that angle. Certainly cybernetics pioneer Heinz von Foerster was onto something when he submitted his theorem that "the hard sciences are successful because they deal with the soft problems; the soft sciences are struggling because they deal with the hard problems."[56] However, I argue that for new media studies and digital humanities to succeed—for systematic research in digital culture to establish a critical historical vocabulary—depth is needed in all available approaches. It must be at ease with ergonomics and motion studies as well as with aesthetic theory, it must cope with the legacy of cybernetics as with media archeology, and it must probe the codes and channels of current computer-mediated communication on the background of a longer conceptual history of models, simulations, and games. After all that, if

it can still seem as if the pristine ratios of information theory remain at odds with the reality of our noisy channels, then this asymmetry is owed perhaps to Lewis Mumford's axiomatic diagnosis:

> If all the mechanical inventions of the last five thousand years were suddenly wiped away, there would be a catastrophic loss of life; but man would still be human. But if one took away the function of interpretation, man would sink into a more helpless and brutish state than any animal; close to paralysis.[57]

Thus research on digital culture and aesthetic communication must not dissolve into sociological statistics or ethnographic descriptions of how fans establish a niche but ought to exercise a critical awareness that gives rise to interpretation, demonstrating in case studies, close readings, or thought experiments how meaning arises and traverses the media network. And so the digital humanities assert that "from the standpoint of art forms instantiated in informatic media (aural sounds, visual images, linguistic signs), the noise *is* the art."[58]

NOTES

INTRODUCTION

1 Katherine Hayles, "Two Voices, One Channel: Equivocation in Michael Serres," *SubStance* 17, no. 3, iss. 57 (1988): 3–12 at 3.

2 See John Guillory, "Genesis of the Media Concept," *Critical Inquiry* 36, no. 2 (Winter 2010): 321–62.

3 Alan Liu, "Imagining the New Media Encounter," in *A Companion to Digital Literary Studies*, ed. Susan Schreibman and Ray Siemens (Oxford: Blackwell, 2008), 3–25; see http://www.digitalhumanities.org/companionDLS.

4 See James Gleick, *The Information: A History, a Theory, a Flood* (New York: Pantheon, 2011).

5 Mark Poster, *The Mode of Information: Poststructuralism and Social Context* (Chicago: University of Chicago Press, 1990), 20; and Mark Poster, *Information Please: Culture and Politics in the Age of Digital Machines* (Durham, N.C.: Duke University Press, 2006). Also Max Bense, "Philosophie der Technik," *Physikalische Blätter* 10 (1954): 481–85; Peter Rechenberg, "Zum Informationsbegriff der Informationstheorie," *Informatik-Spektrum* 26, no. 5 (October 2003): 317–26; and Werner Meyer-Eppler, *Grundlagen und Anwendungen der Informationstheorie* (Berlin: Springer, 1969).

6 Warren Weaver, "Recent Contributions to the Mathematical Theory of Communication," in *The Mathematical Theory of Communication* (Urbana: University of Illinois Press, 1949), 9.

7 Bruce Clark, "Information," in *Critical Terms for Media Studies*, ed. W. J. T. Mitchell and M. B. N. Hansen, 157–71 (Chicago: University of Chicago Press, 2010), 164.

8 See W. Ross Ashby, *An Introduction to Cybernetics* (London: Chapman & Hall, 1956). Also Katherine Hayles, "Designs on the Body: Norbert Wiener, Cybernetics, and the Play of Metaphor," *History of the Human*

Sciences 3, no. 2 (1990): 211–28; and Erkki Huhtamo, "From Cybernation to Interaction: A Contribution to an Archaeology of Interactivity," in *The Digital Dialectic: New Essays on New Media*, ed. Peter Lunenfeld, 96–110, 250–52 (Cambridge, Mass.: MIT Press, 1999).

9 Jacques Lacan, "Psychanalyse et Cybernétique, ou de la Nature du Langage," in *Le Seminaire, Livre II: Le Moi dans la Théorie de Freud et dans la Technique de la Psychanalyse*, 339–54 (Paris: Seuil, 1978). It is a jarring omission to see no recognition for a couple decades of American theorists writing about Lacan's take on cybernetics in Lydia H. Liu, "The Cybernetic Unconscious: Rethinking Lacan, Poe, and French Theory," *Critical Inquiry* 36, no. 2 (Winter 2010): 288–320.

10 Jacques Derrida, *Of Grammatology* (Baltimore: Johns Hopkins University Press, 1976), 9 and 84, respectively.

11 Hermann Schmidt, *Denkschrift zur Gründung eines Instituts für Regelungstechnik* (Berlin: VDI, 1941); see Helmar Frank, *Kybernetische Analysen subjektiver Sachverhalte* (Quickborn bei Hamburg, Germany: Schnelle, 1964), 45ff.

12 François Jacob, *The Logic of Life* (New York: Pantheon, 1973), 1–2. See Eugene Thacker, *Biomedia* (Minneapolis: University of Minnesota Press, 2004).

13 Michel Foucault, "Message ou Bruit?" *Concours Médicale* 88 (October 1966): 6285–86; repr. in Michel Foucault, *Dits et Ecrits I* (Paris: Gallimard, 2001), 557–60.

14 See Martin Jay, "In the Empire of the Gaze: Foucault and the Denigration of Vision in Twentieth-Century French Thought," in *Foucault: A Critical Reader*, ed. David Hoy, 175–205 (Oxford: Basil Blackwell, 1989); and Lauri Siisiäinen, "From the Empire of the Gaze to Noisy Bodies: Foucault, Audition and Medical Power," *Theory and Event* 11, no. 1 (2008), http://muse.jhu.edu/journals/theory_and_event/v011/11.1siisiainen.html.

15 John D. Peters, "Information: Notes Toward a Critical History," *Journal of Communication Inquiry* 12, no. 2 (1988): 9–23. See Sascha Ott, *Information: Zur Genese und Anwendung eines Begriffs* (Konstanz, Germany: UVK, 2004); and Peter Janich, *Was ist Information? Kritik einer Legende* (Frankfurt: Suhrkamp, 2006).

16 Alan Turing, "Lecture to the Mathematical Society on 20 February 1947," in *The Charles Babbage Institute Reprint Series for the History of Computing, vol. 10: AM Turing's ACE Report of 1946 and Other Papers*, ed. B. E. Carpenter and R. W. Doran, 111 (Cambridge, Mass.: MIT Press, 1986).

17 Warren S. McCullough, "Summary of the Points of Agreement Reached in the Previous Nine Conferences on Cybernetics," in *Cybernetics: Circular Causal and Feedback Mechanisms in Biological and Social Systems 1946–1953*, vol. 10, ed. Heinz von Foerster (New York: Josiah Macy Jr. Foundation, 1955), 75–76 (emphasis mine).

18 See Abraham Moles, ed., *Epoche Atom und Automation: Enzyklopädie des technischen Jahrhunderts in zehn Bänden, vol. 6: Kommunikation, Information* (Geneva, Switzerland: Kister, 1959).

19 The Nyquist programming language is the creation of Roger Dannenberg, http://www.cs.cmu.edu/~music/nyquist/; compare http://audacity.sourceforge.net/help/nyquist. Swedish-American engineer Harry Nyquist is remembered for his work at Bell Labs on thermal noise, feedback amplifiers, telegraphy, fax, and TV communications.

20 See Katherine Hayles, "Chaos as Orderly Disorder: Shifting Ground in Contemporary Literature and Science," *New Literary History* 20, no. 2 (Winter 1989): 305–22.

21 Jasia Reichardt, *The Computer in Art* (London: Studio Vista, 1971), 93. On Bense, who instigated Reichardt's curatorial effort, see Angela Haardt, "Max Bense: Ästhetische Theorien oder Beobachtungen zu einer teilweisen Ablösung der Ästhetik von der Philosophie," *Zeitschrift für Ästhetik und Allgemeine Kunstwissenschaft* 15 (1970): 19–36.

22 Rudolf Arnheim, *Entropy and Art: An Essay on Disorder and Order* (Berkeley: University of California Press, 1971), 15 (and compare his note on page 20). Arnheim here refers to Norbert Wiener, *The Human Use of Human Beings* (Boston: Houghton Mifflin, 1950), 129. See Peter Lloyd Jones, "Some Thoughts on Rudolf Arnheim's Book 'Entropy and Art,'" *Leonardo* 6 (1973): 29–35.

23 Michel Serres, *Genesis* (Ann Arbor: University of Michigan Press, 1995), 7.

24 Research on the Lombard effect is carried out in linguistics as well as in the ecology of whalesong and birdsong under conditions of noise pollution.

25 Claude Shannon, "The Zero Error Capacity of a Noisy Channel," *Institute of Radio Engineers, Transactions on Information Theory* IT-2 (September 1956): 8–19. Compare Claude Shannon, Letter to Vannevar Bush, February 16, 1939, in Claude Shannon, *Collected Papers*, ed. N. J. A. Sloane and A. D. Wyner, 455 (New York: IEEE 1993).

26 Claude Shannon, "Communication Theory of Secrecy Systems," *Bell Technical Journal* 28 (October 1949): 656–715 at 685.

27 Guy Debord, *Comments on the Society of the Spectacle* (London: Verso,

1990). Compare Timothy May, "The Crypto Anarchist Manifesto," in *Crypto Anarchy, Cyberstates, and Pirate Utopias*, ed. Peter Ludlow, 65–80 (Cambridge, Mass.: MIT Press, 2001).

28 On the productive tension of philosophy and cybernetics in the "noographic" twentieth century, see Erich Hörl, "Das kybernetische Bild des Denkens," in *Die Transformation des Humanen: Beiträge zur Kulturgeschichte der Kybernetik*, ed. Michael Hagner, 163–95 (Frankfurt: Suhrkamp, 2008).

29 Vilém Flusser, *Ins Universum der technischen Bilder* (Göttingen, Germany: European Photography, 1985). See also pioneering computer artist Frieder Nake's text, "Vilém Flusser und Max Bense des Pixels angesichtig werdend: Eine Überlegung am Rande der Computergrafik," in *Fotografie Denken: Über Vilém Flussers Philosophie der Medienmoderne*, ed. Gottfried Jäger, 169–82 (Bielefeld, Germany: Kerber, 2001).

30 Vilém Flusser, "Die Krise der Linearität," in *Absolut Vilém Flusser*, ed. Nils Röller and Silvia Wagnermaier (Freiburg, Germany: Orange-Press, 2003), xx. Flusser argues that writing contains the binary that is its undoing: "While letters unravel the surface of an image into lines, numbers grind this surface into points and intervals. While literal thinking spools scenes as processes, numerical thought computes scenes into grains."

31 For an interesting contextualization of Flusser's take, see Rodrigo Duarte, "Das Lob der Oberflächlichkeit und ihre Kritik: Flussers Medientheorie und die Kulturindustrie-Theori von Horkheimer und Adorno," in *Rückblick auf die Postmoderne*, ed. Gerhard Schweppenhäuser and Jürg Gleiter, 94–113 (Weimar, Germany: Universitätsverlag, 2002).

32 Vilém Flusser, *Writing: Does Writing Have a Future?* (Minneapolis: University of Minnesota Press, 2011), 1.

33 Alan Liu, "Transcendental Data: Toward a Cultural History and Aesthetics of the New Encoded Discourse," in *Local Transcendence: Essays on Postmodern Historicism and the Database*, 209–36 (Chicago: University of Chicago Press, 2008), 210–11.

34 Liu, "Transcendental Data," referring to Friedrich Kittler, *Discourse Networks 1800/1900* (Stanford, Calif.: Stanford University Press, 1992).

35 See Friedrich Kittler, "Fiktion und Simulation," in *Aisthesis: Wahrnehmung Heute oder Pesrpektiven eine anderen Ästhetik*, ed. Karlheinz Barck, 196–213 (Leipzig, Germany: Reclam, 1990).

36 Arnheim, *Entropy and Art*, 18. A discussion of Arnheim, Bense, and other mid-twentieth-century thinkers is found in Christoph Klütsch, *Computergrafik: Ästhetische Experimente zwischen zwei Kulturen. Die Anfänge der Computerkunst in den 1960er Jahren* (Vienna, Austria: Springer, 2007).

37 Edward Shanken, "Art in the Information Age: Technology and Conceptual Art," *Leonardo* 35, no. 4 (2002): 433–38. Gianetti traces generative and participatory aesthetics back to the work of Helmar Frank and Herbert Franke, following in the footsteps of Abraham Moles and Max Bense. Claudia Gianetti, *Ästhetik des Digitalen* (Frankfurt: Springer, 2004).

38 See Götz Großklaus, *Medien-Zeit, Medien-Raum* (Frankfurt: Suhrkamp, 1995), 134.

39 Jack Bratich, "Popular Secrecy and Occultural Studies," *Cultural Studies* 21, no. 1 (January 2007): 42–58.

40 Andrew Hodges, *Alan Turing: The Enigma* (London: Vintage, 1992), 251; and Steven Johnson, *Emergence: The Connected Lives of Ants, Brains, Cities, and Software* (New York: Scribner, 2002), 45. See also Axel Roch, *Claude E. Shannon: Spielzeug, Leben, und die geheime Geschichte seiner Theorie der Information* (Berlin: Gegenstalt, 2010), 15–16 and passim.

41 Vilém Flusser, *Ins Universum der technischen Bilder* (Göttingen, Germany: European Photography, 1985); English translation published as volume 32 of the University of Minnesota Press series Electronic Mediations as Vilém Flusser, *Into the Universe of Technical Images* (2011).

1. HYPERTEXT AND ITS ANACHRONISMS

1 This chapter is an echo of, or companion piece to, Peter Krapp, *Déjà Vu: Aberrations of Cultural Memory* (Minneapolis: University of Minnesota Press, 2004). The argument here develops a line of investigation indicated but not explored in chapter 6 of my earlier book. It was produced from the same computerized card index, so one might consider it a DJ Vu remix.

2 Compare Katherine Hayles, "Translating Media: Why We Should Rethink Textuality," *Yale Journal of Criticism* 16, no. 2 (2003): 263–90.

3 Tiziana Terranova, *Network Culture: Politics for the Information Age* (London: Pluto Press, 2004), 1 and 7, respectively. See Nicholson Baker, "Discards," in *The Size of Thoughts and Other Lumber*, 125–81 (London: Picador, 1996); Richard A. Lanham, *The Electronic Word* (Chicago: University of Chicago Press, 1993); and Richard J. Finneran, ed., *The Literary Text in the Digital Age* (Ann Arbor: University of Michigan Press, 1996).

4 See Michel de Certeau, *The Practice of Everyday Life* (Berkeley: University of California Press, 2002), 24–30.

5 See Katherine Hayles, "Intermediation: Textuality and the Regime of Computation," in *My Mother Was a Computer: Digital Subjects and Literary Texts*, 15–38 (Chicago: University of Chicago Press, 2005).

6 A different concept of hypertext was proposed in Gérard Genette, *Palimpseste* (Paris: Gallimard, 1982), who opposes it to hypotext as defining transtextual relations.

7 Theodor Holm Nelson, "Opening Hypertext: A Memoir," in *Literacy Online: The Promise (and Peril) of Reading and Writing with Computers*, ed. Myron C. Tuman, 43–57 (Philadelphia: University of Pennsylvania Press, 1992). See Jacob Nielsen, *Multimedia and Hypertext* (Boston: AP Professional, 1996), 2; Norbert Bolz, "Zur Theorie der Hypermedien," in *Raum und Verfahren*, 17–27 (Basel, Switzerland: Stroemfeld/Roter Stern, 1993); and Friedrich A. Kittler, "Bewegliche Lettern: Ein Rückblick auf das Buch," *Kursbuch* 133 (1998): 195–200.

8 Not to forget a footnote on some books about the footnote, above all Anthony Grafton, *The Footnote: A Curious History* (Cambridge, Mass.: Harvard University Press, 1997), who refuses to date the origin of footnoting but wants to "connect scattered threads of research," and Chuck Zerby, *The Devil's Details: A History of Footnotes* (Montpelier, Vt.: Invisible Cities, 2002), a book that invites being read as an extended note to Grafton's ambivalent defense of pedantry.

9 Heath Bunting, *readme.html* (1998), http://www.irational.org/heath/_readme.html.

10 George P. Landow, "Changing Texts, Changing Readers: Hypertext in Literary Education, Criticism, and Scholarship," in *Reorientations: Critical Theories & Pedagogies*, ed. Bruce Henricksen and Thais E. Morgan, 133–61 (Urbana: Illinois University Press, 1990); compare Paul Edwards, "Hypertext and Hypertension: Post-Structuralist Critical Theory, Social Studies of Science, and Software," *Social Studies of Science* 24, no. 2 (May 1994): 229–78.

11 For the claim that new media art divorces the interface from database content, see Lev Manovich, *The Language of New Media* (Cambridge, Mass.: MIT Press, 2001), 226–27.

12 Aleida Assmann and Jan Assmann, "Schrift und Gedächtnis," in *Schrift und Gedächtnis* (Munich: Fink, 1983), 277 and 281.

13 Examples for this archetypal move are legion; I mention only a few: Nicholas Carr, *The Shallows: What the Internet Is Doing to Our Brains* (New York: W.W. Norton, 2010), and Andrew Keen, *The Cult of the Amateur: How Today's Internet Is Killing Our Culture* (New York: Crown Business, 2007).

14 Joseph Tabbi, "Review of Books in the Age of Their Technological Obsolescence," *American Bookreview* 17, no. 2 (December 1995–January 1996): 31.

15 Conrad Gessner, *Pandectarum sive partitionum universalium libri XXI* (Zurich, 1548); compare H. Wellisch, "How to Make an Index—16th Century Style: Conrad Gessner on Indexes and Catalogs," *International Classification* 8 (1981): 10–15. Despite Gessner's recommendations, most libraries worked with printed and bound catalogs all the way into the mid-twentieth century. See Markus Krajewski, *Paper Machines: About Cards & Catalogs, 1548–1929* (Cambridge, Mass.: MIT Press, 2011).

16 Christoph Meinel, "Enzyklopädie der Welt und Verzettelung des Wissens: Aporien der Empirie bei Joachim Jungius," in *Enzyklopädien der frühen Neuzeit: Beiträge zu ihrer Erforschung*, ed. Franz Eybl, Wolfgang Harms, Hans-Henrik Krummacher, and Werner Welzig, 162–87 (Tübingen, Germany: Niemeyer, 1995).

17 Vincent Placcius, "De scrinio litterato," in *De arte excerpendi*, 121–59 (Stockholm and Hamburg, 1689).

18 John Locke, "Méthode nouvelle de dresser des Recueils communiquée par l'Auteur," *Bibliothèque Universelle et Historique*, vol. 2, 315–40 (Amsterdam, 1668); Jean Paul, *Das Leben des Quintus Fixlein* (Stuttgart, Germany: Reclam, 1987) and Jean Paul, "Die Taschenbibliothek," in *Sämtliche Werke*, II:3 (Frankfurt: Zweitauseneins, 1996), 772; C. G. von Murr, "Von Leibnizens Excerpirschrank," *Journal zur Kunstgeschichte und Allgemeinen Litteratur* VII (1779): 211; all here are cited after Markus Krajewski, "Zitatzuträger: Aus der Geschichte der Zettel/Daten/Bank," in *Anführen—Vorführen—Aufführen: Das Zitat in Literatur und Theorie*, ed. Nils Plath and Volker Pantenburg, 177–95 (Bielefeld, Germany: Aisthesis, 2002).

19 "Only a historian of playing cards might find this relevant," cautioned Jean-Baptiste Labiche, *Notices sur les depôts littéraires et la révolution bibliographique* (Paris: Parent, 1880), 64. But see the commentary by Hans Petschar, "Einige Bemerkungen, die sorgfältige Verfertigung eines Bibliothekskatalogs für das allgemeine Lesepublikum betreffend," in *Der Zettelkatalog: Ein historisches System geistiger Ordnung*, ed. Hans Petschar, Ernst Strouhal, and Heimo Zobernig, 17 (Vienna: Springer, 1999). Compare Hellmut Lehmann-Haupt, *Gutenberg and the Master of the Playing Cards* (New Haven, Conn.: Yale University Press, 1966).

20 Johann Jacob Moser, "Einige Vortheile für Cantzley-Verwandte und Gelehrte in Absicht auf Acten-Verzeichnisse, Auszüge und Register," in *Lebensgeschichte, von ihm selbst geschrieben*, vol. 3 (Frankfurt and Leipzig, 1777); Karl Rosenkranz, *Georg Friedrich Wilhelm Hegels Leben* (Berlin, 1844), 12; and Hermann Schmitz, "Hegels Begriff der Erinnerung,"

Archiv für Begriffsgeschichte 9 (1964): 37–44; compare Friedrich Kittler, *Die Nacht der Substanz* (Bern, Switzerland: Benteli, 1989), 18.

21 Nora Barlow, ed., *The Autobiography of Charles Darwin, 1809–1882,* vol. 1 (London: Collins, 1958), 137.

22 Günter Kunert, "Zettel," *Akzente* 33, no. 5 (1986): 391–94. Also Francesco Sacchini, *Über die Lektüre, ihren Nutzen und die Vortheile sie gehörig anzuwenden* (Karlsruhe, 1832), 101–102.

23 Beatrice Webb, *My Apprenticeship* (Cambridge, Mass.: Cambridge University Press, 1926), 426–33; C. Wright Mills, *The Sociological Imagination* (London: Penguin, 1970), 217–45.

24 Raymond Carver, "On Writing," in *Fires: Essays, Poems, Stories,* 22–27 (New York: Vintage, 1968). Georges Perec, "Notes Concerning the Objects That Are on My Work-Table," in *Species of Places and Other Pieces* (New York: Penguin, 1999), 145 and 152. Perec's novel *Life: A User's Manual* (London: Harvill, 1987) features characters who share his obsession with indexing; see also David Bellos, *Georges Perec: A Life in Words* (London: Harvill, 1999), 207 and passim.

25 Didier Eribon, *Conversations with Claude Lévi-Strauss* (Chicago: University of Chicago Press, 1991), vii–viii. See Claude Lévi-Strauss, *Structural Anthropology* (New York: Basic Books 1963), 129f.

26 Daniel Ferrer, "Hypertextual Representation of Literary Working Papers," *Journal of the Association for Literary and Linguistic Computing* 10, no. 2 (1995): 143–45; Tim William Machan, "Chaucer's Poetry, Versioning, and Hypertext," *Philological Quarterly* 73, no. 3 (1994): 299–316.

27 Edward Barrett, ed., *The Society of Text* (Cambridge, Mass.: MIT Press, 1989); Charles Platt, "Why Hypertext Doesn't Really Work," *The New York Review of Science Fiction* 72 (August 1994): 1–5; Stuart Moulthrop, "You Say You Want a Revolution? Hypertext and the Laws of Media," in *Essays in Postmodern Culture,* ed. Eyal Amiran und John Unworth, 69–97 (Oxford: Oxford University Press, 1993); Robert Markley, ed., *Virtual Reality and Its Discontents* (Baltimore: The Johns Hopkins University Press, 1996).

28 Vilém Flusser, *Schrift* (Düsseldorf, Germany: Bollmann, 1995), 79.

29 Friedrich Kittler, "Geschichte der Kommunikationmedien," in *Raum und Verfahren,* 169–88 (Basel, Switzerland: Stroemfeld/Roter Stern, 1993), 183 and 186.

30 Jacques Lacan, "Psychanalyse et cybernétique, ou de la nature du langage," in *Le Seminaire, Livre II: Le moi dans la théorie de Freud et dans*

la technique de la psychanalyse, 339–54 (Paris: Seuil, 1978); see Laurence Rickels, "Cyber-Lacan," in *Nazi Psychoanalysis*, vol. 2, 60–62 (Minneapolis: University of Minnesota Press, 2003).

31 See Hans-Ulrich Obrist in conversation with Julian Assange, *e-flux journal* 25 (2011), http://www.e-flux.com/journal/view/232. On metalanguage, see Jacques Derrida, *Glas* (Paris: Galilée, 1974). The fold of so-called metalanguage is irreducible, like a pocket or cyst that incessantly forms anew; Derrida suggests that for this theoretical question, no other word is possible.

32 See Carl Bridenbaugh, "The Great Mutation," *American Historical Review* 68, no. 2 (1963), 315–31. Jacques Derrida maintained that the horizon is the "*toujours-déjà-là* of a future that keeps the indeterminacy of infinite openness intact." *Introduction à "L'Origine de la Géométrie de Husserl"* (Paris: PUF, 1962), 123.

33 E.g., Darryl Laferte, "Hypertext and Hypermedia: Toward a Rhizorhetorical Investigation of Communication," *Readerly/Writerly Texts: Essays on Literature, Literary/Textual Criticism, and Pedagogy* 3, no. 1 (Fall–Winter 1995): 51–68; Julian Stallabrass, *Internet Art: The Online Clash of Culture and Commerce* (London: Tate Publishing, 2003).

34 See Katherine Hayles, "Traumas of Code," *Critical Inquiry* 33 (Autumn 2006): 136–57.

35 Jacques Derrida, "This Is Not an Oral Footnote," in *Annotation and Its Texts*, ed. Stephen A. Barney, 199 (Oxford: Oxford University Press, 1991).

36 George P. Landow, *Hypertext: The Convergence of Contemporary Critical Theory and Technology* (Baltimore: The Johns Hopkins University Press, 1992); and George P. Landow, ed., *Hyper/Text/Theory* (Baltimore: The Johns Hopkins University Press, 1994). See my site at http://hydra.humanities.uci.edu/derrida.

37 Norbert Bolz, "Zur Theorie der Hypermedien," in *Raum und Verfahren*, 17–27 (Basel, Switzerland: Stroemfeld/Roter Stern, 1993), 17. Of course, such filiations give rise to the quip that "a scholar is only a librarian's way of creating another scholar," as Dennett wrote in allusion to Samuel Butler (who had asserted in his *Life and Habit* in 1877 that "a hen is only an egg's way of making another egg"); see Daniel Dennett, *Darwin's Dangerous Idea* (London: Penguin, 1995), 202.

38 Georg Henrik von Wright, "The Wittgenstein Papers," *The Philosophical Review* 78, no. 4 (1969), 483–563 at 487.

39 Innis Papers, Archives of the University of Toronto, Thomas Fisher Library, Box 8. The cards themselves seem to be lost, but a typescript based on them was published posthumously.

40 William Christian, *The Idea File of Harold Adams Innis* (Toronto: University of Toronto Press, 1980).

41 Vladimir Nabokov, *The Original of Laura* (London: Knopf, 2009). Nabokov wrote most of his novels, including *Lolita* and *Pale Fire*, on index cards. His novel *Ada* takes up more than 2000 cards. *The Original of Laura* consists of 139 transcribed cards. See also Richard Sieburth, "Leiris/ Nerval: A Few File Cards," *October* 112 (Spring 2005), 51–62.

42 George P. Landow, "Hypertext, Metatext, and the Electronic Canon," in *Literacy Online: The Promise (and Peril) of Reading and Writing with Computers*, ed. Myron C. Tuman, 67–94 (Pittsburgh: University of Pennsylvania Press, 1992).

43 See Katherine Hayles, "Information or Noise? Competing Economies in Barthes's S/Z and Shannon's Information Theory," in *One Culture: Essays in Literature and Science*, ed. George Levine, 119–142 (Madison: University of Wisconsin Press, 1987).

44 This was Paul de Man's attack on Barthes's literary-historical assumptions: "You distort history because you need a historical myth to justify a method which is not yet able to justify itself by its results," in *The Structuralist Controversy: The Languages of Criticism and the Sciences of Man*, ed. Richard Macksey and Eugenio Donato (Baltimore: The Johns Hopkins University Press, 1972), 150.

45 Roland Barthes, *S/Z* (Paris: Plon, 1970), 9–28, esp. iv, v, ix.

46 Theodor Adorno, "Skoteinos, oder Wie zu lesen sei," in *Drei Studien zu Hegel*, 105–73 (Frankfurt: Suhrkamp, 1969), 154.

47 Anna Everett, "Digitextuality and Click Theory: Theses on Convergence Media in the Digital Age," in *New Media: Theories and Practices of Digitextuality*, ed. Anna Everett and John T. Caldwell, 3–28 (New York: Routledge/AFI, 2003), referring to Barthes's "narrative within a narrative." See Roland Barthes, *S/Z* (New York: Hill and Wang, 1974), 90; Jon Dovey, "Notes Toward a Hypertexual Theory of Narrative," in *New Screen Media: Cinema/Art/Narrative*, ed. Martin Rieser and Andrea Zapp, 19–20 (London: BFI, 2002); and Jon Dovey, *Desktop Theatre of Amnesia* (Liverpool, England: Moviola, 1995).

48 John Mowitt, *Text: The Genealogy of an Antidisciplinary Object* (Durham, N.C.: Duke University Press, 1992), 117.

49 Mowitt, *Text*, 118. See Mowitt, "What Is a Text Today?" *PMLA* 117, no. 5 (2002): 1217–21.

50 "An almost obsessive relation to writing instruments" (interview with Jean-Louis de Rambures of *Le Monde*, September 27, 1973), in Roland Barthes, *The Grain of the Voice* (Berkeley: University of California Press, 1985), 177–82.

51 Barthes, *The Grain of the Voice*, 182. I also note that my reading of Barthes's *fichier* has been indexed, as it were, by Rowan Wilken, "The Card Index as Creativity Machine," *Culture Machine* 11 (2010): 7–30.

52 Barthes's notecard titled "fiches" reads, "D'origine érudite, la fiche devient le coin vengeur que le désir insère dans la loi compacte du travail. Principe poétique: ce carré savant ira dans le tableau de l'écriture, non dans celui du savoir."

53 "Le fichier n'est pas le livre à venir: il n'y a pas d'oeuvre manquante que quelques milliers de fiches inédites viendraient constituer. Barthes a écrit tout ce qu'il avait à écrire." Nathalie Leger, "Immensément et en detail," in *R/B* (Paris: Centre Pompidou/Seuil/IMEC, 2002), 94. However, her co-editor, Marianne Alphant, thinks the notes for his last course limn the ichnographic *moi-poisson* book he was working toward: Marianne Alphant, "Presque un roman," in *R/B*, 125–28. And the executor of Barthes's unpublished papers also believes "these courses revolve around the idea of a possible novel, a novel that death prevented him from writing." Eric Marty, "Interview with Jacques Henric," *Art Press* 285 (December 2002): 51.

54 Roland Barthes, "Comment est fait ce livre," *Art Press* 285 (December 2002): 55. Ferrer contends that at several points in his career, Barthes stopped just short of embracing genetic criticism: Daniel Ferrer, "Genetic Criticism in the Wake of Barthes," in *Writing the Image: After Roland Barthes*, ed. Jean-Michel Rabaté, 217–27 (Philadelphia: University of Pennsylvania Press, 1997).

55 Tiziana Terranova, "Communication beyond Meaning," *Social Text* 22, no. 3 (Fall 2004): 51–73 at 53. As Anne Herschberg Pierrot writes, *Roland Barthes par Roland Barthes* "manifests the pleasure of auto-commentary and of reflexivity which includes the relation of the author to his manuscript." Anne Herschberg Pierrot, "Les manuscrits de *Roland Barthes par Roland Barthes*: Style et genèse," *Genesis* 19 (2002): 195. See also Denis Hollier, "Notes (on the Index Card)," *October* 112 (Spring 2005): 35–44.

56 Another recent proponent of the convergence theory along the lines of

a generalized footnote is Joe Amato, "Endnotes for a Theory of Convergence," in Everett and Caldwell, *New Media*, 255–64. This piece is written as if it contained only endnotes but is nevertheless augmented by two supplemental "ending notes" after the main body of fake "endnotes" ends.

57 Chris Marker, *Immemory* (Paris: Centre Pompidou, 1998); Olia Lialina, *Anna Karenina Goes to Paradise*, http://www.teleportacia.org/anna/. For an overview of George Legrady's work, see *Catalogue George Legrady: From Analogue to Digital* (Ottawa, Ontario: National Gallery of Canada, 1998). See also Katherine Hayles, "Metaphoric Networks in 'Lexia to Perplexia,'" *Digital Creativity* 12, no. 3 (2001): 133–139.

58 See Cory Arcangel, *Data Diaries* (2002), http://www.turbulence.org/Works/arcangel.

59 Alexander Galloway, "Data Diaries by Cory Arcangel," http://rhizome.org/object.php?o=32948&m=1029467 and http://databaseimaginary.banff.org.

60 David Bunn, *Subliminal Messages* (Cologne, Germany: Walter König). Compare David Bunn, "A Place for Everything and Everything in Its Place," *Discourse* 20, no. 3 (Fall 1998): 175–78; and David Bunn, "Body-snatching," *Discourse* 24, no. 1 (Winter 2002): 120–48.

61 Christian Marclay, *White Noise*, Kunsthalle, Bern, Switzerland, 1998; Fawbush Gallery, New York, 1994, and DAAD Galerie, Berlin, 1994. See Russell Ferguson, *Christian Marclay* (UCLA Hammer Museum, 2003), 184–87.

62 NPR Weekend Edition, Saturday, November 1, 2003: NPR's Lynn Neary spoke to Robert Hobbs, professor of art history at Virginia Commonwealth University and curator of a show of Lombardi's work at the Drawing Center in New York City.

63 See Frances Richard, "Obsessive–Generous: Toward a Diagram of Mark Lombardi," *Williamsburg Quarterly* (February 2002), http://www.wburg.com/0202/arts/lombardi.html, partly reprinted in the catalog *Mark Lombardi: Global Networks* (New York: Independent Curators, 2003), 115–18. A photo of Lombardi's pink and green index cards appears there, p. 49.

64 Ernst von Salomon, *Der Fragebogen* (Reinbek, Germany: Rowohlt, 1951); translated, often inadequately but always valiantly, as *The Questionnaire* (Garden City, NY: Doubleday, 1955). Von Salomon takes as his poetic program the de-Nazification questionnaire handed to Germans after the end of World War II; he answers some questions at epistolary length, but

others are merely marked with cross-references to later or earlier Q&A.

65 Walter Benjamin, "Vereidigter Bücherrevisor," in *Gesammelte Schriften*, vol. IV.1 (Frankfurt: Suhrkamp, 1991), 102–4.

66 Boyd Rayward, "The Case of Paul Otlet, Pioneer of Information Science, Internationalist, Visionary," *Journal of Librarianship and Information Science* 23 (September 1991): 135–45, and Boyd Rayward, "Visions of Xanadu: Paul Otlet (1868–1944) and Hypertext," *Journal of the American Society of Information Science* 45 (1994): 235–50. See Paul Otlet, *Traité de Documentation* (Brussels: Editiones Mundaneum, 1934).

67 Walter Benjamin, "Vorstufen zum Erzähler-Essay," in *Gesammelte Schriften*, vol. II.3 (Frankfurt: Suhrkamp, 1990), 1282.

68 Alan Turing, "Computing Machinery and Intelligence," *Mind* 59, no. 236 (1950): 433–60; Jean Lassegue, "What Kind of Turing Test Did Turing Have in Mind?" *Tekhnema* 3 (1996): 37–58; Ian McEwan, "The Imitation Game," in *Three Plays for Television* (London: Picador, 1981); Alan Hodges, *The Enigma of Intelligence* (London: Allen Unwin, 1983); and Marvin Minsky, *The Turing Option* (New York: Warner Books, 1992).

69 Friedrich Kittler, "Die künstliche Intelligenz des Weltkriegs: Alan Turing." In *Arsenale der Seele*, ed. F. Kittler and Georg Christoph Tholen (Munich: Fink, 1989), 198.

70 Robert Pinsky, "The Muse in the Machine, or: The Poetics of Zork," *New York Times Book Review*, March 19, 1995.

71 Charles Hartman's program "Prose," somewhat unstable in DOS but satisfying in its Apple OS version, is found at http://www.conncoll.edu/ccother/cohar/programs/.

72 Hugh Kenner and Joseph O'Rourke, "A Travesty Generator for Micros," *Byte* 9, no. 12 (November 1984): 129–31, 449–69. Their fundamental insight is that material is limited; the challenges are posed by technical and economical iteration of connection.

73 Alvin Kiernan, *The Death of Literature* (New Haven, Conn.: Yale University Press, 1990); see the critique of Sven Birkerts's *Gutenberg Elegies* in Friedrich Kittler, "Computeranalphabetismus," in *Literatur im Informationszeitalter*, ed. Dirk Matejowski and F. Kittler, 237–51 (Frankfurt: Springer, 1997).

74 See Jochen Meißner, "Von der Schrift zum Hypertext: Typographie in der *Schule der Atheisten*," in *"Alles = Gewendet!" Zu Arno Schmidts "Die Schule der Atheisten,"* ed. Horst Denkler and Carsten Würmann, 219–52 (Bielefeld, Germany: Aisthesis, 2000).

75 F. Peter Ott, "Tradition and Innovation: An Introduction to the Prose

Theory and Practice of Arno Schmidt," *German Quarterly* 51, no. 1 (1978): 26.

76 See the contributions to the special issue of *Text & Kritik* 20 (1971), as well as Siegbert Prawer, "Bless Thee Bottom! Thou Art Translated," in *Essays in German and Dutch Literature,* ed. W. D. Scott-Robson, 156–91 (London: Institute of Germanic Studies 1973); and Heinrich Vormweg, "Traum eines Babylonikers," *Merkur* 25 (1971): 354–61.

77 For the popular comparison of hypertext and Joyce, see Landow, *Hypertext,* 10: "implicit hypertext in nonelectronic form. Again, take Joyce's *Ulysses* as an example." Others draw Schmidt and Derrida's *Glas* into the mix. H. C. Lucas, "Zwischen Antigone und Christiane: Die Rolle der Schwester in Hegels Biographie und Philosophie und in Derridas *Glas,*" *Hegel-Jahrbuch 1984–1985* (1988): 409–42 at 433: "ein Leseerlebnis, das wohl nur dem von Arno Schmidts *Zettels Traum* oder von James Joyces *Finnegans Wake* vergleichbar ist." More recently, Volker Langbehn considers *Zettels Traum* an "anti-classical work" like Joyce's *Finnegans Wake* and Derrida's *Glas.* See Volker Langbehn, *Arno Schmidt's Zettels Traum: An Analysis* (Rochester, N.Y.: Camden House, 2003), 6; compare Söke Dinkla, "The Art of Narrative: Towards the Floating Work of Art," in Rieser and Zapp, *New Screen Media,* 31–32.

78 Arno Schmidt, "Der Platz, an dem ich schreibe," *Essays und Aufsätze,* vol. 2, 28–31 (Zurich: Haffmanns Verlag, 1995). For the history of library technology, see Krajewski, *Paper Machines.*

79 Vladimir Nabokov, *Pale Fire* (New York: Putnam, 1962).

80 For further information, see Brian Boyd, *Nabokov's Pale Fire: The Magic of Artistic Discovery* (Princeton, N.J.: Princeton University Press, 1999); and Markus Krajewski, "Ver(b)rannt im Fahlen Feuer: Ein Karteikarten-kommentar," *Kunstforum International* 155 (June–July 2001): 288–92. As Krajewski notes, there is at least one book structured as a card game: Marc Saporta, *Composition numéro 1: Roman* (Paris: Seuil, 1962); see also Reinhold Grimm, "Marc Saporta oder der Roman als Kartenspiel," *Sprache im Technischen Zeitalter* 14 (1965): 1172–84.

81 Vladimir Stibic, *Tools of the Mind* (Amsterdam: Elsevier, 1982), 77; Stibic also mentions Jack London's index cards.

82 Louis Zukovsky, *A* (Berkeley, Calif.: City Lights, 1978), 525. For an introduction, see Don Byrd, "Getting Ready to Read 'A,'" *Boundary 2* 10, no. 2 (Winter 1982): 291–308.

83 Louis Zukovsky, *Bottom: On Shakespeare* (Austin: University of Texas

Press, 1963); Hugh Kenner, "Bottom on Zukovsky," *Modern Language Notes* 90, no. 6 (1975): 921–22.

84 Although very little of Bense's massive output has been translated, his influence on cyberpoetry and Net literature is unmistakable. For his text aesthetics, see Joachim Jacob, *Schönheit der Literatur: Zur Geschichte eines Problems von Gorgias bis Max Bense* (Tübingen, Germany: Niemeyer, 2007).

85 Niklas Luhmann, "Kommunikation mit Zettelkästen: Ein Erfahrungsbericht," in *Universität als Milieu*, ed. André Kieserling, 53–61 (Bielefeld, Germany: Haux, 1993). Various interesting attempts to render such private filing systems operable as software include *Evernote* (http:// evernote.com) and *Zettelkasten* (http://www.verzetteln.de/synapsen).

86 Niklas Luhmann, *Archimedes und wir: Interviews*, 142–49 (Berlin: Merve, 1987). Compare William Rasch, "Theory of a Different Order: A Conversation with Katherine Hayles and Niklas Luhmann," *Cultural Critique* 31, no. 2 (Autumn 1995): 7–36.

87 Detlev Krause, *Luhmann-Lexikon* (Stuttgart, Germany: UTB, 2001); Claudio Baraldi, Giancarlo Corsi, and Elena Esposito, *GLU: Glossar zu Niklas Luhmanns Theorie sozialer Systeme* (Frankfurt: Suhrkamp, 1997); and Theodor M. Bardmann and Alexander Lambrecht, *Systemtheorie verstehen: Eine multimediale Einführung in systemisches Denken* (Wiesbaden, Germany: Westdeutscher Verlag, 1999).

88 Joachim Maier and René Bauer, http://www.nic-las.com; on collaborative authorship, see also Martha Woodmansee, "On the Author Effect: Recovering Collectivity," *Cardozo Art and Entertainment Law Journal* 2 (1992): 279–92.

89 For a survey of archival processes in new media culture, see Hedwig Pompe and Leander Scholz, eds., *Archivprozesse: Die Kommunikation der Aufbewahrung* (Cologne, Germany: DuMont, 2002). Further ruminations are Dewey-decimated in Andreas Metzing, ed., *Digitale Archive: Ein neues Paradigma?* (Marburg, Germany: Archivschule, 2000).

90 *From Memex to Hypertext: Vannevar Bush and the Mind's Machine*, ed. James M. Nyce and Paul Kahn (Boston: Academic Press, 1991). See Hilmar Schmundt, "*Autor ex machina*: Electronic Hyperfictions; Utopian Poststructuralism and the Romanticism of the Computer Age," *Arbeiten aus Anglistik und Amerikanistik* 19, no. 2 (1994): 223–46.

91 Theodor Nelson, *Computer Lib/Dream Machines* (Redmond, Wash.: Tempus Books/Microsoft Press, 1987), CL 1–4, CL 4–9.

92 Jacques Derrida, *Glas* (Paris: Seuil, 1974).

93 Theodor Nelson, "The Transclusion Paradigm," in *Project Xanadu,* d8 (Sapporo, Japan: Sapporo Hyperlab, 1995).

94 Jacques Derrida, *Limited Inc* (Evanston, Ill.: Northwestern University Press 1988), 21.

95 J. Hillis Miller, "Literary Theory, Telecommunications, and the Making of History," in *Scholarship and Technology in the Humanities,* ed. May Katzen, 11–20 (New York: Bowker-Saur, 1991); Landow, *Hypertext,* 2.

96 Mark Taylor and Esa Saarinen, *Imagologies* (New York: Routledge, 1994), 9; Geoffrey Bennington, "Derridabase," in *Jacques Derrida* (Paris: Seuil, 1991), 291.

97 Gregory Ulmer, *Applied Grammatology* (Baltimore: The Johns Hopkins University Press, 1985), 303; Mark Poster, *The Mode of Information* (Berkeley: University of California Press, 1990), 128.

98 Theodor Nelson, "A File Structure for the Complex, the Changing and the Indeterminate," in *Proceedings of the ACM 20th National Conference,* ed. Lewis Winner (New York: ACM, 1965); and Nelson, "What Is Literature?" in *Literary Machines: The Report on, and of, Project Xanadu* (Swarthmore, Pa.: Nelson, 1981).

99 Theodor Nelson, "Hypertext Is Ready: HTML for Home and Office," *New Media* 5, no. 8 (August 1995): 17. A working model of Nelson's Xanadu is found at http://www.udanax.com.

100 See Peter Krapp, "Derrida Online," *Oxford Literary Review* 18 (1996): 159–73. Compare Arlette Farge, *Le goût de l'archive* (Paris: Seuil, 1989); Sonia Combe, *Archives interdites: L'histoire confisquée* (Paris: Albin Michel, 1994); and Jean Favier, *Les archives* (Paris: PUF, 1958).

101 Jean-François Lyotard, "Dialectique, index, forme," in *Discours, figure,* 27–52 (Paris: Klincksieck, 1971), 41; Geoffrey Bennington, *Legislations* (London: Verso, 1994), 274–94.

102 http://www.thefileroom.org; Susan Snodgrass, "Antonio Muntadas: The File Room," *New Art Examiner* 22 (October 1994): 48–49; and Judith Russi Kirshner, "The File Room," *Ars Electronica* 1995, http://www.aec.at/festival1995/catalog/muntadas.html.

103 Robert Atkins, "The Art World and I Go On Line," *Art in America* 83, no. 12 (December 1995): 60; and Miriam Rosen, "Web-Specific Works: The Internet as a Space for Public Art," *Art & Design* 11 (January–February 1996): 86–96.

104 Archives have become a hot topic in the art world. Compare Alex Andriaansens, ed., *Making Art of Databases* (Rotterdam, The Netherlands:

V2 Publishing, 2003); Charles Merewether, ed., *The Archive: Documents of Contemporary Art* (London: Whitechapel, 2006); Okwui Enwezor, ed., *Archive Fever: Uses of the Document in Contemporary Art* (New York: International Center of Photography, 2008); and Sven Spieker, *The Big Archive: Art from Bureaucracy* (Cambridge, Mass.: MIT Press, 2008).

105 Art & Language, *Index 01* (1972), Installation at P.S.1, New York, 1999 (Collection Daros, Switzerland); *Index 02* (1972), Installation Lisson Gallery, London, 1978 (Collection Herbert); *Index 05: Instructions for Reading the Index* (1973, Collection Carine & Philippe Meaille, France). See the PS1 retrospective *The Artist Out of Work: Art & Language, 1972–1981,* http://www.lissongallery.com/theArtists/Art&Language/artlanguage.html.

106 The most recent version of Webstalker can be found at http://bak.spc.org/iod.

107 Software engineering is "information hiding," modules hiding functions: Jörg Pflüger, "Distributed Intelligence Agencies," in *Hyperkult: Geschichte, Theorie und Kontext digitaler Medien,* ed. M. Warnke, W. Coy, and G. C. Tholen, 433–60 (Frankfurt: Stroemfeld/Nexus, 1997). Compare Laura U. Marks, "Invisible Media," in Everett and Caldwell, *New Media,* 40.

108 Katherine Hayles, "Deeper into the Machine: Learning to Speak Digital," *Computers and Composition* 19 (2002): 371–86; Fredric Jameson, *The Political Unconscious* (Ithaca, N.Y.: Cornell University Press, 1980), 60–61.

109 Lev Manovich, "Old Media as New Media: Cinema," in *The New Media Book,* ed. Dan Harries, 209–18 (London: BFI, 2002), 217.

110 See Steven Johnson, *Interface Culture* (New York: Basic Books, 1997).

111 See Katherine Hayles, "Computing the Human," *Theory, Culture & Society* 22, no. 1 (2005): 131–51.

112 "Apparition de la fiche at constitution des sciences humaines: encore une invention que les historiens célèbrent peu." Michel Foucault, *Surveillir et punir: Naissance de la prison* (Paris: Gallimard, 1975), 287, referring to A. Bonneville, *De la recidive* (Paris, 1844), 92–93.

2. TERROR AND PLAY

1 See Michael Mann, *The Sources of Social Power,* vol. 1, *A History of Power from the Beginning to AD 1760* (Cambridge, England: Cambridge University Press, 1986); Manuel Castells, *The Rise of Network Society* (Oxford, England: Oxford University Press, 1996); and Bruno Latour, *Pandora's Hope: Essays on the Reality of Science Studies* (Cambridge, Mass.: Harvard University Press, 1999), 204f.

2 David Gunkel, "Introduction to Hacking and Hacktivism," *New Media*

and Society 7, no. 5 (2005): 595–97; Jeffrey Juris, "New Digital Media and Activist Networking within Anti-Corporate Globalization Movements," *Annals of the American Academy of Political and Social Science* 597 (January 2005): 189–208.

3 Rita Raley, *Tactical Media* (Minneapolis: University of Minnesota Press, 2009), 6.

4 See Katherine Hayles, "The Complexities of Seriation," *PMLA* 117, no. 1 (January 2002: Mobile Citizens, Media States): 117–21.

5 Claude Shannon, "Communication Theory of Secrecy Systems," *Bell Technical Journal* 28 (October 1949): 656.

6 Jared Sandberg with Thomas Hayden, "Holes in the Net: What to Worry about Next," *Newsweek* 135, no. 8 (February 21, 2000): 47–49.

7 John Perry Barlow, "Crime & Puzzlement" (1990), http://www.eff.org/Publications/JohnPerryBarlow, here cited after Wendy Grossman, *net.wars* (New York: New York University Press, 1997), 129.

8 See Sandor Vegh, "Classifying Forms of Online Activism," in *Cyberactivism,* ed. M. McCaughey and M. Ayers, 71–95 (New York: Routledge, 2003); and David J. Gunkel, *Hacking Cyberspace* (Boulder, Colo.: Westview, 2001).

9 Paul Taylor, "From Hackers to Hacktivists: Speed Bumps on the Global Superhighway?" *New Media & Society* 7, no. 5 (2005): 625–46.

10 Laurence Lessig, *Code, and Other Laws of Cyberspace* (New York: Basic Books, 1999), 40.

11 Dorothy E. Denning, "Activism, Hacktivism, and Cyberterrorism: The Internet as a Tool for Influencing Foreign Policy," in *Networks and Netwars: The Future of Terror, Crime, and Militancy,* ed. John Aquilla and David Ronfeldt, 239–88 (Santa Monica, Calif.: RAND National Defense Research Institute, 2003), 248, 265.

12 For Radical Software Group's "Carnivore," see http://rhizome.org/carnivore.

13 Ricardo Dominguez, ed., "Activism/Activismo/Ativismo," *e-misférica* 1, no. 1 (Fall 2004), http://hemi.nyu.edu/journal/1_1/activism.html; Stefan Wray, "Electronic Civil Disobedience and the World Wide Web of Hacktivism: A Mapping of Extraparliamentarian Direct Action Net Politics," http://www.nyu.edu/projects/wray/wwwhack.html; and Stefan Wray, "Aspects of Hacker Culture," http://www.du.edu/~mbrittai/4200/socio_criminal.htm.

14 With this "Virtual Sit-In on University of California Office of the Presi-

dent" on March 4, 2010, Dominguez incurred the predictable wrath of University of California, San Diego administrators and enjoyed some ambivalent limelight. See http://ucaft.org/content/ucsd-coalition-letter-vc-paul-drake-re-ricardo-dominguez, http://www.hastac.org/blogs/margaret-rhee/support-ricardo-dominguez-and-calit2-banglab, and http://www.walkingtools.net/.

15 See Tim Jordan and Paul Taylor, *Hacktivism and Cyberwars: Rebels with a Cause?* (New York: Routledge, 2004).

16 Roger C. Molander, Andrew S. Riddile, and Peter E. Wilson, *Strategic Information Warfare: A New Face of War,* Memorandum MR-661-OSD (Santa Monica, Calif.: RAND Corp., 1996).

17 Vernon Loeb, "NSA Admits to Spying on Princess Diana," *Washington Post* (December 12, 1998): A13: "The National Security Agency has disclosed that U.S. intelligence is holding 1,056 pages of classified information about the late Princess Diana." Compare Dana Priest and William M. Arkin, "A Hidden World, Growing Beyond Control," *The Washington Post* (July 19, 2010).

18 The University of Toronto established the Citizen Lab in 2001 out of the conviction that citizens should not be compelled to accept technology at face value.

19 See *Spiegel Online,* April 7, 2001, http://www.spiegel.de, and Mathias Dornseif, "Government Mandated Blocking of Foreign Web Content," in *Security, E-Learning, E-Services: Proceedings of the 17. DFN-Arbeitstagung über Kommunikationsnetze,* ed. Jan von Knop, Wilhelm Haverkamp, and Eike Jessen, 617–48 (Düsseldorf, Germany: DFN, 2003).

20 http://wikileaks.org/file/us-cia-redcell-exporter-of-terrorism-2010. pdf; Catherine Theohary and John Rollins, "Terrorist Use of the Internet: Information Operations in Cyberspace," *Congressional Research Service* 7-5700 R41674, March 8, 2011. Compare the Cyber Security Research and Development Act (November 27, 2002), http://www. house.gov/science/cyber/hr3394.pdf. See also Declan McCullagh, "Cyberterror and Professional Paranoiacs," CNETnews.com, March 21, 2003, http://news.com.com/Cyberterror+and+professional+para noiacs/2010-1071_3-993594.html.

21 Dorothy E. Denning, "Concerning Hackers Who Break into Computer Systems" (presented at the 13th National Computer Security Conference, Washington, DC, October 1–4, 1990), http://www.cs.georgetown. edu/~denning/hackers/Hackers-NCSC.txt. Also Dorothy E. Denning,

"Postscript to 'Concerning Hackers Who Break into Computer Systems,'" June 11, 1995, http://www.cs.georgetown.edu/~denning/hackers/Hackers-Postscript.txt.

22 Dorothy E. Denning, "Hacktivism: An Emerging Threat to Diplomacy," *Foreign Service Journal*, September 2000, http://www.afsa.org/fsj/sept00/Denning.cfm. Compare Evegeny Morozov, "Battling the Cyber Warmongers," *The Wall Street Journal* (May 8, 2010), http://online.wsj.com/page/2_0333-20100508.html.

23 Bertolt Brecht, "Der Rundfunk als Kommunikationsapparat," in *Gesammelte Schriften*, vol. 18, 117–34 (Frankfurt: Suhrkamp, 1967). Compare Sandor Vegh, "Hacktivists or Cyberterrorists? The Changing Media Discourse on Hacking," *First Monday* 7, no. 10 (October 2002), http://www.firstmonday.org/issues/issue7_10/vegh.

24 Matthew Fuller, *Behind the Blip: Essays on the Culture of Software* (New York: Autonomedia, 2003), 127; "Attacks by 'Anonymous' WikiLeaks Proponents Not Anonymous," CTIT Technical Report 10.41 (December 10, 2010), http://www.utwente.nl/ewi/dacs; Alexander Galloway, *Protocol: How Control Exists after Decentralization* (Cambridge, Mass.: MIT Press, 2004), 53–54.

25 Canonical analyses include Richard Hofstadter, *The Paranoid Style in American Politics* (New York: Knopf, 1965); Richard O. Curry, ed., *Conspiracy: The Fear of Subversion in American History* (New York: Holt, Rinehart and Winston, 1972); George Johnson, *Architects of Fear* (Los Angeles: Tarcher, 1983); Daniel Pipes, *Conspiracy: How the Paranoid Style Flourishes and Where It Comes From* (New York: The Free Press, 1997); Mark Fenster, *Conspiracy Theories: Secrecy and Power in American Culture* (Minneapolis: University of Minnesota Press, 1999); Timothy Melley, *Empire of Conspiracy: The Culture of Paranoia in Post-War America* (Ithaca, N.Y.: Cornell University Press, 2000); and Ray Pratt, *Projecting Paranoia: Conspiratorial Visions in American Film* (Lawrence: University Press of Kansas, 2001).

26 Esther Dyson, "The End of the Official Story," *Brill's Content Online*, July/August 1998, 50–51.

27 Richard Grenier, "On the Trail of America's Paranoid Class," *The National Interest*, Spring 1992, 84.

28 Hofstadter, *Paranoid Style*, 4.

29 Jodi Dean, "Webs of Conspiracy," in *The World Wide Web and Contemporary Cultural Theory*, ed. Andrew Herman and Thomas Swiss (London: Routledge, 2000), 63.

30 Dyson, "End of the Official Story," 50.

31 Julian Assange, "State and Terrorist Conspiracies" (November 10, 2006), http://iq.org/conspiracies.pdf; see Dean, "Webs of Conspiracy," 71–72. Compare Jürgen Habermas, *The Structural Transformation of the Public Sphere: An Inquiry into a Category of Bourgeois Society* (Cambridge, Mass.: MIT Press, 1998), 35.

32 Steven Aftergood, "National Security Secrecy: How the Limits Change," *Social Research* 77, no. 3 (Fall 2010): 839–52. See Amy Harmon, "NASA Flew to Mars for Rocks? Sure," *New York Times*, July 20, 1997, 4E.

33 Catherine Liu, "Conspiracy (Theories)," *South Atlantic Quarterly* 97, no. 2 (Spring 1998): 80–99. Compare John Ralston Saul, *Voltaire's Bastards: The Dictatorship of Reason in the West* (London: Vintage 1993), chapter 12, "The Art of the Secret."

34 Serge Moscovici, "The Conspiracy Mentality," in *Changing Conceptions of Conspiracy*, ed. Carl F. Gramm and Serge Moscovici (New York: Springer, 1987), 153. See also Ralf Klausnitzer, "Verfolgte Verfolger: Konditionen des modernen Konspirationismus," *Transkriptionen* 9 (March 2008): 6–10.

35 Fredric Jameson, *Postmodernism, or The Cultural Logic of Late Capitalism* (London: Verso, 1991), 38.

36 Fenster, *Conspiracy Theories*, 12–13.

37 See Friedrich Kittler, "Cold War Networks or Kaiserstr. 2, Neubabelsberg," in *Old Media, New Media: A Theory and History Reader*, ed. Wendy Chun and Thomas Keenan, 181–86 (New York: Routledge, 2006). Compare H. P. Willmott, *The Great Crusade: A New Complete History of the Second World War* (New York: Free Press, 1990), 144.

38 Joseph Weizenbaum, "ELIZA: A Computer Program for the Study of Natural Language Communication between Man and Machine," *Communications of the ACM* 6, no. 3 (March 1966): 36–45.

39 Kenneth Mark Colby, "Artificial Paranoia," *Artificial Intelligence* 2 (1971): 1–25. See also the symposium on "Modeling a Paranoid Mind," *Behavioral and Brain Sciences* 4 (1981): 515–60.

40 Vint Cerf, "Parry Encounters the Doctor," *Datamation*, July 1973, 62–64.

41 Joseph Weizenbaum, *Computer Power and Human Reason: From Judgment to Calculation* (London: Pelican, 1984), 203.

42 Fuller, *Behind the Blip*, 93.

43 Weizenbaum, *Computer Power*, 191.

44 For a philosophical iteration, see Boris Groys, *Unter Verdacht: Eine Phänomenologie der Medien* (Munich: Carl Hanser Verlag, 2000).

45 See Karl Popper, *Conjectures and Refutations: The Growth of Scientific*

Knowledge (London: Routledge, 1963), 341–42.

46 Walter Benjamin, "The Work of Art in the Age of Mechanical Reproduction," in *Illuminations*, 217–251 (New York: Schocken, 1969), 240.

47 Andy Wachowski and Larry Wachowski, *The Matrix* (1999) and *The Matrix Reloaded* (2003).

48 Compare Manfred Osten, *Das geraubte Gedächtnis: Digitale Systeme und die Zerstörung der Erinnerungskultur* (Leipzig, Germany: Insel, 2004), and Cornelia Vismann, *Akten: Medientechnik und Recht* (Frankfurt: Fischer, 2000), partially translated as *Files: Law and Technology* (Stanford, Calif.: Stanford University Press, 2008). See also Viktor Meyer-Schönberger, *Delete: The Virtue of Forgetting in the Digital Age* (Princeton, N.J.: Princeton University Press, 2009).

49 Claude Shannon, "Communication Theory of Secrecy Systems," *Bell Technical Journal* 28 (October 1949): 656–715.

50 Katie Hafner and Matthew Lyon, *Where Wizards Stay Up Late: The Origins of the Internet* (New York: Touchstone, 1998).

51 Paul Baran, "On Distributed Communications: IX Security, Secrecy, and Tamper-Free Considerations," Memorandum RM-3765-PR (Santa Monica, Calif.: RAND, 1964), http://www.rand.org/publications/RM/RM3765/RM3765.chapter5.html.

52 Although arguably most relevant in media studies, this has been noticed also in cultural studies; see Clare Birchall, "The Secret," *Cultural Studies* 21, no. 1 (January 2007): 1–4. Compare Jodi Dean, *Publicity's Secret: How Technoculture Capitalizes on Democracy* (Ithaca, N.Y.: Cornell University Press, 2002).

53 Compare Brian Carpenter, ed., "Request for Comments: 1958, Architectural Principles of the Internet," Network Working Group (1996), http://www.ietf.org/rfc/rfc1958.txt; and Lessig, *Code*, 36–40.

54 Louis Marin, *Lectures traversières* (Paris: Albin Michel, 1992), 195.

55 C. P. Snow, *Science and Government* (Cambridge, Mass.: Harvard University Press, 1961), 73. Compare Sissela Bok, *Secrets: On the Ethics of Concealment and Revelation* (New York: Pantheon, 1982), 283.

56 Douglas Thomas, *Hacker Culture* (Minneapolis: University of Minnesota Press, 2002).

57 Laurence Rickels, "Cryptology," in *Hi-Fives: A Trip to Semiotics*, ed. Roberta Kevelson, 191–204 (New York: Peter Lang, 1998), 191.

58 For a reading of Freud and new media, see Marshall McLuhan, *Understanding Media: The Extensions of Man* (New York: Signet, 1966), 36f.

59 Slavoj Žižek, "Is It Possible to Traverse the Fantasy in Cyberspace?"

in *The Žižek Reader*, ed. Elizabeth Wright, 102–24 (Oxford, England: Blackwell, 2002), 121.

60 Claude Lévi-Strauss, *Structural Anthropology* (New York: Basic Books, 1963), 229. See James W. Carey and John Quirk, "The Mythos of the Electronic Revolution," *The American Scholar* 39, no. 2 (1970): 219–41; 39, no. 3 (1970): 395–424.

61 See Carpenter, "Request for Comments," and Larry Lessig, *The Future of Ideas* (New York: Vintage, 2002), 36–40.

62 Vannevar Bush, "As We May Think," *Atlantic Monthly* 176, no. 1 (July 1945): 101–8 at 103.

63 Markus Krajewski, *Paper Machines: About Cards & Catalogs, 1548–1929* (Cambridge, Mass.: MIT Press, 2010). The Dewey Decimal System's owner is now the Online Computer Library Center; see http://www.oclc.org/dewey/.

64 Associated Press, October 24, 2003.

65 Jack Goody and Ian Watt, "The Consequences of Literacy," in *Literacy in Traditional Societies*, ed. Jack Goody, 27–69 (Cambridge, England: Cambridge University Press, 1968).

66 Eric A. Havelock, "The Orality of Socrates and the Literacy of Plato," *New Essays on Socrates*, ed. E. Kelly, 67–93 (Washington, D.C.: University Press of America, 1984).

67 Walter J. Ong, *Orality and Literacy* (London: Methuen, 1982).

68 A map of Italian hacktivism (a parody of JoDi's map.jodi.org) by Tatiana Bazzichelli for the Read_me Software Art Festival can be found at http://www.ecn.org/aha/map.htm.

69 B. Gellman, "Cyber-Attacks by Al Qaeda Feared," *Washington Post*, June 27, 2002, A01.

70 G. J. Walters, *Human Rights in an Information Age* (Toronto: University of Toronto Press, 2001), 191.

71 Eric A. Havelock, *Preface to Plato* (Cambridge, Mass.: Harvard University Press, 1963), 140.

72 Walter J. Ong, *Rhetoric, Romance and Technology* (Ithaca, N.Y.: Cornell University Press, 1971), 2.

3. NOISE FLOOR

1 Kim Cascone, "The Aesthetics of Failure: 'Post-Digital' Tendencies in Contemporary Computer Music," in *Audio Culture*, ed. Christoph Cox and Daniel Warner, 392–98 (London: Continuum, 2004), 393. Compare Chris Salter, *Entangled: Technology and the Transformation of Performance*

(Cambridge, Mass.: MIT Press, 2010), 178: "Another movement within the audiovisual coding scene amplified its processual characteristics through the revealing and subsequent use of errors and glitches."

2 Salomé Voegelin, *Listening to Noise and Silence: Towards a Philosophy of Sound Art* (New York: Continuum, 2010), 43.

3 Abraham Moles, *Information Theory and Esthetic Perception* (Urbana: University of Illinois Press, 1966), 78.

4 See Christoph Cox, "Sound Art and the Sonic Unconscious," *Organised Sound* 14, no. 1 (2009): 19–26; and Paul Hegarty, "Just What Is It That Makes Today's Noise Music So Different, So Appealing?" *Organised Sound* 13, no. 1 (2008): 13–20.

5 An overview of Carsten Nicolai's work can be found in Dorothea Strauss, ed., *Carsten Nicolai: Static Fades* (Zurich: Haus Konstruktiv, 2007).

6 Adam Collis, "Sounds of the System: The Emancipation of Noise in the Music of Carsten Nicolai," *Organised Sound* 13, no. 1 (2008): 31–39. Compare Hans-Ulrich Obrist and Carsten Nicolai, "Laboratorium Is the Answer. What Is the Question? A Conversation," in *Autopilot*, 59–85 (Berlin: Die Gestalten Verlag, 2002).

7 Interview with Stefan Betke, *Fact Magazine*, January 2009, http://www.factmag.com/2009/01/01/interview-pole/.

8 Rick Altman, "The Material Heterogeneity of Recorded Sound," in *Sound Theory—Sound Practice*, ed. R. Altman, 15–31 (London: Routledge, 1992), 26.

9 Mark Poster, *The Mode of Information* (Chicago: University of Chicago Press, 1990), 10.

10 Greg Hainge, "Of Glitch and Men: The Place of the Human in the Successful Integration of Failure and Noise in the Digital Realm," *Communication Theory* 17 (2007): 26–42 at 28. Also Greg Hainge, "Come On Feel the Noise: Technology and Its Dysfunctions in the Music of Sensation," *To the Quick* 5 (2002), http://to-the-quick.binghampton.edu/pdf/tothequick5.pdf.

11 Compare Phil Thomson, "Atoms and Errors: Towards a History and Aesthetics of Microsound," *Organized Sound* 9, no. 2 (2004): 207–10; and Eliot Bates, "Glitches, Bugs, and Hisses: The Degeneration of Musical Recordings and the Contemporary Music Work," in *Bad Music: The Music We Love to Hate*, ed. C. J. Washburne and M. Derno, 275–93 (London: Routledge, 2004).

12 Paul Hegarty, *Noise/Music: A History* (New York: Continuum, 2007), ix.

Compare Joel Chadabe, *Electric Sound: The Past and Promise of Electronic Music* (New York: Prentice Hall, 1997).

13 Douglas Kahn, "Track Organology," in *Critical Issues in Electronic Media*, ed. Simon Penny, 205–17 (Albany, N.Y.: SUNY Press, 1995).

14 Recent sound art events that emphasized new media and software culture include *Sonic Boom* (London: Hayward Gallery, 2000), *Sonic Acts* (Amsterdam and Den Haag, 2001), *Bitstreams* (New York: Whitney Museum, 2001), *Sonic Process* (Barcelona, 2002), and *Sons et Lumières* (Paris: Centre Pompidou, 2005). See also Alan Licht, *Sound Art: Beyond Music, Between Categories* (New York: Rizzoli, 2007), and Brandon LaBelle's *Background Noise: Perspectives on Sound Art* (London: Continuum, 2006).

15 Douglas Kahn, "Histories of Sound Once Removed," in *Wireless Imagination: Sound, Radio, and the Avant-Garde*, 10 (Cambridge, Mass.: MIT Press, 1994).

16 Marina Rosenfeld and John Cage, "Glitch," in *Arcana II: Musicians on Musicians*, ed. John Zorn, 219–23 (New York: Hips Road, 2007), 221. Compare Branden Joseph, *Beyond the Dream Syndicate: Tony Conrad and the Arts after Cage* (New York: Zone Books, 2008).

17 Peter Shapiro, "Deck Wreckers: The Turntable as Instrument," in *Undercurrents: The Hidden Wiring of Modern Music*, 163–76 (London: Continuum, 2002), 170. Compare the CD by Christian Marclay, *Records 1981–1989* (Suisa, 1997), and Thomas Y. Levin, "Indexically Concrète: The Aesthetic Politics of Christian Marclay's Gramophonia," *Parkett* 56 (1999): 162–77.

18 http://www.telesymbiosis.com/movies/glitchyandscratchy_hi.mov.

19 See Joanna Demers, *Listening through the Noise: The Aesthetics of Experimental Electronic Music* (Oxford, England: Oxford University Press, 2010).

20 A recording is available, accompanied by remixes from DJ Spooky and others, as Walter Ruttmann, *Weekend Remix* (Intermedium Records, 2001). My French CD of the original dates the first broadcast to May 15, 1930, whereas other sources say June 13, 1930; at any rate, it was also part of the Second International Congress of Independent Film in Brussels in December 1930. Compare John Oswald's comment about his contribution to the remix, *wknd 58*: "There is constant noise on the recording, and that's what I had to work with. Instead of trying to eliminate it as completely as possible by technical means, I decided to do the opposite." http://www.medienkunstnetz.de/works/weekend-remix.

21 Pierre Schaeffer, *À la recherche d'une musique concrete* (Paris: Le Seuil, 1951), 22. On October 5, 1948, the first "Concert de Bruits" was broadcast on French radio, as part of a program founded by Pierre Schaeffer called Club d'Essai. Compositions consisted of real occurring noises and sounds recorded by the cassette recorder; Schaeffer's efforts paved the way for later important composers, including Luc Ferrari, François Bayle, Karlheinz Stockhausen, and Olivier Messiaen.

22 Karlheinz Stockhausen, "Elektronische und Instrumentalmusik," *Die Reihe* (1961): 50–59; trans. in *Audio Culture*, ed. Christoph Cox and Daniel Warner, 370–80 (London: Continuum, 2004). See Robin Maconue, ed., *Stockhausen on Music: Lectures and Interviews* (London: Marion Boyars, 2000).

23 On Coil, Merzbow, Mego, and others, see Thomas Bey William Bailey, *Microbionic: Radical Electronic Music and Sound Art in the 21st Century* (San Francisco: Creation Books, 2009).

24 Lester Bangs, "How to Succeed in Torture without Really Trying," in Greil Marcus, ed., *Psychotic Reactions and Carburetor Dung*, 5–19 (New York: Alfred A. Knopf, 1987). On guitar feedback, see also Bruce Clark, "Information," in *Critical Terms for Media Studies*, 157–71 (Chicago: University of Chicago Press, 2010), 168–70.

25 Despite Reed's claim in interviews that it cannot be transcribed, Los Angeles composer Ulrich Krieger transcribed *Metal Machine Music* for an eleven-piece ensemble to perform it in 2007: http://pitchfork.com/features/interviews/6690-lou-reed.

26 *Metal Machine Music* is available again from http://www.loureed.com/metalmachinemusic, and Lou Reed performed it on stage at the Royal Festival Hall in London on April 19, 2010.

27 Paul Morley, "I've Said It Before and I'll Say It Again," *Observer*, April 11, 2010, n.p.

28 Compare Drew Daniel's book on Throbbing Gristle's *Twenty Jazz Funk Greats* (London: Continuum, 2007), and Simon Ford, *Wreckers of Civilization* (London: Black Dog, 2000).

29 Kahn, "Histories of Sound Once Removed," 12. See Csaba Toth, "Noise Theory," in *Noise & Capitalism*, 25–37 (San Sebastián, Spain: Arteleku, 2009), http://www.arteleku.net/audiolab/noise_capitalism.pdf.

30 Cascone, "Aesthetics of Failure," 393. Conversely, I was amused to find in a recent book on computer music a complaint about variable bitrates for MP3 files for its enclosed CD and a glitch that causes reproduction to end prematurely, although the complete files are present on the data

carrier; see Johannes Goebel, *Computer Musik Ästhetik: Klang—Technologie—Sinn; Aufsätze, Texte und Sendungen* (Mainz, Germany: Schott/ZKM, 2006), 4.

31 Documentation on the role of notation is found in the ZKM exhibition catalog *Notation: Kalkül und Form in den Künsten*, ed. Hubertus von Amelunxen (Berlin: Akademie der Künste, 2009), especially his essay "Notation, die Künste und die musikalische Reproduktion," 19–31.

32 As Shannon had it, "any reversible translation of the messages produced by a stochastic process . . . should be regarded as containing the same information as the original messages." Claude Shannon, "Some Topics in Information Theory," *Proceedings International Congress of Mathematicians* II (1952): 262–63.

33 Ryoji Ikeda and Carsten Nicolai, *Cyclo* (Berlin: Raster-Noton, 2001); compare the special issue "Data Error" of the journal *Neural* (Bari, Italy: issue 28, http://www.neural.it). Surveying the complexity of notation, The Kitchen recently held an exhibition called *Between Thought and Sound: Graphic Notation in Contemporary Music* (New York, September 7–October 20, 2007), curated by Alex Waterman, Debra Singer, and Mathew Lyons.

34 Steven Anderson, "Microsound in Public Space: Compositional Methods to Enhance Site-Specific Sound," *Organised Sound* 13, no. 1 (2008): 51–60, describes a sound installation that synchronizes visual glitch and noise audio. Compare Björn Hellström, *Noise Design: Architectural Modelling and the Aesthetics of Urban Acoustic Space* (Göteborg, Sweden: Bo Ejeby Förlag, 2003).

35 See the documentary booklet and audio CD: Ryoji Ikeda, *Dataphonics* (Paris: Editions Dis Voir, 2010). Also see Dave Tompkins, *How to Wreck a Nice Beach: The Vocoder from World War II to Hip-Hop* (New York: Melville House, 2010).

36 As Lorraine Daston and Peter Galison point out in their study of scientific objectivity since the seventeenth century, it is key to understanding how modern science moved from curiosities to representations of notional specimens and on to a sense of scientific objectivity qua responsibility: *Objectivity* (New York: Zone Books, 2007).

37 For Andrea Polli's works, see http://www.andreapolli.com. Compare Alva Noto, *Unitxt* (Berlin: Raster-Noton, 2008), and "The Sound of Numbers Crunching," *The Wire* 238 (December 2003): 40–48. Numerous other releases along the same lines are available from http://www.raster-noton.de.

38 Compare Kahn, "Histories of Sound Once Removed," 17, and Paul Thé-
 berge, *Any Sound You Can Imagine: Making Music/Consuming Technology*
 (Middletown, Conn.: Wesleyan University Press, 1997).

39 Moles, *Information Theory*, 105.

40 Rob Young, liner notes to the CD *Early Modulations: Vintage Volts* (New
 York: Caipirinha Music, 1999), reprinted from *The Wire* (September
 1999).

41 Theodor W. Adorno, "The Form of the Phonograph Record," in *Essays
 on Music*, 277–82 (Berkeley: University of California Press, 2002), 277;
 compare Adorno, "The Curves of the Needle," in *Essays on Music*, 275
 (Berkeley: University of California Press, 2002); compare Evan Eisenberg,
 The Recording Angel: Explorations in Phonography (New York: McGraw-
 Hill, 1987), 129–30, and Laszlo Moholy-Nagy, "New Plasticism in Music:
 Possibilities of the Gramophone," in *Broken Music: Artists' Recordworks*,
 55–56 (Berlin: Gelbe Musik, 1989).

42 Steve Goodman, "Sonic Algorithm," in *Software Studies: A Lexicon*, ed.
 Matthew Fuller, 229 (Cambridge, Mass.: MIT Press, 2008). Also Steve
 Goodman, "Contagious Noise: From Digital Glitches to Audio Viruses,"
 in *The Spam Book: On Viruses, Porn, and Other Anomalies from the Dark
 Side of Digital Culture*, ed. Jussi Parikka and Tony Sampson, 125–40
 (Cresskill, N.J.: Hampton Press, 2010). Compare Nick Prior, "Putting a
 Glitch in the Field: Bourdieu, Actor Network Theory, and Contemporary
 Music," *Cultural Sociology* 2, no. 3 (2008): 301–19.

43 An influential early series of TU Berlin lectures on music and tech-
 nology is assembled in F. Winckel, ed., *Klangstruktur der Musik: Neue
 Erkenntnisse musik-elektronischer Forschung* (Berlin-Borsigwalde: Verlag
 für Radio-Foto-Kinotechnik, 1955).

44 Hegarty, *Noise/Music*, 188.

45 Compare Paul D. Greene and Thomas Porcello, eds., *Wired for Sound:
 Engineering and Technologies in Sonic Cultures* (Middletown, Conn.: Wes-
 leyan University Press, 2005); and Nicolas Collins, *Handmade Electronic
 Music: The Art of Hardware Hacking* (New York: Routledge, 2006).

46 Yasunao Tone, "John Cage and Recording," *Leonardo Music Journal* 13
 (2003): 11–15. See Caleb Kelly, "Yasunao Tone's Wounded and Skipping
 Compact Discs: From Improvisation and Indeterminate Composition
 to Glitching CDs," *Leonardo Electronic Almanac* 10, no. 9 (2002), http://
 leoalmanac.org/journal/Vol_10/lea_v10_n09.txt.

47 Hans Ulrich Obrist, "Interview with Yasunao Tone at Yokohama Trien-
 nale in August 2001," in *Yasunao Tone: Noise Media Language*, ed. Achim

Wollscheid, 72 (New York: Errant Bodies/DAP, 2007); and Yasunao Tone, "John Cage and Recording," *Leonardo Music Journal* 13 (2003): 11–15.

48 Examples for sonification of images are already found in the work of László Moholy-Nagy, Oskar Fischinger, and Norman McLaren. For a survey of glitch in visual arts and computer graphics, see Imran Moradi and Ant Scott, eds., *Glitch: Designing Imperfection* (New York: Mark Batty, 2009).

49 Young, liner notes to *Early Modulations*. Other CDs worth mentioning include *The Historical CD of Digital Sound Synthesis* (Mainz, Germany: Wergo, Computer Music Currents 13, 1995); *Columbia–Princeton Electronic Music Center* (New York: New World Records, 1998); *Pioneers of Electronic Music* (New York: New World Records, 2006); and the five volumes of the *Anthology of Noise & Electronic Music 1920–2007* (Berlin: Sub Rosa).

50 Hegarty, who deplores the prevalence of headphones in sound art installation, notes that early concerts by the band Cornelius had headphones for the audience to hear the music: Hegarty, *Noise/Music*, 178. (I note in the seclusion of this footnote that the audiophile headphone forum Head-Fi.org reaches more than 700,000 monthly visitors.)

51 George D. Birkhoff, "A Mathematical Theory of Aesthetics and Its Application to Poetry and Musics," *The Rice Institute Pamphlet* 19, no. 3 (1932): 189–330.

52 Max Bense, "Einführung in die informationstheoretische Ästhetik," in *Ausgewählte Schriften*, vol. 3: *Ästhetik und Texttheorie*, 251–417 (Stuttgart, Germany: Metzler, 1998), 316.

53 Jacques Attali, *Noise: The Political Economy of Music* (Minneapolis: University of Minnesota Press, 1985), 6 and 30, respectively. As Douglas Kahn mocks, "It is a bit surprising to find how rehearsed a Luddite Jacques Attali is in his book *Noise* as he makes the phonograph the wicked steam engine of the undesirable epoch of repetition and banishes it from artistic technologies bearing a premonition of the desirable epoch of composition." Kahn, "Track Organology," 207.

54 Michel Serres, *The Parasite* (Baltimore, Md.: The Johns Hopkins University Press, 1982), 127. On Serres, see Katherine Hayles, "Two Voices, One Channel: Equivocation in Michael Serres," *SubStance* 17, no. 3, iss. 57 (1988): 3–12.

55 See Maurice Martenot, "Künstlerische und technische Merkmale des elektronischen Musikinstruments: Zukunftsperspektiven," in *Gravesano: Musik—Raumgestaltung—Elektroakustik*, ed. Werner Meyer-Eppler, 72–77

(Mainz, Germany: Arsviva Verlag Hermann Scherchen, 1955).

56　See John Pierce, *An Introduction to Information Theory: Symbols, Signals, and Noise* (New York: Dover, 1961), 253 and passim. Compare Heinz von Foerster and James W. Beauchamp, eds., *Music by Computers* (New York: Wiley, 1969).

57　Jonathan Fildes, "'Oldest' Computer Music Unveiled," *BBC News Online*, June 17, 2008. http://news.bbc.co.uk/go/pr/fr/-/2/hi/technology/7458479.stm. In 1967, John Chowning discovered frequency modulation, another revolutionary contribution to what would become the synthesizer industry. One should also footnote the Decca record *Music from Mathematics* of 1962 and the essay John Pierce published in 1965 in the magazine *Playboy*: "Portrait of the Computer as a Young Artist." After retiring from Bell Labs, and then from the Jet Propulsion Laboratory at CalTech, Pierce served for a long time as visiting professor of music at Stanford.

58　Ben Edward's (aka Benge's) brilliant audio CD and historic documentation booklet *Twenty Systems* (2008) deserves a mention here.

59　Jaron Lanier, *You Are Not a Gadget: A Manifesto* (New York: Knopf, 2010).

60　Young, liner notes to *Early Modulations*.

61　Olga Goriunova and Alexei Shulgin, "Glitch," in *Software Studies: A Lexicon*, ed. Matthew Fuller, 113 (Cambridge, Mass.: MIT Press, 2008).

62　http://www.2playerproductions.com, http://fangamer.net/products/rtp-dvd.

63　Colin Cherry, *On Human Communication: A Review, a Survey, and a Criticism* (Cambridge, Mass.: MIT Press, 1978), 53.

64　Kenneth Goldsmith, "It Was a Bug, Dave: The Dawn of Glitchwerks," *New York Press* 1999; archived online at http://www.wfmu.org/%7Ekennyg/popular/articles/glitchwerks.html.

65　Compare Torben Sangild, "Glitch: The Beauty of Malfunction," in *Bad Music: The Music We Love to Hate*, ed. C. J. Washburne and M. Derno, 257–74 (London: Routledge, 2004); and Caleb Stuart, "Damaged Sound: Glitching and Skipping Compact Discs in the Audio of Yasunao Tone, Nicolas Collins, and Oval," *Leonardo Music Journal* 13 (2003): 47–52. See also Hegarty, *Noise/Music*, 181 and passim.

66　Philip Sherbourne, liner notes to *Clicks and Cuts 2* (Mille Plateaux, 2001). A sonic reference should be made here to how glitching turned catchy in the work of Markus Popp, *Ovalprocess* (Chicago: Thrilljockey, 2000). See Kim Cascone, "Popp Art," *Artbyte* 3, no. 4 (2000): 76–78.

67　Achim Stepanski (founder of the record label Mille Plateaux), liner

notes to *Clicks and Cuts 2* (Mille Plateaux, 2001). Of course, his record label is named after the famous philosophical tract by Guattari and Deleuze that praised "a sound machine (not a machine for reproducing sounds) which molecularizes and atomizes, ionizes sound matter and harnesses a cosmic energy": Gilles Deleuze and Félix Guattari, *A Thousand Plateaus* (Minneapolis: University of Minnesota Press, 1987), 343. See Timothy Murphy, "What I Hear Is Thinking Too: The Deleuze Tribute Recordings," in *Deleuze and Music*, ed. Ian Buchanan and Marcel Swiboda, 159–74 (Edinburgh: Edinburgh University Press, 2004). See also Achim Szepanski, "A Mille Plateaux Manifesto," *Organised Sound* 7, no. 1 (2001): 225–28. Some key releases of the seminal and recently relaunched Mille Plateaux label include the *Clicks & Cuts* series, 2000–2010, and records by Microstoria, Frank Bretschneider, Rechenzentrum, and many others.

68 See Bernhard Siegert, "Kakographie oder Kommunikation? Verhältnisse zwischen Kulturtechnik und Parasitentum," *Mediale Historiographien* 1 (2001): 87–99, with reference to Marcel Mauss, "Les techniques du corps," *Journal de Psychologie* 32 (1935): 271–93.

69 Bates, "Glitches, Bugs, and Hisses," 289.

70 See also Mark J. Butler, *Unlocking the Groove: Rhythm, Meter, and Musical Design in Electronic Dance Music* (Bloomington: Indiana University Press, 2006).

71 Philip Sherbourne, liner notes to *Clicks and Cuts 2* (Mille Plateaux, 2001).

72 http://illformed.org/blog/glitch. There is now also a browser-based massively multiplayer online game of the same title, although less literally about the kind of glitch discussed here; see http://tinyspeck.com.

73 Diedrich Diedrichsen, liner notes to *Clicks and Cuts 2* (Mille Plateaux, 2001). Also see Andy Battaglia, "Sharps & Flats," *Salon* (February 8, 2000), http://www.salon.com/entertainment/music/review/2000/02/08/clickscuts/index.html.

74 On this point see Moles, *Information Theory*, 19ff., who goes to great lengths in considering music as a prime example for information theory.

75 Rolf Grossmann, "Die Spitze des Eisbergs: Schlüsselfragen musikalischer Laptopkultur," *Positionen: Beiträge zur Neuen Musik* 68 (August 2006): 2–7.

76 Hainge, "Of Glitch and Men," 27.

77 Heinz von Foerster quoted in Flo Conway and Jim Siegelman, *Dark Hero of the Information Age: In Search of Norbert Wiener, the Father of Cybernetics*

(New York: Basic Books, 2005), 189. Compare M. R. Titchener, "A Measure of Information," IEEE Data Compression Conference, 2000 (DCC Proceedings, 2000), 353–62. A useful historical sketch of information theory is found in chapter 2 of Colin Cherry, *On Human Communication* (Cambridge, Mass.: MIT Press, 1978).

78 See the interview "Glitch Catch: In Search of the Unknown," with Dutch VJ Karl Klomp, in "OK Failure," *OK Parking* 2 (Winter/Spring 2009): 38–39.

79 John Pierce, *An Introduction to Information Theory: Symbols, Signals, and Noise* (New York: Dover Publications, 1980), 251.

80 Kahn, "Track Organology," 213.

81 Moles, *Information Theory*, 145.

82 See Laurie Spiegel, "An Information Theory Based Compositional Model," *Leonardo Music Journal* 7 (January 1998), http://retiary.org/ls/writings/info_theory_music.html.

83 See the special issue on William S. Burroughs, Brion Gysin, and Throbbing Gristle of the journal *Re/Search* 4–5 (1982), and Charles Neal, ed., *Tape Delay: Confessions from the Eighties Underground* (London: SAF, 1987).

84 In an anechoic chamber, most of us would probably perceive some sonic phenomena, partially related to our own pulse and breathing. This may point us to McLuhan's shift from figure to ground: Marshall McLuhan, *Letters* (Toronto: Oxford University Press, 1987), 467–72 and passim.

85 See K. D. Kryter, A. Z. Weisz, and F. M. Wiener, "Damage Risk Criterion for and Auditory Fatigue from the Audiac," *Journal of the Acoustical Society of America* 33, no. 6 (June 1961): 858–59; and Albert Q. Maisel, "Who's Afraid of the Dentist?" *Popular Science* (August 1960): 59–62. Also George Prochnik, *In Pursuit of Silence: Listening for Meaning in a World of Noise* (New York: Random House, 2010), 160–62.

86 Salomé Voegelin, *Listening to Noise and Silence: Towards a Philosophy of Sound Art* (New York: Continuum, 2010), 44.

87 Neither neurophysiological nor cognitive science angles are pursued here, although some cultural theorists allow for them: for instance Dirk Baecker, "Kopfhörer: Für eine Kognitionstheorie der Musik," *Soundcultures: Über elektronische und digitale Musik*, ed. Marcus Kleiner and Achim Szepanski, 137–51 (Frankfurt: Suhrkamp, 2003). Compare also Seth Kim-Cohen, *In the Blink of an Ear: Toward a Non-Cochlear Sonic Art* (New York: Continuum, 2009).

88 A controversial reference here is the "Markoff-chain music" of L. A.

Hiller and L. M. Isaacson's *Illiac Suite for String Quartet* (Bryn Mawr, Pa.: Theodore Presser, 1957).

89 Caleb Kelly, *Cracked Media* (Cambridge, Mass.: MIT Press, 2009), 10, with reference to Bruce Andrews, "Praxis: A Political Economy of Noise and Informalism," in *Close Listening: Poetry and the Performed Word*, ed. Charles Bernstein, 73–85 (New York: Oxford University Press, 1998). Compare Jeremy Gilbert and Ewan Pearson, *Discographies: Dance Music, Culture, and the Politics of Sound* (New York: Routledge, 1999).

90 Compare Claus Pias, "Hollerith Feathered Crystal: Art, Science, and Computing in the Age of Cybernetics," *Grey Room* 31 (Winter 2007): 110–34; and Joel Cohen, "Translator's Preface," in Moles, *Information Theory*.

91 Claude Shannon and Warren Weaver, *The Mathematical Theory of Communication* (Urbana: University of Illinois Press, 1949); compare William G. Tuller, "Theoretical Limits on the Rate of Transmission of Information," *Proceedings of the Institute of Radio Engineers* 37, no. 5 (May 1949): 468–78.

92 Pierre Boulez, "L'esthetique et les fétiches," in *Panorama de l'art musical contemporain*, ed. C Samuel, 402–94 (Paris: Points de Repère I, 1962).

93 Ray Brassier, "Genre Is Obsolete," in *Noise & Capitalism*, 60–71 (San Sebastián, Spain: Arteleku, 2009), 62. See http://www.arteleku.net/audiolab/noise_capitalism.pdf.

94 Compare Csaba Toth, "The Work of Noise," in *Poetics/Politics: Radical Aesthetics for the Classroom*, ed. Amitava Kumar, 201–18 (New York: St. Martin's Press, 1999); and "Sonic Rim: Performing Noise around the Pacific," in *Variable Resistance: Australian Sound Art*, ed. Kathleen Ford and Philip Samartzis, 14–23 (San Francisco: San Francisco Museum of Modern Art, 2003).

95 Friedrich Kittler, *Grammophon, Film, Typewriter* (Berlin: Brinkmann & Bose, 1986), 5.

96 Sam Inglis, "Music as Software," *Sound on Sound* (October 2002), http://www.soundonsound.com/sos/oct02/articles/oval.asp.

97 Hegarty, *Noise/Music*, 188.

98 Judy Lochhead, "Hearing Chaos," *American Music* 19, no. 2 (2001): 210–46. The temptation, however, is to exaggerate serendipity, as when Hayles asks, "Why should John Cage become interested in experimenting with stochastic variations in music about the same time that Roland Barthes was extolling the virtues of noisy interpretations of literature and Edward Lorenz was noticing the effect of small uncertainties on

the nonlinear equations that described weather formations?" Katherine Hayles, *Chaos Bound* (Ithaca, N.Y.: Cornell University Press, 2001), 4.

99 See David Borgo, *Sync or Swarm: Improvised Music in a Complex Age* (London: Continuum, 2005), for an attempt to enter into a discussion of chaos and complexity in "musicking."

4. GAMING THE GLITCH

1 For usability and technology, see Steve Woolgar, "Configuring the User: The Case of Usability Trials," in *A Sociology of Monsters: Essays on Power, Technology, and Domination*, ed. John Law, 57–99 (New York: Routledge, 1991); and Thierry Bardini and August Horvath, "The Social Construction of the Personal Computer User," *Journal of Communication* 45, no. 3 (1995): 40–65. For theoretical issues raised by technologized society, see Carl Mitcham, *Thinking through Technology: The Path between Engineering and Philosophy* (Chicago: University of Chicago Press, 1994).

2 Olga Goriunova and Alexei Shulgin, "Glitch," *Software Studies: A Lexicon*, ed. Matthew Fuller, 110–19 (Cambridge, Mass.: MIT Press, 2008), 111.

3 John Cogburn and Mark Silcox, *Philosophy through Videogames* (New York: Routledge, 2009), 107. They add that Neil Stephenson's novel *The Diamond Age* (New York: Spectra, 2000) has a computer programmer code "a series of interactive games to teach his daughter about the basic limitation theorems of computability theory" (171).

4 Wlad Godzich, "Figuring Out What Matters," in *Making Sense in Life and Literature*, H. U. Gumbrecht, vii–xvi (Minneapolis: University of Minnesota Press, 1992), xv.

5 Indeed, there is a danger that "we jeopardize the most important option offered by the materialities approach if we dream of a new stability for renewed concepts in a future age of theory," Gumbrecht warns; "This most important option might well be the possibility of seeing the world under a radical perspective of contingency." Hans Ulrich Gumbrecht, "A Farewell to Interpretation," in *Materialities of Communication*, ed. H. U. Gumbrecht and K. L. Pfeiffer, 389–402 (Stanford, Calif.: Stanford University Press, 1994), 402. Also see Karl Mannheim, *Ideologie und Utopie* (Frankfurt: Klostermann, 1952), note 38.

6 Compare Alexander Galloway, *Gaming: Essays on Algorithmic Culture* (Minneapolis: University of Minnesota Press, 2006); and McKenzie Wark, *Gamer Theory* (Cambridge, Mass.: Harvard University Press, 2007).

7 See Claus Pias on informatics versus thermodynamic pessimism, "Wie

die Arbeit zum Spiel wird," in *Anthropologie der Arbeit*, ed. Eva Horn and Ulrich Bröckling, 209–29 (Tübingen, Germany: Narr, 2002).

8 See Jerry Minter, "Computer Gaming's New Worlds," *Computer Graphics* 31, no. 1 (1997): 12–13. See also Thomas Apperley, *Gaming Rhythms: Play and Counterplay from the Situated to the Global* (Amsterdam: Institute of Network Cultures, 2010).

9 See Stan Liebowitz and Stephen Margolis, "Typing Errors," *Reason Magazine* (June 1996), http://reason.com/archives/1996/06/01/typing-errors; and compare *How Users Matter: The Co-Construction of Users and Technology*, ed. Nelly Outshoorn and Trevor Pinch (Cambridge, Mass.: MIT Press, 2003).

10 Dennis Chao, "*Doom* as an Interface for Process Management," *SIGCHI 2001* 3, no. 1, 152–57 (March 31–April 4, 2001, Seattle, Wash.); see his extensive project documentation at http://cs.unm.edu/~dlchao/flake/doom/chi/chi.html.

11 Paul Vickers and James Alty, "The Well-Tempered Compiler? The Aesthetics of Program Auralization," in *Aesthetic Computing*, ed. Paul Fishwick, 336–53 (Cambridge, Mass.: MIT Press, 2006).

12 Apple interface designer Jef Raskin, "Intuitive Equals Familiar," *Communications of the ACM* 37, no. 9 (September 1994): 17–18. Also Brad Myers, "A Brief History of Human Computer Interaction Technology," *ACM Interactions* 5, no. 2 (1998): 44–54.

13 Chao, "*Doom* as an Interface for Process Management," 154.

14 Compare Lawrence Miller and Jeff Johnson, "The Xerox Star: An Influential User Interface Design," in *Human–Computer Interface Design: Success Stories, Emerging Methods, and Real-World Context*, Marianne Rudisill et al, 70–100 (San Francisco: Morgan Kaufmann, 1996); and W. Bewley et al, "Human Factors Testing in the Design of Xerox's 8010 Star Office Work-Station," *Proceedings of the ACM Conference on Human Factors in Computing Systems* (1983): 72–77.

15 For Chris Pruett's "*Marathon* Process Manager" for the Mac, see http://www.dreamdawn.com/chris/projects.html.

16 Brody Condon, *Adam Killer*, 1999–2001, http://www.tmpspace.com/ak_1.html.

17 Rebecca Cannon, "Meltdown," in *Videogames and Art* (London: Intellect Books, 2007), 58. On machinima, see Henry Lowood and Michael Nitsche, eds., *Machinima Reader* (Cambridge, Mass.: MIT Press, 2011), and chapter 5 in this book.

18 Brody Condon, "Where Do Virtual Corpses Go?" http://www.cosignconference.org/downloads/papers/condon_cosign_2002.pdf.

19 An example for bad infinity as a game glitch is the *Pokemon* bad egg, http://bulbapedia.bulbagarden.net/wiki/Bad_egg.

20 Gilles Deleuze, "Tenth Series of the Ideal Game," in *The Logic of Sense*, 58–65 (London: Athlone, 1990), 60–61, referring to J. L. Borges, *Ficciones* (New York: Grove, 1962), 69–70.

21 The conceptual model is already analyzed in J. C. R. Licklider and R. W. Taylor, "The Computer as a Communication Device," *Science and Technology* (April 1968): 21–41; republished online for *In Memoriam: J. C. R. Licklider, 1915–1990*. Research Report 61, Digital Equipment Corporation Systems Research Center, August 1990. http://gatekeeper.dec.com/pub/DEC/SRC/research-reports/abstracts/src-rr-061.html.

22 Marshall McLuhan, "Games: The Extensions of Man," in *Understanding Media* (London: Routledge and Kegan Paul, 1964), 249.

23 Compare Alex Galloway, *Protocol: How Control Exists after Decentralization* (Cambridge, Mass.: MIT Press, 2004); and Eugene Thacker and Alex Galloway, *The Exploit: A Theory of Networks* (Minneapolis: University of Minnesota Press, 2007).

24 Julian Dibbell, *My Tiny Life: Crime and Passion in a Virtual World* (New York: Henry Holt, 1998), 70–72.

25 Wulf Halbach, "Simulated Breakdowns," in *Materialities of Communication*, ed. H. U. Gumbrecht and K. L. Pfeiffer, 335–43 (Stanford, Calif.: Stanford University Press, 1994), 343. Compare also Denis Kambouchner, "The Theory of Accidents," *Glyph* 7 (1980): 149–75.

26 Walt Scacchi, "Visualizing Socio-Technical Interaction Networks," http://www.isr.uci.edu/~wscacchi/.

27 Greg Kline, "Game Used to Simulate Disaster Scenarios," *The News-Gazette*, February 17, 2008, http://www.news-gazette.com/news/u_of_i/2008/02/17/game_used_to_simulate_disaster_scenarios.

28 Here cited after Shaun Gegan, "Magnavox Odyssey FAQ," http://home.neo.lrun.com/skg/faq.html; compare W. K. English, D. C. Engelbart, and M. L. Berman, "Display Selection Techniques for Text Manipulation," *IEEE Transactions on Human Factors in Electronics* 8, no. 1 (March 1967): 5–15.

29 See Hans-Georg Gadamer, *Truth and Method* (London: Continuum, 2004), 102–61; original German published as *Wahrheit und Methode: Grundzüge einer philosophischen Hermeneutik* (Tübingen, Germany: Siebeck, 1972), 107ff. For a historical sketch of contingency, see Hans Blumenberg, "Kontingenz," in *Handwörterbuch für Theologie und Religionswissenschaft*, 1793–94 (Tübingen, Germany: Mohr, Paul Siebeck, 1959).

30 For the history of interactive fiction, see Nick Montfort, *Twisty Little Passages* (Cambridge, Mass.: MIT Press, 2003).

31 Dennis Gabor, quoted in Roberto Cordeschi, *The Discovery of the Artificial: Behavior, Mind, and Machines before and beyond Cybernetics* (Dordrecht, The Netherlands: Springer, 2002), 163. Max Bense, "Über Labyrinthe," in *Artistik und Engagement* (Cologne, Germany: Kiepenheuer und Witsch, 1970), 139–42, with reference to Jorge Luis Borges and André Gide.

32 Clarence S. Yoakum and Robert M. Yerkes, *Army Mental Tests* (New York, 1920), 83; and Claude Shannon, "Presentation of a Maze-Solving Machine," *Transactions of the 8th Conference Entitled "Cybernetics," Eighth Conference on Cybernetics, 1951,* ed. Heinz von Foerster, 173–80 (New York, 1954). See Ivan Sutherland, "A Method for Solving Arbitrary-Wall Mazes by Computer," *IEEE Transactions on Computers* C-18, no. 12 (December 1969): 1192–97; and Wayne H. Caplinger, "On Micromice and the First European Micromouse Competition," *AISB Quarterly* 39 (December 1980), http://davidbuckley.net/RS/mmouse/AISBQ39.htm.

33 http://www.bitsavers.org/pdf/mit/tx-0/memos/Ward_MOUSE_Jan59. txt. Compare J. M. Graetz, "The Origin of Spacewar," *Creative Computing* 1981, archived at http://www.wheels.org/spacewar/creative/ SpacewarOrigin.html.

34 See David Lebling, Marc S. Blank, and Timothy A. Anderson, "Zork: A Computerized Fantasy Simulation Game," *IEEE Computer* 4 (1979): 51–59; and Tim Anderson and Stu Galley, "The History of Zork," *The New Zork Times* 4, nos. 1–3 (1985), the latter cited after Montfort, *Twisty Little Passages,* 80.

35 Dale Peterson, *Genesis II: Creation and Recreation with Computers* (Reston, Va.: Reston, 1983), 188. See Rick Adams, "A History of *Adventure,*" http://www.rickadams.org/adventure/a_history.html.

36 Montfort, *Twisty Little Passages,* 100–101.

37 Graham Nelson, "The Craft of *Adventure:* Five Articles on the Design of Adventure Games," http://www.if-archive.org/if-archive/programming/general-discussion/Craft.Of.Adventure.txt.

38 Tim Berners-Lee, "Information Management: A Proposal," http://www. w3.org/History/1989/proposal.html. In Bush's concept of the memex, the user "builds a trail of his interest through the maze of materials available to him. And his trails do not fade." Vannevar Bush, "As We May Think," *Atlantic Monthly* 176, no. 1 (July 1945): 101–108.

39 James Gillies and Robert Cailliau, *How the Web Was Born* (Oxford, England: Oxford University Press, 2000), 170.

40 John Perry Barlow, "Crime & Puzzlement" (1990), http://www.eff. org/Publications/JohnPerryBarlow, cited after Wendy Grossman, *net.wars* (New York: NYU Press, 1997), 129.

41 Montfort, *Twisty Little Passages*, 73.

42 On the etymology, history, and use of *contingency*, see H. Schepers, "Möglichkeit und Kontingenz: Zur Geschichte der philosophischen Terminologie vor Leibniz," *Filosofia* (1963): 901–14; Richard Rorty, *Contingency, Irony, and Solidarity* (Cambridge, England: Cambridge University Press, 1989); Jacques Monod, *Chance and Necessity: An Essay on the Natural Philosophy of Modern Biology* (New York: Knopf, 1971); and Stephen Jay Gould, *Wonderful Life: The Burgess Shale and the Nature of History* (New York: Norton, 1989).

43 Ernst Bloch distinguishes between the merely (passively) plausible and the creatively (actively) variable: *Das Prinzip Hoffnung* (Frankfurt: Suhrkamp, 1969), vol. 1, 258ff. Compare H. P. Bahrdt, "Plädoyer für eine Futurologie mittlerer Reichweite," *Menschen im Jahr 2000*, ed. Robert Jungk (Frankfurt: Umschau, 1969), 143ff.; and Ossip K. Flechtheim, *Futurologie: Der Kampf um die Zukunft* (Frankfurt: Fischer, 1972), 154ff.

44 Alan Liu, "Escaping History: The New Historicism, Databases, and Contingency," in *Local Transcendence: Essays on Postmodern Historicism and the Database*, 239–62 (Chicago: University of Chicago Press, 2008), 261.

45 http://glitchmania.com/Home.html, http://glitchblog.com/.

46 See http://404.jodi.org.

47 Pit Schultz, "Jodi as Software Culture," in *Install.exe* (Berlin: Merian, 2002), n.p.

48 Alexander Galloway, *Protocol: Or How Control Exists after Decentralization* (Cambridge, Mass.: MIT Press, 2004), 225–26.

49 http://sod.jodi.org/. Jodi also produced a CD-ROM with twelve mods of the classic first-person shooter *Quake* and a list of cheats for the videogame *Max Payne:* http://www.untitled-game.org and http:// maxpaynecheatsonly.jodi.org.

50 http://www.farbs.org/games.html. Also see Joan Leandre's R/C and NostalG, http://www.retroyou.org and http://runme.org/ project/+SOFTSFRAGILE/.

51 *Mega Man 9* (Capcom, 2008).

52 Gregory R. Beabout, *Freedom and Its Misuses: Kierkegaard on Anxiety and Despair* (Milwaukee, Wis.: Marquette University Press, 1996).

53 See Ian Hunter's discussion of "the aesthetic as an ethical technology"

incorporated into the government sphere, in his essay "Aesthetics and Cultural Studies," in *Cultural Studies*, ed. L. Grossberg, C. Nelson, and P. Treichler, 347–72 (New York: Routledge, 1992).

54 Michel Foucault, *The Order of Things* (New York: Routledge, 2002), x.

55 Dieter Henrich, "Hegels Theorie über den Zufall," in *Hegel im Kontext*, 157–86 (Frankfurt: Suhrkamp, 1971), with reference to G. W. F. Hegel, *Die Vernunft in der Geschichte* (Hamburg: Felix Meiner, 1955), 29.

56 Lev Manovich, "Interaction as an Aesthetic Event," *Receiver* 17 (2006), http://www.receiver.vodafone.com; also Gary McCarron, "Pixel Perfect: Towards a Political Economy of Digital Fidelity," *Canadian Journal of Communication* 24, no. 2 (1999), http://www.cjc-online.ca/viewarticle.php?id=520&layout=html.

57 Ernst Mach, "Knowledge and Error," in *Knowledge and Error* (Boston: D. Reidel, 1976), 90.

58 Erhard Schüttpelz illustrates the conceptualization of distortion as accidental to some, meaningful message to others, with reference to the jump cut introduced by Méliès: a celluloid strip mixed up, resulting in the apparent metamorphosis of a bus into a hearse. (See Georges Sadoul, *L'Invention du cinéma*, cited after Siegfried Kracauer, *Theorie des Films: Die Errettung der äußeren Wirklichkeit* [Frankfurt: Suhrkamp, 1975], 60.) Erhard Schüttpelz, *Signale der Störung* (Munich: Wilhelm Fink, 2003), 15ff.

59 As Gadamer says, "The work of art cannot simply be isolated from the contingency of the chance conditions in which it appears." *Truth and Method* (London: Continuum, 2004), 115.

60 Alexander Galloway, "Language Wants to Be Overlooked: On Software and Ideology," *Journal of Visual Culture* 5, no. 3 (2006): 315–32 at 326.

61 José Ortega y Gasset, *Obras Completas*, vol. 4 (Madrid: Editorial Taurus, 1983), 398. Cited after Yvette Sanchez, "Der bessere Fehler—als Programm oder Fatum," in *Fehler im System: Irrtum, Defizit und Katastrophe als Faktoren kultureller Produktivität*, ed. Y. Sanchez and F. P. Ingold (Göttingen, Germany: Wallstein Verlag, 2008), 22.

62 See Paul Ormerod, *Why Most Things Fail: Evolution, Extinction and Economics* (London: Faber and Faber, 2005).

63 Claus Pias, "Der Auftrag: Kybernetik und Revolution in Chile," in *Politiken der Medien*, ed. D. Gethmann and M. Stauff, 131–54 (Zurich: Diaphanes, 2004).

64 J. C. R. Licklider and R. Taylor, "The Computer as a Communication Device," *Science and Technology* (April 1968): 21–41.

5. MACHINIMA AND THE SUSPENSIONS OF ANIMATION

1 http://www.machinima.org/paul_blog/2005/03/still-seeing-breen-take-3.html.

2 http://rvb.roosterteeth.com; see Kevin Delaney, "When Art Imitates Videogames, You Have 'Red vs Blue,'" *The Wall Street Journal,* April 9, 2004; and Bruno Starrs, "Reverbing: The Red vs Blue Machinima as Anti-War Film," *Continuum Journal of Media & Cultural Studies* 24, no. 2 (April 2010): 265–77.

3 For these and many more machinima examples, see http://www.machinima.com and http://www.archive.org/details/machinima.

4 Two how-to books assist the machinimator: Hugh Hancock and John-nie Ingram, *Machinima for Dummies* (New York: Wiley, 2007); and Matt Kelland, Dave Morris, and Dave Lloyd, *Machinima: Making Animated Movies in 3D Virtual Environments* (Boston: Thomson, 2005).

5 Two eloquent appeals for a historically and conceptually rigorous study of gaming are Ian Bogost, "Comparative Videogame Criticism," *Games and Culture* 1, no. 1 (January 2006): 41–46; and Alex Galloway, *Gaming: Essays on Algorithmic Culture* (Minneapolis: University of Minnesota Press, 2006).

6 See Marcel Mauss, "Les Techniques du Corps," *Journal de Psychologie* 32 (1935): 3–4; and André Leroi-Gourhan, *Gesture and Speech* (Cambridge, Mass.: MIT Press, 1993). It is worth noting, however, that like Pierre Lévy, Leroi-Gourhan refers more to the Catholic teleology of Teilhard de Chardin than to Darwin, or archaeology, or anthropology for support of his history of technology.

7 For a gesture's socioeconomic and cultural context, see Radan Martinec, "Gestures That Co-Occur with Speech as a Systematic Resource," *Social Semiotics* 14, no. 2 (August 2004): 193–213. Compare Adam Kendon, *Gesture: Visible Action as Utterance* (Cambridge, Mass.: MIT Press, 2004), chapter 4.

8 Barry Atkins, "What Are We Really Looking At? The Future-Orientation of Video Game Play," *Games and Culture* I, no. 2 (April 2006): 127–40.

9 Giorgio Agamben, "Notes on Gesture," in *Means without End: Notes on Politics,* 49–60 (Minneapolis: University of Minnesota Press, 2000), 53. Another translation is available in Giorgio Agamben, *Infancy and History: The Destruction of Experience* (London: Verso, 1993), 133–40. Compare Samuel Weber, "Violence and Gesture: Agamben Reading Benjamin Reading Kafka Reading Cervantes," in *Benjamin's -abilities,* 195–210 (Cambridge, Mass.: Harvard University Press, 2008).

10 Walter Benjamin, "What Is Epic Theater?" in *Illuminations*, ed. Hannah Arendt, 147–54 (New York: Schocken Books, 1977). See Samuel Weber, "Between a Human Life and a Word: Benjamin's Excitable Gestures," in *Mediatized Drama, Dramatized Media*, ed. Eckart Voigts-Virchow, 15–30 (Trier, Germany: Wissenschaftlicher Verlag, 2000). Compare Samuel Weber, "Citability—of Gesture," in *Benjamin's -abilities*, 95–114 (Cambridge, Mass.: Harvard University Press, 2008), 97.

11 Weber, "Citability," 113.

12 Alice Crawford, "The Digital Turn: Animation in the Age of Information Technologies," in *Prime Time Animation*, ed. Carol Stabile and Mark Harrison, 110–30 (New York: Routledge, 2003). See Michael Nitsche and Maureen Thomas, "Play It Again, Sam: Film Performance, Virtual Environments, and Game Engines," in *New Visions in Performance: The Impact of Digital Technologies*, ed. Gavin Carver and Colin Beardon, 121–38 (Abingdon, England: Swets & Zeitlinger, 2004).

13 Katie Salen and Eric Zimmerman, *Rules of Play* (Cambridge, Mass.: MIT Press, 2003), 539; Henry Lowood, "Warcraft Adventures: Texts, Relay and Machinima in a Game-Based Story World," in *Third Person: Authoring and Exploring Vast Narratives*, ed. Pat Harrigan and Noah Wardrip-Fruin, 407–28 (Cambridge, Mass.: MIT Press, 2007).

14 Katie Salen, "Strange Universe: The Art of Machinima," in *Future Cinema: The Cinematic Imaginary after Film*, ed. Jeffrey Shaw and Peter Weibel, 538–41 (Cambridge, Mass.: MIT Press, 2003). See also Elijah Horwatt, "New Media Resistance: Machinima and the Avant-Garde," *Cineaction* 73–74 (2008), http://cineaction.ca/issue73sample.htm.

15 Ivan E. Sutherland, *Sketchpad: A Man–Machine Graphical Communication System* (New York: Garland, 1980).

16 Raymond Bellour, "The Unattainable Text," *Screen* 16, no. 3 (1975): 19–28. Compare Leo Berkeley, "Situating Machinima in the New Mediascape," *Australian Journal of Emerging Technologies and Society* 4, no. 2 (2006): 65–80.

17 See http://www.youtube.com/watch?v=qzHORJ3Ht54 and http://www.warthog-jump.com, respectively.

18 Félix Guattari, "Regimes, Pathways, Subjects," in *Incorporation (Zone 6)*, ed. Jonathan Crary and Sanford Kwinter, 29 (New York: Urzone, 1992). Compare Tim Mehigan, "Brecht and Gestus: The Place of the Subject," *Faultline* 2 (1993): 73–95.

19 Jean Luc-Godard and Youseff Ishaghpour, "Part I Interview," in *Cinema*, 3–112 (New York: Berg, 2005), 38–39. See Marsha Kinder, "Narrative

Equivocations between Movies and Games," in *The New Media Book,* ed. Dan Harries, 119–32 (London: British Film Institute, 2002).

20 Agamben, "Notes on Gesture," 55.

21 See Wolfgang Hagen, "The Style of Sources," in *New Media, Old Media: A History and Theory Reader,* 157–75 (New York: Routledge, 2005).

22 Agamben, "Notes on Gesture," 53. Discarding all reference to consciousness, American experimental behaviorism tried to discount mental activity and experience by focusing exclusively on observable interactions in environments. Consequently, mental labor would consist merely in the spatiotemporal organization of motion; education would not aim for comprehension but rather would constitute training to optimize certain functions according to a rule-oriented process.

23 Agamben, "Notes on Gesture," 55.

24 Jonathan Crary, *Techniques of the Observer: On Vision and Modernity in the 19th Century* (Cambridge, Mass.: MIT Press, 1990), 110.

25 Don Ihde, *Bodies in Technology* (Minneapolis: University of Minnesota Press, 2002), xi and passim.

26 Gilles Deleuze, *Cinema 1: The Movement-Image* (Minneapolis: University of Minnesota Press, 1987), 56–57; Maurice Merleau-Ponty, *Phenomenology of Perception* (Atlantic Highlands, N.J.: Humanities Press, 1962), 68; Merleau-Ponty, "Film and the New Psychology," in *Sense and Non-Sense,* 48–59 (Evanston, Ill.: Northwestern University Press, 1964), 58.

27 Merleau-Ponty, "Film and the New Psychology," 57.

28 Regarding Etienne-Jules Marey, chronophotography, and gesture, see Alan Sekula, "The Body and the Archive," in *The Contest of Meaning: Critical Histories of Photography,* ed. R. Bolton, 343–49 (Cambridge, Mass.: MIT Press, 1999); Marta Braun, "The Expanded Present: Photographing Movement," in *Beauty of Another Order: Photography in Science,* ed. Ann Thomas, 150–84 (New Haven, Conn.: Yale University Press, 1997); and Marta Braun, "Muybridge's Scientific Fictions," *Studies in Visual Communication* 10, no. 1 (Summer 1984): 2–22. See also Etienne-Jules Marey, *La méthode graphique dans les sciences expérimentales et principalement en physiologie et en médecine* (Paris: Masson, 1878).

29 Henry Lowood, "Shall We Play a Game: Thoughts on the Computer Game Archive of the Future" (2002), http://www.stanford.edu/~lowood/Texts/shall_game.pdf; and Henry Lowood, "High-Performance Play: The Making of Machinima," *Videogames and Art: Intersections and Interactions,* ed. Andy Clarke and Grethe Mitchell, 59–79 (London: Intellect Books, 2008). Inroads machinima makes in the art world can

be seen in the Laguna Beach Art Museum's exhibit "WoW: Emergent Media Phenomenon" (2009); in the work of the Second Life Machinima Artists Guild, http://slmachinimaarts.ning.com/; in the entries to the Bitfilm Festival 2009 (Hamburg and Tel Aviv); or in the MachiniCast Machinima Award Show.

30 See Claus Pias, *Computer Spiel Welten* (Munich: Sequenzia, 2002).

31 *BusinessWire,* November 9, 2008. Machinima.com now claims $14 million in venture capital. See Ben Fritz, "Machinima Directors Step Up Their Game," *LA Times,* August 29, 2010, http://www.latimes.com/entertainment/news/la-ca-machinima-20100829,0,6035173.story.

32 Salen and Zimmerman, *Rules of Play,* 550; see Katie Salen, "Telefragging Monster Movies," in *Game On: History and Culture of Video Games,* ed. Lucien King, 98–111 (London: King, 2002).

33 See http://www.strangecompany.org/ for information on Hugh Hancock; see http://blog.machinima.org for information on Paul Marino. For the equation "Hollywood + Moore's Law = Machinima," see also Paul Marino, *3D Game-Based Filmmaking: The Art of Machinima* (Sebastopol, Calif.: Paraglyph, 2004), 11 and passim.

34 See http://www.strangecompany.org/Ozymandias.

35 Hans Magnus Enzensberger, "Constituents of a Theory of the Media," *New Left Review* 64 (1970): 13–36; repr. in Noah Wardrip-Fruin and Nick Monfort, eds., *The New Media Reader,* 261–75 (Cambridge, Mass.: MIT Press, 2003).

36 Carrie Noland, "Digital Gestures," in *New Media Poetics,* ed. Thomas Swiss and Adalaide Morris, 217–43 (Cambridge, Mass.: MIT Press, 2006), 220; after Christopher J. Keep, "The Disturbing Liveliness of Machines: Rethinking the Body in Hypertext Theory and Fiction," in *Cyberspace Textuality: Computer Technology and Literary Theory,* ed. Marie-Laure Ryan, 164–81 (Bloomington: Indiana University Press, 1999).

37 Michel Foucault, *Discipline and Punish: The Birth of the Prison* (New York: Viking, 1979), 152.

38 Alexandre Alexeieff, "In Praise of Animated Film," in *Cartoons: One Hundred Years of Cinema Animation,* ed. Giannalberto Bendazzi (Bloomington: Indiana University Press, 1996), xxi.

39 Compare R. A. Fairthorne, "Some Clerical Operations and Languages," in *Information Theory,* 111–20 (London: Butterworth, 1956), and Claus Pias, "Digitale Sekretäre: 1968, 1978, 1998," in *Europa: Kultur der Sekretäre,* ed. Joseph Vogl and Bernhard Siegert, 235–51 (Zurich: Diaphanes, 2002).

40 Stanley Hall, "The Ministry of Pictures," *The Perry Magazine* 2, no. 6

(February 1900): 240; cited after Eward W. Earle, "Models of the World," in *Making Good Time: Scientific Management, The Gilbreths, Photography and Motion, Futurism,* ed. Mike Mandel, 5 (Riverside: California Museum of Photography, 1989).

41 Marshall McLuhan, "Games: The Extensions of Man," in *Understanding Media,* 258 (London: Routledge and Kegan Paul, 1964).

42 See Frank B. Gilbreth and Lilian M. Gilbreth, "Application of Motion Study," in *Management and Administration,* September 1924, n.p., and for a very detailed and systematic overview of the Gilbreths' methods, Anne G. Shaw, *The Purpose and Practice of Motion Study* (Manchester, England: Columbine Press, 1952).

43 See http://www.thisspartanlife.com and http://www.youtube.com/watch?v=dmyO1A5J8SU.

44 See http://www.gamics.com, and "Games + Comics = Gamics," *The Globe and Mail* (Toronto, April 5, 2009), http://www.theglobeandmail.com/news/technology/games-comics-gamics/article812003. There are also some literary efforts regarding machinima, such as Mike Hoefflinger, "Moving Pictures," http://packetswitched.blogspot.com/MovingPicturesPSP2005f/MovingPicturesv09HTML.htm; and Patrick Kolan, "Give the Dog a Bone," *Jump Button Mag* (2006; no longer online at http://jumpbuttonmag.com/?p=21).

45 See http://www.atlas-enterprises.net and again http://sh.roosterteeth.com.

46 http://q4u1.uchicago.edu, http://www.thingsasian.com/goto_article/article.2950.html.

47 See Gabriele Brandstetter, *Tanz-Lektüren: Körperbilder und Raumfiguren der Avantgarde* (Frankfurt: M. Suhrkamp, 1995), 46ff., with reference to Rudolf von Laban.

48 http://www.furplay.com.

49 Theodor W. Adorno, *Aesthetic Theory* (Minneapolis: University of Minnesota Press, 1997), 100. Compare Johan Huizinga, *Homo ludens* (Boston: Beacon, 1955), 470ff.

50 Marshall McLuhan, "Games: The Extensions of Man," in *Understanding Media* (London: Routledge and Kegan Paul, 1964), 257.

51 See Stelarc, "Movatar: Inverse Motion-Capture System," http://stelarc.org/?catID=20225. Compare the discussion of Stelarc in Andy Clarke, *Natural Born Cyborgs: Minds, Technologies, and the Future of Human Intelligence* (Oxford: Oxford University Press, 2003), 115.

52 Compare Roger Caillois, *Man, Play, and Games* (New York: Schocken,

1979); and Jacques Ehrmann, "*Homo ludens* revisited," *Yale French Studies* 41 (1968): 31–57.

53 Sherri Irvin, "Appropriation and Authorship in Contemporary Art," *British Journal of Aesthetics* 45, no. 2 (April 2005): 123–37. Compare the presentations at the April 2009 conference "Play Machinima Law" at Stanford, http://kotaku.com/5293190/watch-the-play-machinima-law-conference.

54 Vilém Flusser, *Gesten: Versuch einer Phänomenologie* (Frankfurt: Fischer, 1994).

55 Compare Claude Shannon, "Certain Results in Coding Theory for Noisy Channels," *Information and Control* 1 (1957): 6–25; and Norbert Wiener, *The Extrapolation, Interpolation, and Smoothing of Stationary Time Series* (New York: Wiley, 1949).

56 Heinz von Foerster, "Responsibilities of Competence," in *Understanding Understanding: Essays on Cybernetics and Cognition* (New York: Springer, 2002), 191. Compare David Mackay, *Information Theory: Inference and Learning Algorithms* (Cambridge, England: Cambridge University Press, 2003), v: "Brains Are the Ultimate Compression and Communication Systems."

57 Lewis Mumford, *Man as Interpreter* (New York: Harcourt Brace, 1950), 2; cited after Carl Mitcham, *Thinking through Technology: The Path between Engineering and Philosophy* (Chicago: University of Chicago Press, 1994), 43.

58 Bruce Clark, "Information," in *Critical Terms for Media Studies*, 157–71 (Chicago: University of Chicago Press, 2010), 164, in the course of discussing timbre, time axis manipulation, and feedback.

INDEX

(continued from page ii)